Kite's Eye View

INDIA

Between Earth and Sky

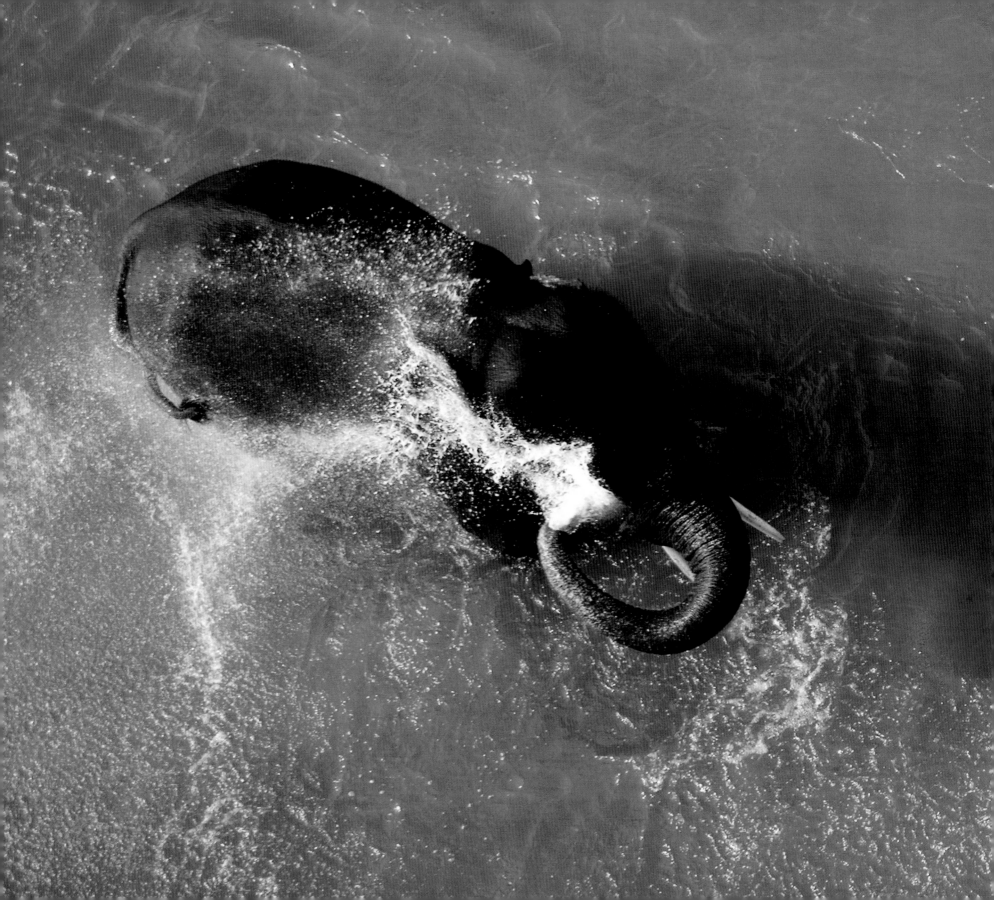

Kite's Eye View

INDIA

Between Earth and Sky

Nicolas Chorier

Foreword by Zubin Mehta

Lustre Press
Roli Books

ISBN: 978-81-7436-863-8

Third impression

All photographs © Nicolas Chorier

© Roli Books Pvt. Ltd., 2013
Published in India by Roli Books
M-75 Greater Kailash II Market, New Delhi 110 048, India
Ph: ++91-11-40682000; Fax: ++91-11-29217185
E-mail: info@rolibooks.com; Website: www.rolibooks.com

Editor: Amit Agarwal
Design: Nitisha Mehta
Layout: Naresh L Mondal
Photo engraving: Noir Ebene
Production: Naresh Nigam, Kumar Raman

Printed and bound at Thomson Press, India.

Preceding pages: *Elephants enjoying a bath at a training centre at Kodanad, near Ernakulam, in Kerala.*
Following pages: '...The police are on the move at the Kumbh Mela; they crowd the banks of the Ganges with their uniforms, they crowd the air with their whistles... It takes me over an hour to walk through a mass of people setting up a huge camp for the night by the fort's walls. Some are getting ready for the night, others are just waiting for next day's sunrise to go for a purifying bath in the river. Giant movie screens have been set up – this is India. Small villages form among the huge mass... A few million people are at the Kumbh!'

To Noé

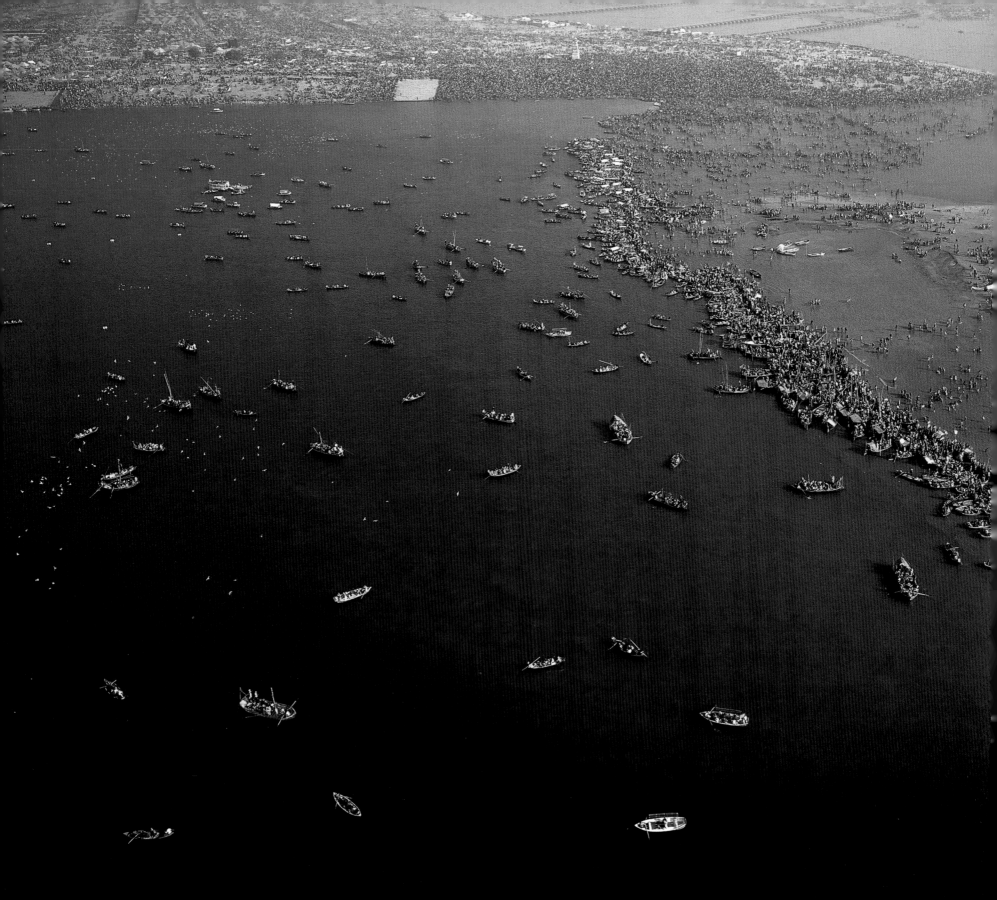

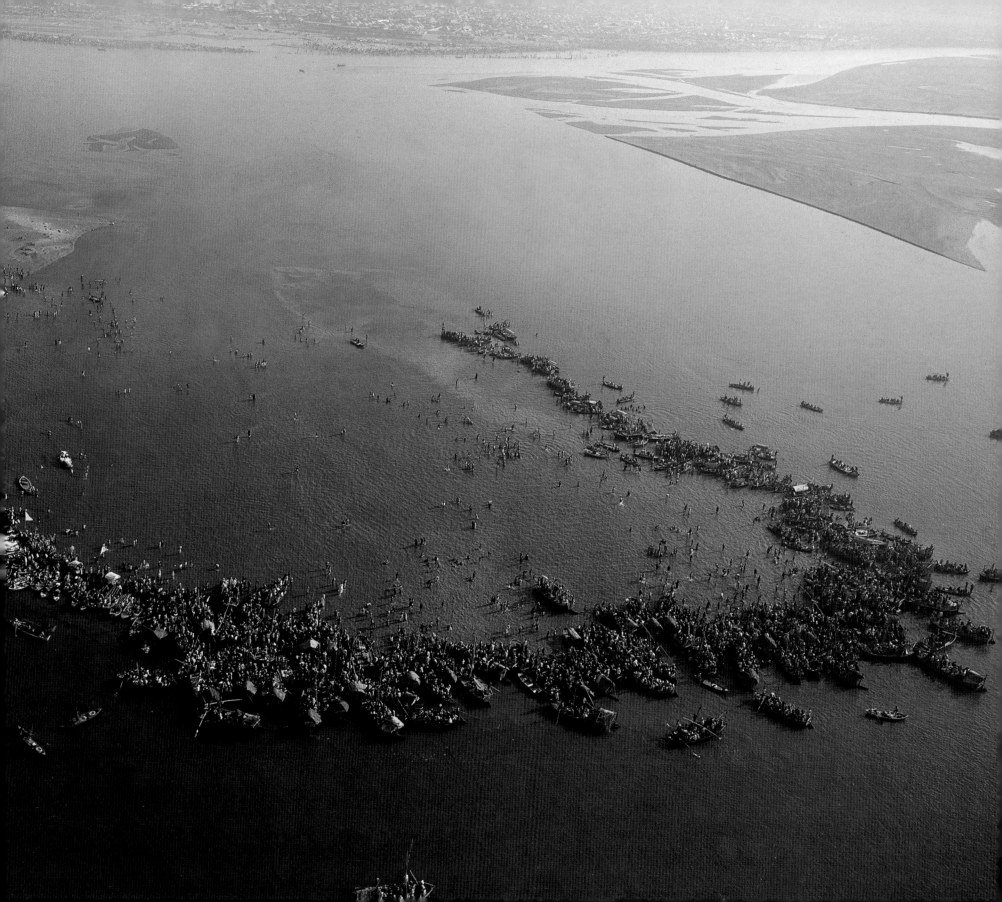

"Throw your dreams into space like a kite, and you do not know what it will bring back, a new life, a new friend, a new love, a new country.

Anais Nin "

FOREWORD

Despite living abroad for over fifty years, my soul has never left my beloved India. My fondest memories, apart from the intense music education I received from my father, is playing cricket with friends at the Oval Maidan in Bombay and... flying kites!

We would go to the kitewallah to get the kite string laced with glass to make it sharper – the whole point of flying a kite was to fight with the next kite and cut it. The trick lay in the way one tied the string on the kite and the balance one achieved to manoeuvre and control it.

I would fly these kites opposite my house at Cuffe Parade. The string would be so sharp that my fingers would bleed. We would also hear of accidents – people falling off the roofs while flying kites.

The last time I flew a kite I must have been fifteen or sixteen years old. I could never imagine then that these floating pieces of paper would one day be a contributing factor to a veritable art form. It is, therefore, exhilarating that after so many beautiful books on India, this one by Nicolas Chorier has come off with the most astonishing technique, photographing my country with not just a bird's-eye view perspective, but an innovation with kites, as he explains in detail in his Introduction.

The photographed areas become even more captivating if the viewer has been there – the Pushkar fair, in my case. A most beautiful overview of the incredible assemblage of people and animals that gives us a completely different perspective of a soulful quality.

Those of us who, unfortunately, spend most of our time outside our country, grab every opportunity to see India represented in a positive way, whether it is in words or pictures. Mr Chorier's presentations make me proud of India's beauty, whether he shows me the vastness of the Himalayas or a couple of fishing boats on a South Indian beach. If I could fly like a kite over any place in India, it would definitely be the Himalayas. How I wish I could once again fly one of these little objects and float it over the mighty Kanchanjunga or just simply over Chowpatty Beach at dawn in my beloved Mumbai.

Zubin Mehta

Facing page: *The seated Nandi (bull) at the Kailasanatha Temple, dedicated to Shiva, in Kanchipuram, Tamil Nadu.*

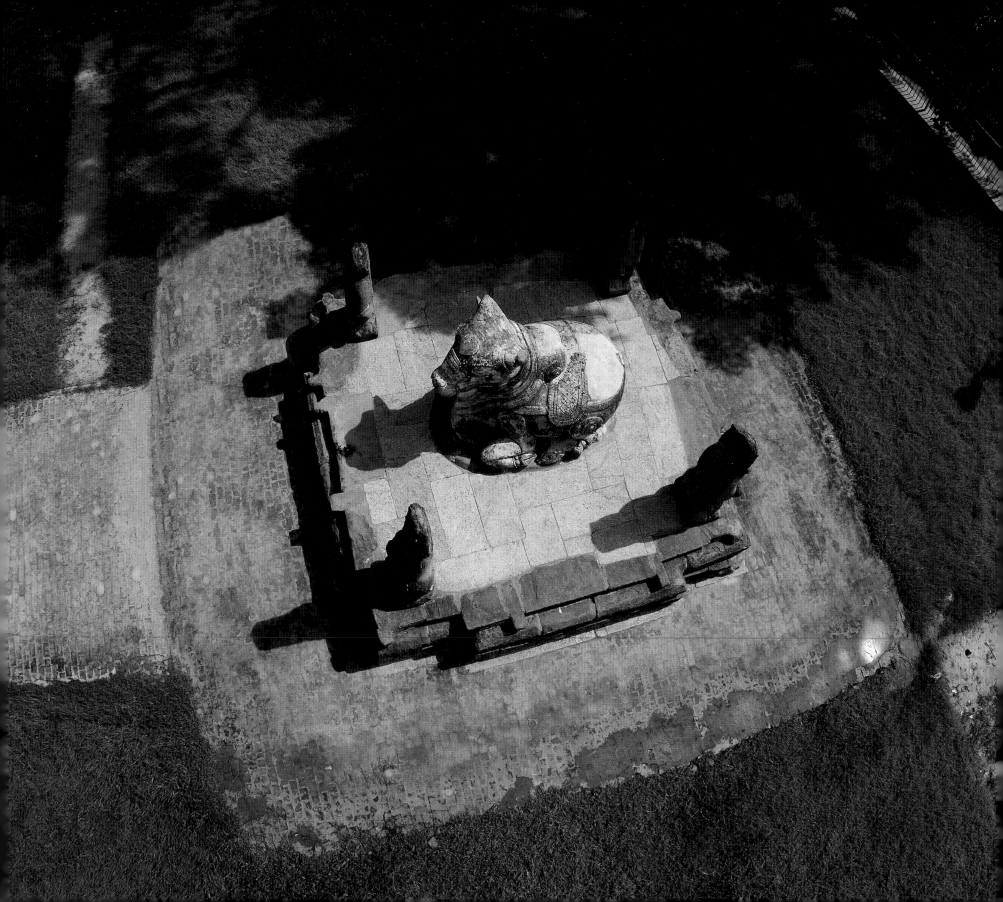

INTRODUCTION

As we sail into the twenty-first century and a global consensus seems to arise on the conservation of the earth's biodiversity and natural resources, we need to find alternative ways to produce and spend energy. Our children's future is at stake.

Kites provide a partial, yet valuable contribution to our global energy needs. In this book, you will see photographs taken from a kite, an activity that takes advantage of the wind, an infinitely renewable source of energy.

'One Sky, One World', say kite-fliers worldwide: the wind knows no borders, and the molecule that hits my kite today was probably flying over Chile yesterday and will be in Mongolia next week...

Kites bring about a general feeling of tolerance and communion, especially in Asia. Everyone marvels at them with a child's eyes, regardless of age and political or religious inclinations. Perhaps they take us back to ancient times, when men talked of gods up there above the clouds. In Asia, thousands of years ago, the first kites were flown precisely to communicate with the gods.

Unfortunately, kites have also been used in war – not only as messengers, but also as bombers, like in Thailand, where they were used to drop dynamite over enemy camps.

Aerial photography using kites started over a century ago. In 1888, in Labruguiére, a small village in southern France, Arthur Batut was the first to start experimenting with this technique. Over the years, in Europe and the United States, numerous other kite-fliers contributed to its development. The late nineteenth century was a time of technological innovation, and kite-flying was the sprouting ground for the development of aerodynamics and early aviation.

A few square inches of fabric, a touch of technical know-how, a whiff of breeze, and lo, there is birdy on the remote. The photographer teams up with the wind – taming this source of energy using a wide range of tools, from the most basic to the highly sophisticated. The resulting photographs challenge one's sense of orientation and perspective, and provide a close view of the world from an unusual angle.

India from a distance

More than any other country in the world, India, with its cultural and natural diversity, offers an amazing variety of subjects, and a friendly challenge to anyone with a photographic inclination. It has

been praised and shown from as many different angles as there are photographers.

I have picked up the challenge in my own way and tried to approach India from an unusual angle, a perspective at once distant and intimate. The kite contemplates from a distance – but the camera's eye unveils many unexpected aspects of a subject. India has had a long-standing kite-flying tradition (to be elaborated later in the text), and its skies have generously let my camera softly approach its human and natural beauty.

Riding the wind

I have always been fascinated by the wind – vast, overpowering, yet sweetly breathing above my head. Along with my camera, carried up on the wings of the kite, my eye soars above the ground.

This fascination gradually led to an expansion of my fields of interest, from agronomic research to archaeology, tourism, national heritage surveys and wildlife documentaries.

Each of these applications led me to devise tailor-made hardware and photographic techniques, which I am constantly improving. Each new venture brings me into contact with dedicated and highly knowledgeable specialists. And every instance turns out to be a rich and fulfilling experience...

Out-of-the-way sites can be accessed from a kite without the need for an airstrip nearby, which makes aerial photography possible any time it is needed, be it for technical, scientific, informational or commercial purposes. It is cheap and requires no equipment other than a windbreaker to meet chilly weather in.

Fitting a camera onto the kite broadens the photographer's perspective and bestows a third dimension – a poetic one – to photography. Suddenly the photographer can see the subject simultaneously from two different angles – from the ground and from above. His vision is expanded and the kite's string is like a second optical nerve.

The kite allows the photographer to wait for just the right time to click, as a ray of sun finally comes to highlight the subject, or when the elephant blows a shower from its trunk. The camera flies in the wind, a silent and unobtrusive spectator, alert and fully integrated into its natural surroundings. Easy to set, the camera can remain stationary over a site for a few hours, thus increasing the chances of success.

TECHNIQUE OF KITE PHOTOGRAPHY

The photographic equipment is mounted on a small cradle hanging on the string under the kite. The camera can be lifted up to a thousand feet, even though low altitudes are often more interesting.

I build my kites after the famous Japanese Rokkaku, which I have always found to perform remarkably well. The traditional Rokkaku is a huge kite often flown by dozens of people in highly popular competitions.

My own kites are, of course, smaller, with the largest reaching 12 square metres (about 40 square feet). They are made out of siliconised nylon and carbon or fibreglass sticks. I have adapted the traditional pattern of these kites to suit my own needs and can pilot them somewhat like the traditional Indian models.

The rig is operated by remote control and can achieve a full 360 degree rotation and 90 degree tilt. An air-to-ground video link sends a signal which provides real-time monitoring on a portable TV screen, for accurate framing.

Prior to a mission, I can become obsessed by the wind conditions around the site. I observe the wind in the trees, and how the birds are flying, to decide which kite I will use, and where I will launch it from.

Once the shooting spot has been decided, I need to find a safe launching place – in a town or city this could be a parking lot, a backyard, a square, a short stretch on a street, a roof even. I only need enough space to be able to take a few steps back and forth. I set up my kite and fly it up to about 30 metres (100 feet). Once I feel my kite flying nice and smoothly, I rig up my camera on the string, and the whole apparatus can then be flown up to the required height.

When my rig is up and flying, it's on automatic mode: the kite self-balances itself once it is about 300 feet high and settles on the correct air stream, steady and operational, waiting for my moves...

I carry my remote control on one shoulder and a video monitor around my neck. I can now shoot – the whole set-up being very flexible. I can easily walk several hundred yards and raise or lower the kite in order to find different shooting angles and position my camera above the subject at will.

Kite photography requires a good knowledge of air conditions and a capacity to assess risks. Flying a kite may seem like a game, but it is one thing to fly it over a deserted beach, and another to make one's way over a city carrying up to four pounds of photographic material. It takes a lot of practice and an intimate knowledge of the kite's behaviour. It's important to know how to react when the wind speed doubles suddenly, or when the string gets tangled in an obstacle, or when a spar breaks, or when the unexpected happens... The traction on the kite's string can be up to 20 kilograms – just imagine what will happen if it falls in the middle of a busy road!

It's good to feel familiar with the equipment and with the kite. The kite string becomes an extension of the arm, and gives real-time information about all that happens up there, 400 feet high, without the need to look up. The tiniest wind kick, a gentle direction change, an extra pull or a temporary loss of lift... you must feel with fingertips, absorb, compensate, let the instinct manage the flight. Then you can concentrate on the photographic action, and stick your eye to the monitor.

Facing page: The radio remote control; the cradle on which the camera is mounted; and the kite.
Right: In action at Humayun's Tomb, Delhi.

Photo: Marian Hanff

INDIAN KITES: FIGHT TO THE FINISH

It's impossible to do a book combining India and kites without a tribute to *patangbaazi*, the Indian kite-flying tradition of fighter kites.

For kite fights, the strings – *manjahs* – are dipped in rice glue, then in ground glass, which makes them razor-sharp. The aim of the game is to cut the opponent's string – and I wouldn't want my own kite to be in the way...

The history of patangbaazi is shrouded in mystery; nothing can be said about it with any degree of certainty. As a regular sport, it came to India during the reign of Mughal emperor Shah Alam. Being a new sport, the people took it up enthusiastically, and overnight a new tribe of *patangbaaz* (expert kite-fliers) was born.

Initially, the kite was made in the form of a prism, and was christened *Tikoni Qandeel* (prismatic candle). Inside this *qandeel* a ball of rags soaked in oil was hung, with the help of a thin wire. As soon as the ball was lit, the hot air filled the qandeel and it started rising in the air, giving a splendid view to spectators. But it was basically a night sport. For the purpose of daylight flying, the *Chhang* and the *Tikkal*, two modified versions, came into being. Quadrangular in shape, they had better air mobility and offered better control to the patangbaaz.

The design of the Tikkal underwent further improvement and it acquired the appearance of the present-day *patang* (kite).

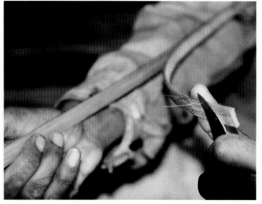

Apart from its sporty side, patangs also played the role of messengers, conveying letters between lovers to distant corners of the city. This role has been described at length in florid Urdu in *Masnavi-e-Zahr-e-Ishq* by Nawab Mirza Shauq, one of the poets of the court of Nawab Wajid Ali Shah.

In 1942, during the height of the Indian freedom movement, a British delegation, the Cripps Mission, visited the country. Freedom fighters all over the country made king-size patangs in shimmering colours on which was written in bold letters: CRIPPS GO BACK.

Not very long ago, parents used to tie the string of a flying Tikkal (the old version, much bigger than a patang) to the leg of their children's bed. The kite string created a vibration in the bed's structure, lulling the children to sleep. Cute, isn't it?

In this age of computerised leisure, how good it is to see the sky fill with patangs – as happens in India during certain festivals – and a whole city turn away from their computers and TV screens to climb up to the roofs and celebrate the new season.

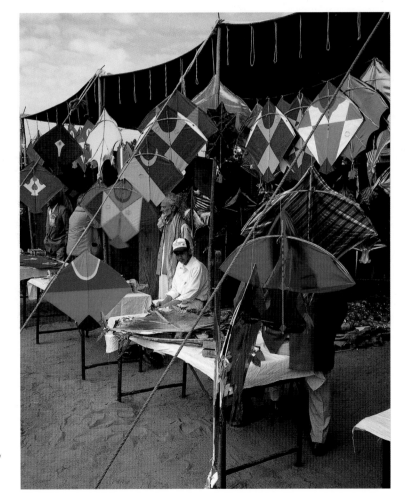

Facing page: *Only paper, bamboo, cotton thread and rice glue is required to make a basic kite.*
Right: *A stall all decked up at a kite festival.*

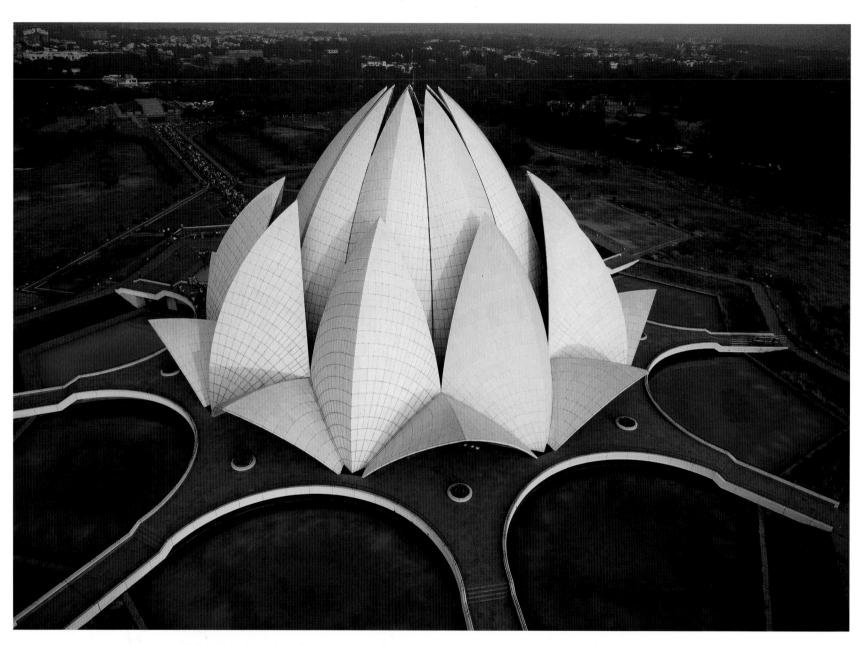

'While generations of architects have only used the lotus symbol as decoration, the Baha'i Temple in Delhi is a courageous and successful example of a modern building shaped like the lotus flower itself. The building almost looks like a model when we look at it from a bird's-eye view...'

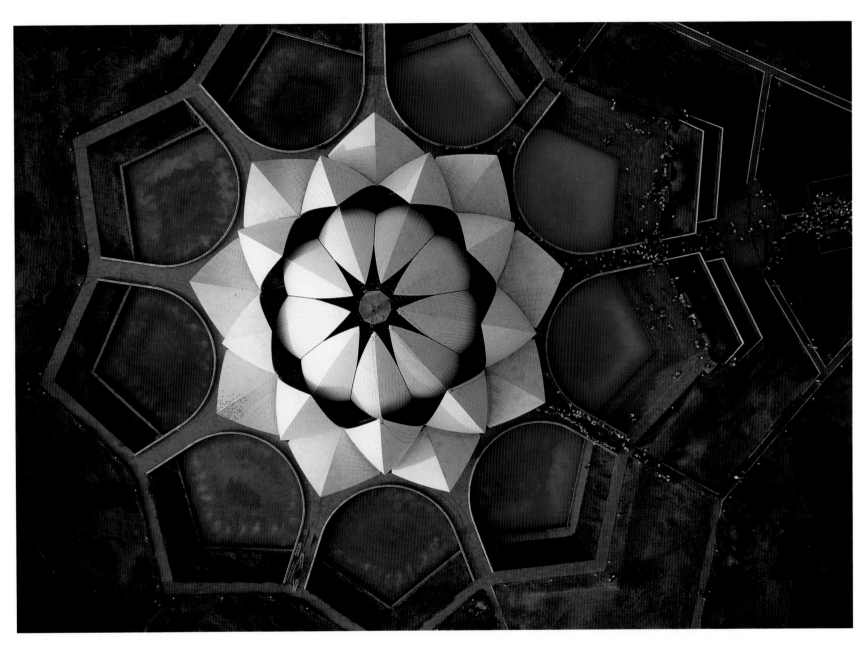

Designed by Iranian architect Fariburz Sahba and opened to the public in 1987, the Baha'i Temple has a central dome and nine sides, the figure nine symbolising unity in the acceptance of the nine major world faiths.

DELHI

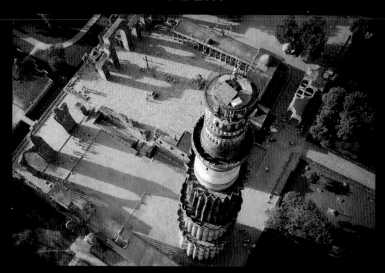

Delhi, India's capital, is also its third largest city, with a population of about 14 million. The seat of political power, Delhi has shaped and decided the destiny of India. Many have invaded Delhi, including the Persian emperor Nadir Shah, who sacked the city in 1739. There have been at least eight cities around modern Delhi, established by various Hindu kings and Muslim conquerors, and most recently by the British. While the first city was that of Indraprastha, featured in the epic Mahabharata three thousand years ago, the eighth – New Delhi – was inaugurated by the British in 1931. Delhi became the capital of modern India in 1947.

Top and facing page: 'I'm not sure I shot that photograph – there were so many radio interferences... When getting close to the Qutub Minar, my camera was shooting by itself, randomly...' A soaring tower at 73 metres, Qutub Minar has five storeys, each marked by a projecting balcony. The site of the first Muslim kingdom in India, it was started by Qutbuddin Aibak, then a slave-general of the Afghan invader Muhammad of Ghuri, in 1193. While Aibak could complete only one storey, his successors – Iltutmish, Alauddin Khilji and Feroze Shah Tughlaq – built the rest.

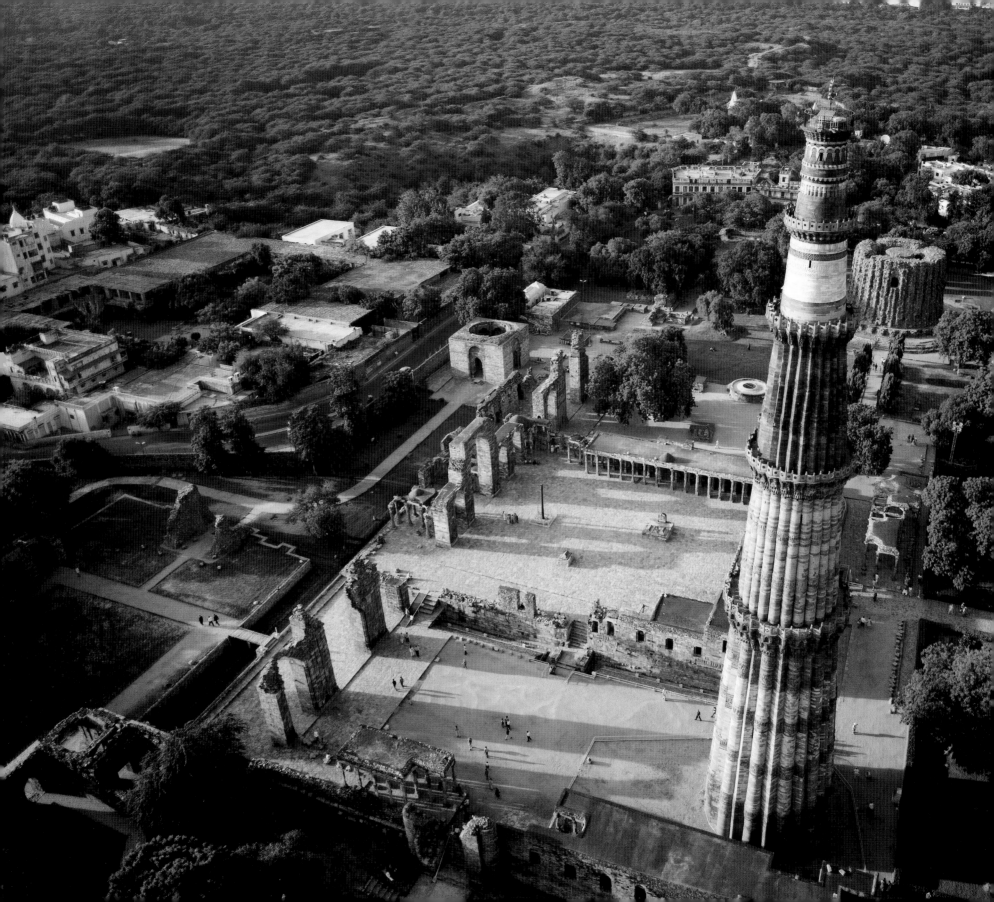

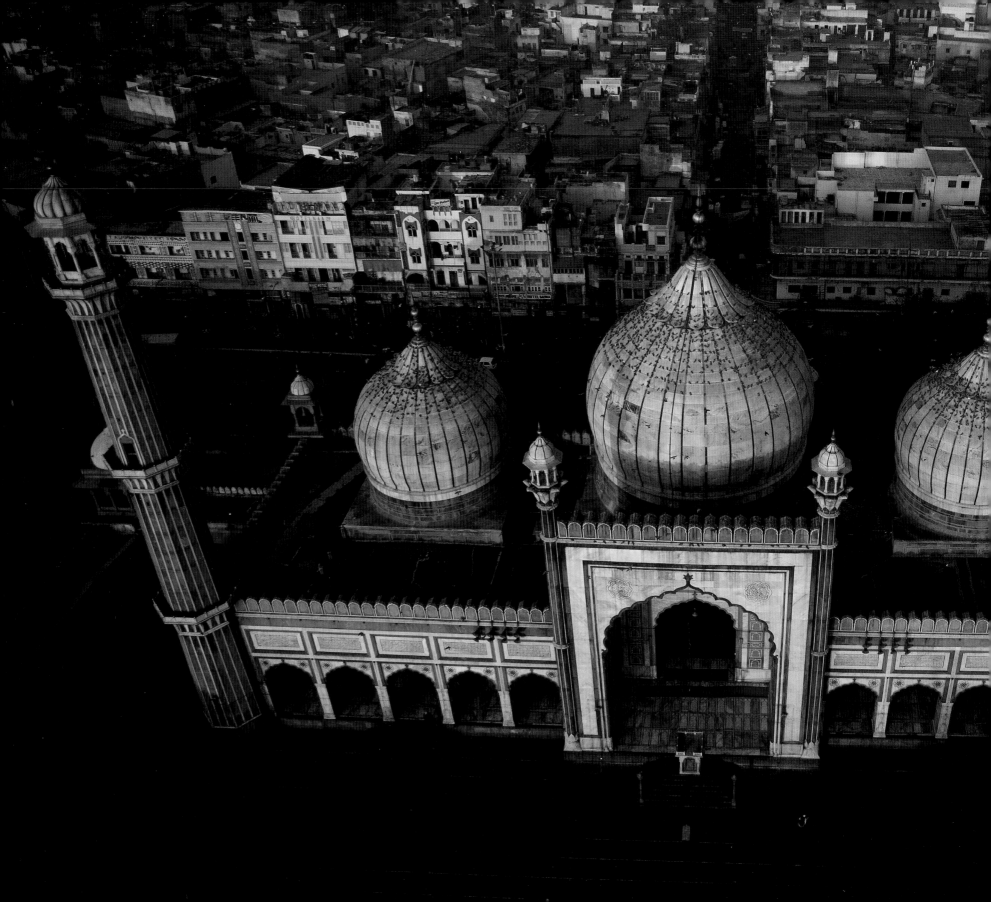

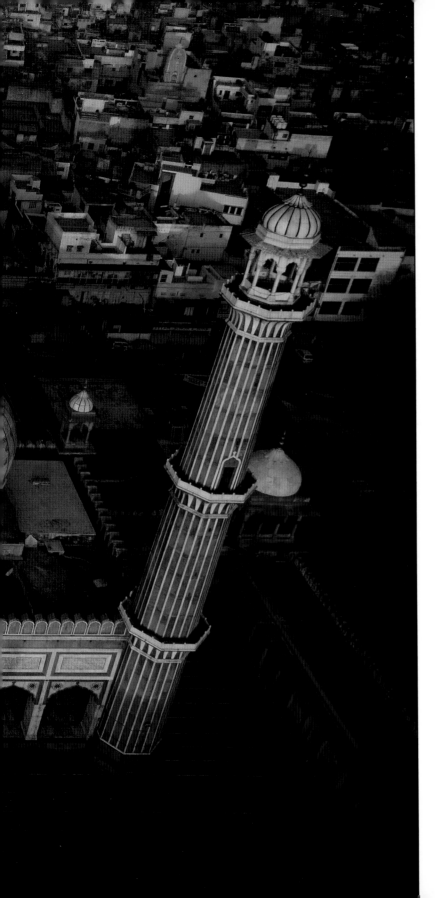

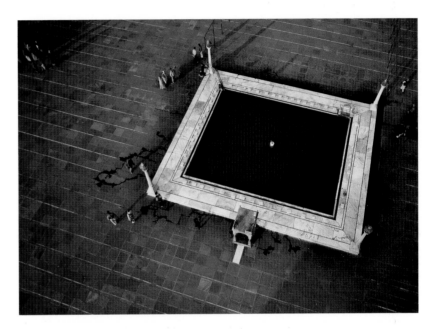

Left: 'It's not easy to fly a big kite in crowded Old Delhi, and it needs a lot of patience to find the appropriate wind and light conditions for a good aerial photograph. I shot the great Jama Masjid in the early morning, in the still cool night wind, before it became misty. The old bazaar surounding the mosque was slowly waking up, and I can still feel the cold surface of the marble pavement under my feet... I was flying my kite from inside the mosque...' *India's largest mosque, the Jama Masjid was built by Mughal emperor Shah Jahan as part of his capital city of Shahjahanabad. Started in 1644, it took five thousand workmen over six years to build it.*

Top: *The* dukka *(water tank) in the mosque courtyard for ritual ablutions.*

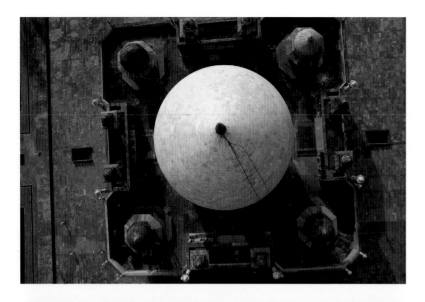

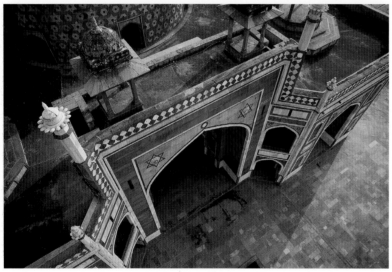

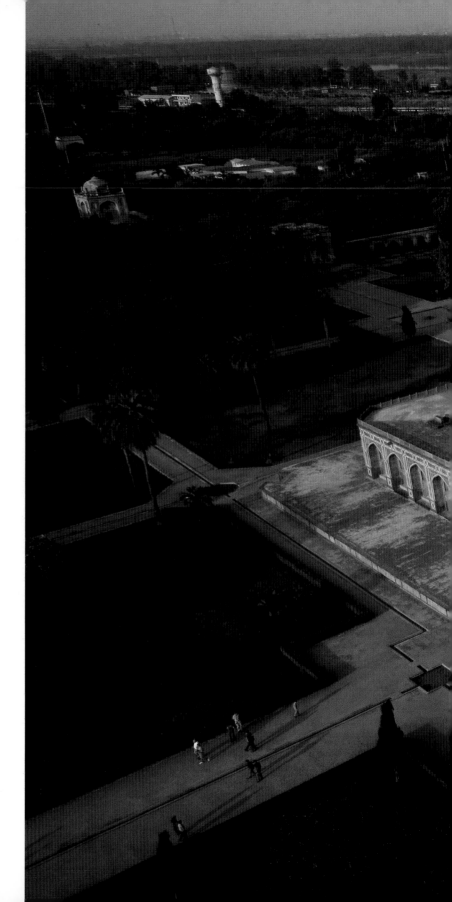

Above and right: 'Today I'm lucky. The wind is so good, clearing the sky in Delhi, and I am there to catch the light when it is good. I have enough space around me, and it is a pleasure to shoot Humayun's Tomb in a three-dimensional way. There are two eagles flying close to my kite, and a huge hawk flying with my camera. They turn around, curious, and stay close during my whole flight. I feel in tune, I exist all the way up to my sail...' The first example of a great Mughal garden tomb, Humayun's Tomb set the standard and inspired many later buildings, including the Taj Mahal. The resting place of Humayun, the second Mughal emperor, the tomb was commissioned by the emperor's senior widow, Haji Begum, and built in 1565 by Persian architect Mirak Mirza Ghiyas.

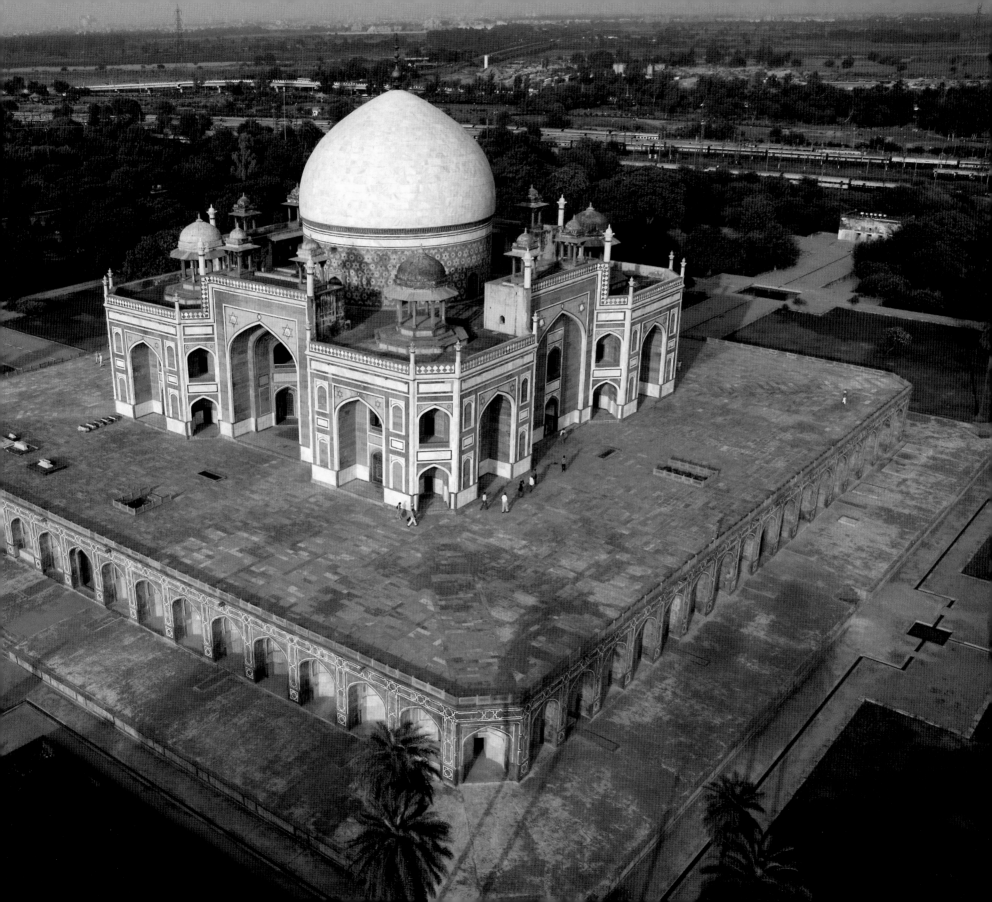

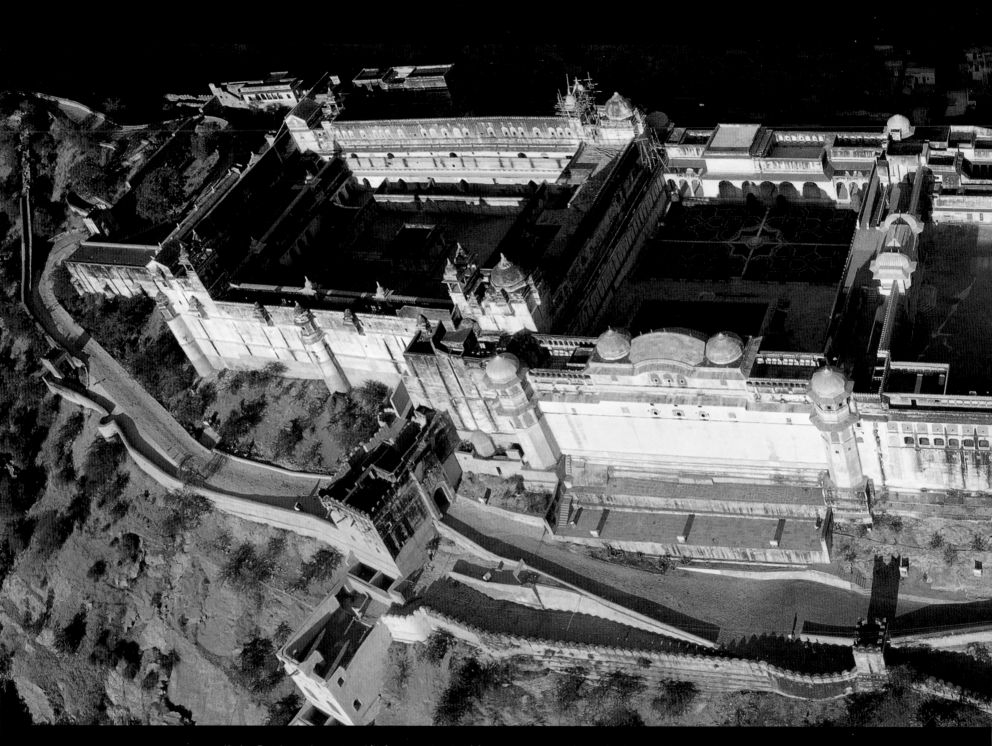

'Amber Fort, located on a steep hill, is so vast that the visitor cannot get a real idea of its size, nor fully appreciate its intricate plan. However, thanks to the kite, comprehensive views of a monument such as this are possible, and are a true bonus for restoration teams as well... I've heard Paul McCartney is visiting the fort today. Shall I become paparazzi for the occasion...?!'

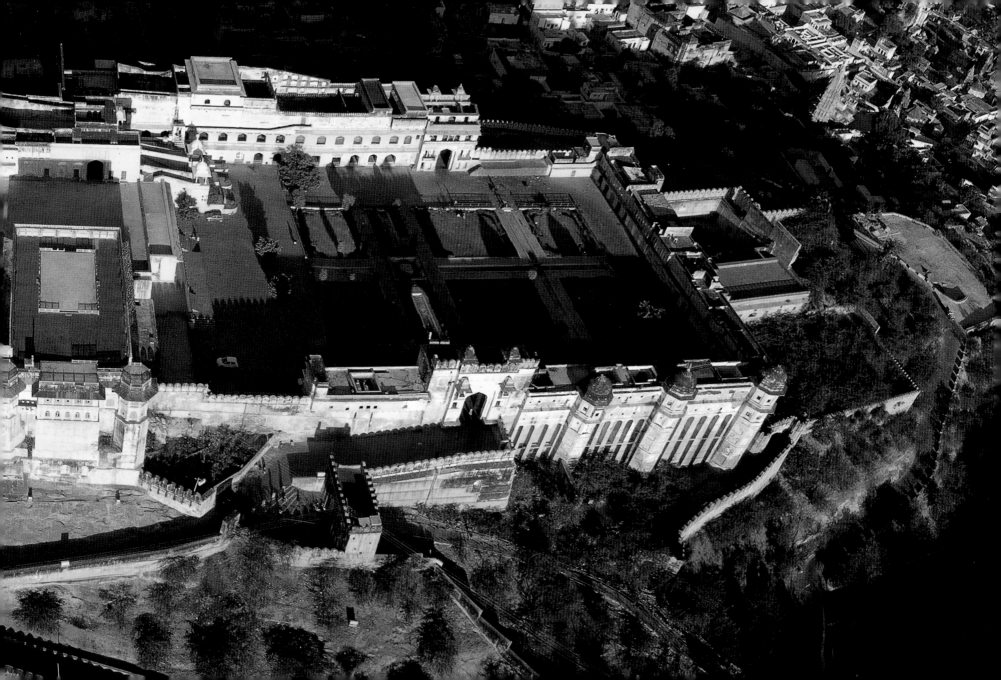

JAIPUR

If Rajasthan, the land of kings, is the most colourful jewel in India's crown, then its capital, Jaipur (261 km southwest of Delhi), is a feast for the senses. A fascinating labyrinth of a royal past, busy bazaars and historic sites, the city is also called the 'Pink City', as that is the colour of many of its buildings.

The city was built by Sawai Jai Singh II, the great warrior, statesman and astronomer, who carefully preserved his predecessors' alliance with the Mughals. Work began on the city in 1727 and took six years to complete. One of the city's most extraordinary sites is the City Palace, a blend of Rajput and Mughal architecture that has been home to the rulers of Jaipur since the eighteenth century. Eleven km north of Jaipur is the magnificent fort-palace of Amber, a beautiful example of Rajput architecture.

Top: One of the courtyards of Amber Fort. Begun in 1592 by Man Singh I, the Rajput commander of Akbar's army, Amber Fort was extended by the Jai Singhs.
Facing page: The Kesar Kyari Bagh, situated in the waters of the Maota Lake in Amber Fort, has star-shaped flower beds where saffron was once planted.

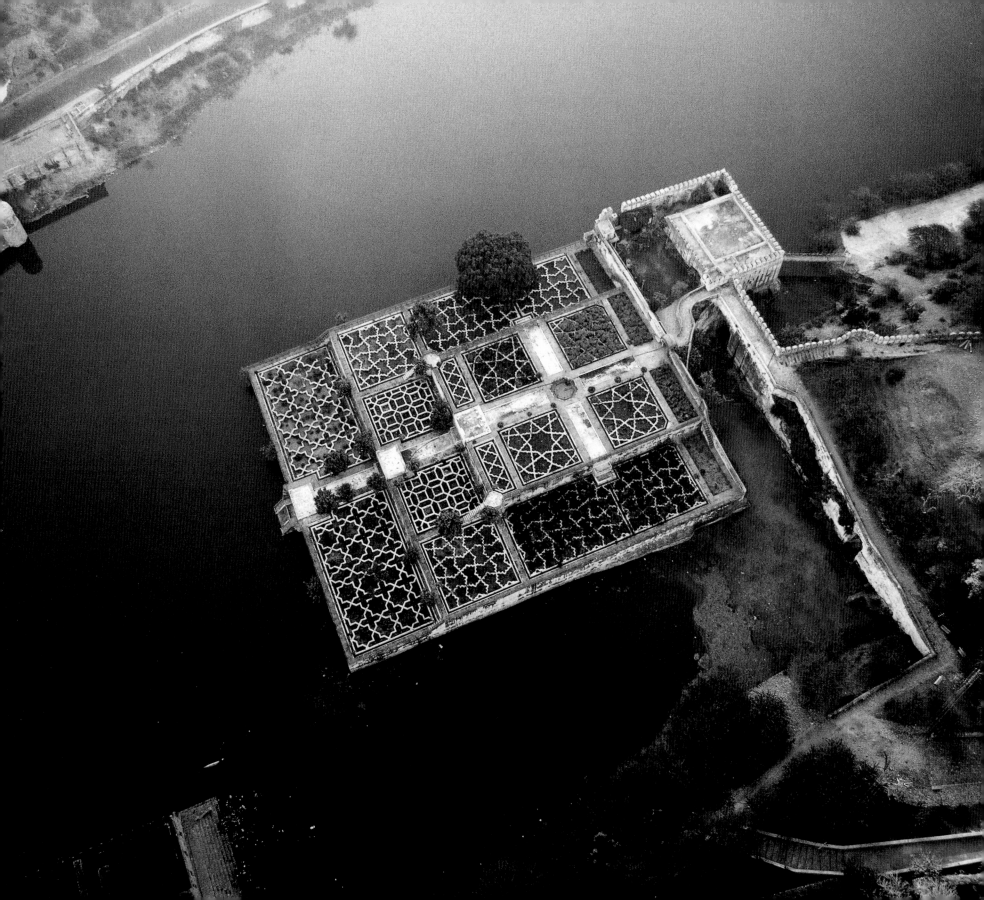

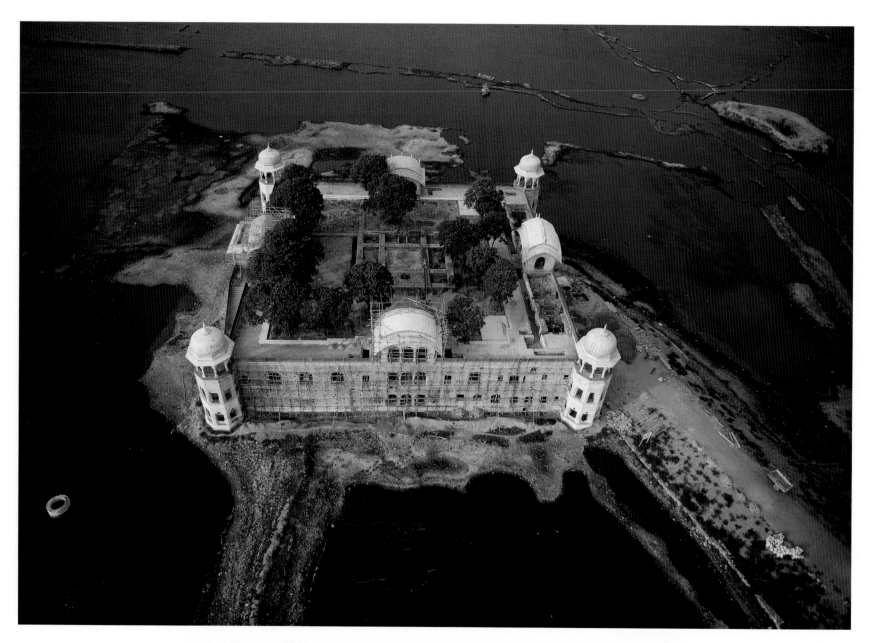

'Jal Mahal is another Rajasthan icon under a restoration process, thanks to the passion of those concerned about preserving heritage buildings... I can't help thinking about the times when kings were building such jewels. Did they ever fly kites here? I wonder if one could see a patang rising up from these suspended gardens in honour of a visiting aristrocrat in the seventeenth century! I suddenly wish my camera could do the job of a time machine and catch a snap of the past...'

Built in the eighteenth century by Madho Singh I as a summer retreat, Jal Mahal was used for duck-hunting parties. The king was inspired by Lake Palace of Udaipur, where he had spent his childhood. Jal Mahal is surrounded by Man Sagar Lake, whose hyacinth-infested waters are now being cleaned up in a major operation.

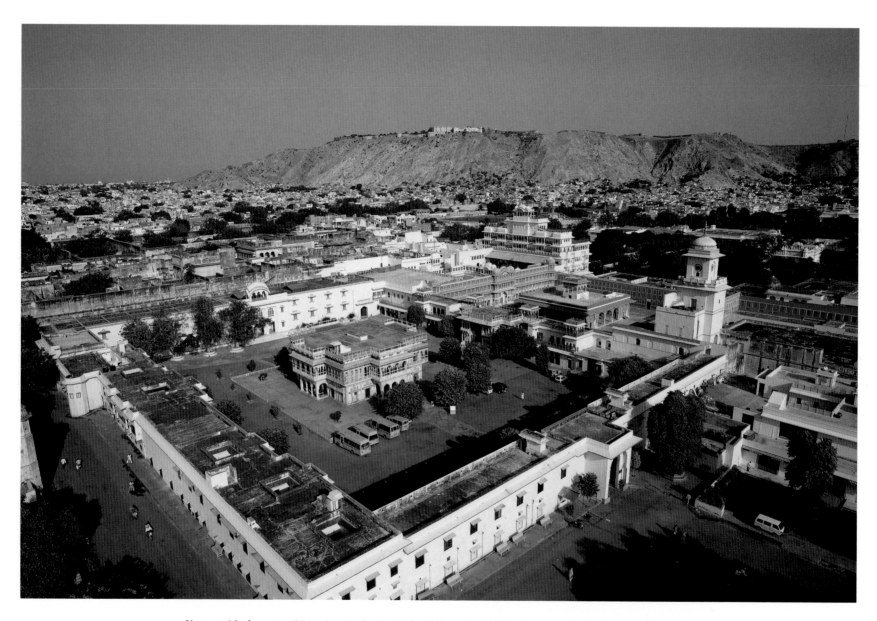

Above and facing page: 'I have been trying to do kite photography in Jaipur for years. Besides a poor wind regime, not suitable for my kites, there are always some patangs in the sky, more or less idle, waiting for a partner for a fight… My big kite attracts these patangs like bees to honey, and they would cut my string within the blink of an eye! Thankfully, I am here on the day of Diwali (Festival of Lights), when only firecrackers fly above the city, and when patangs are stored on the shelf.' Built by Jai Singh II, City Palace was added to by his successors. The royal family still uses the palace as a residence, though a large part of it is now a public museum. The Nahargarh Fort, built by Jai Singh in 1734 to bolster Amber's defences, can be seen on a hill in the background.

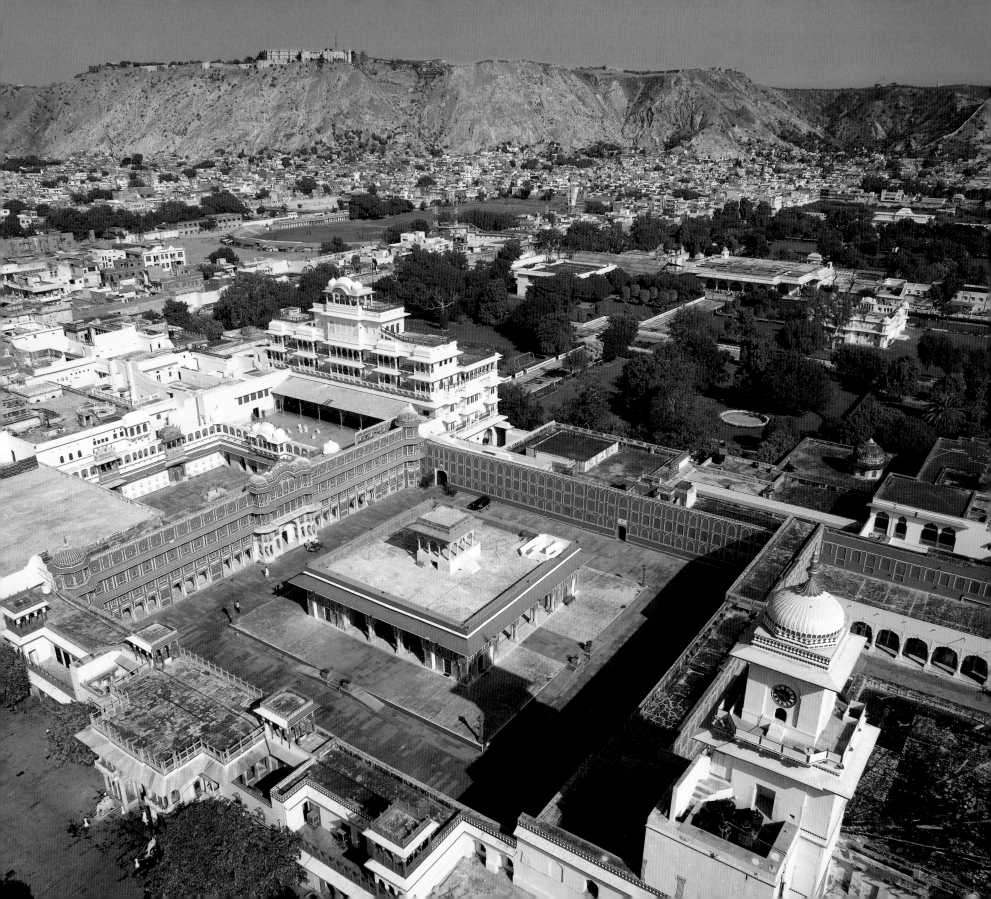

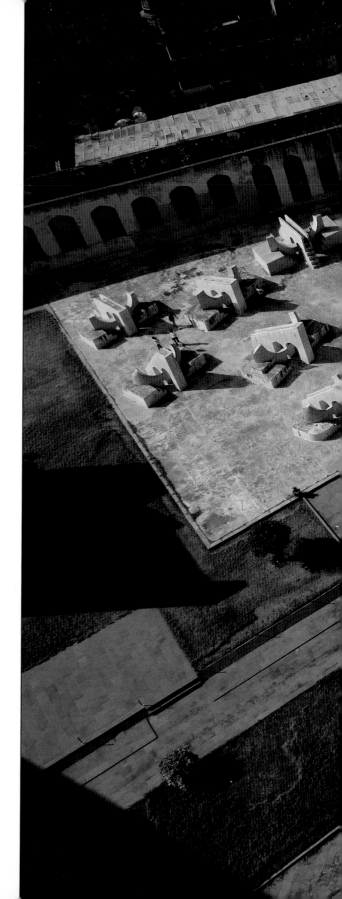

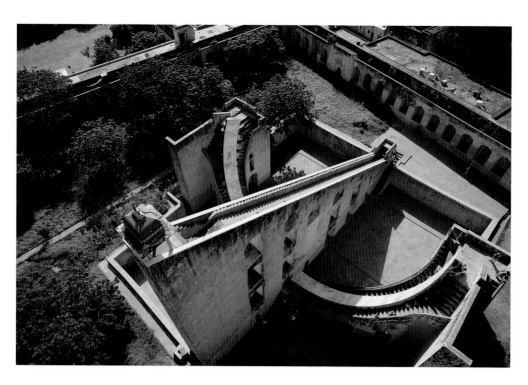

Above and right: 'On Diwali night, as thousands of crackers go up all over the city, I go back to fly my kite from the Jantar Mantar Observatory. There is a smooth cool breeze coming from the north, steady, perfect. As I fly, and give more string to the kite, it starts disappearing in the dark. Above 200 feet, I can't see it anymore. I give it 400 feet more, just being aware of it through the pull on the string. I look at the stars and wonder which one attracts my kite so hard...' Jai Singh II, a keen astronomer, built five observatories, the best of which is in Jaipur. Built between 1728 and 1734, the observatory has sixteen fascinating giant instruments, including a 23-metre-high sundial.

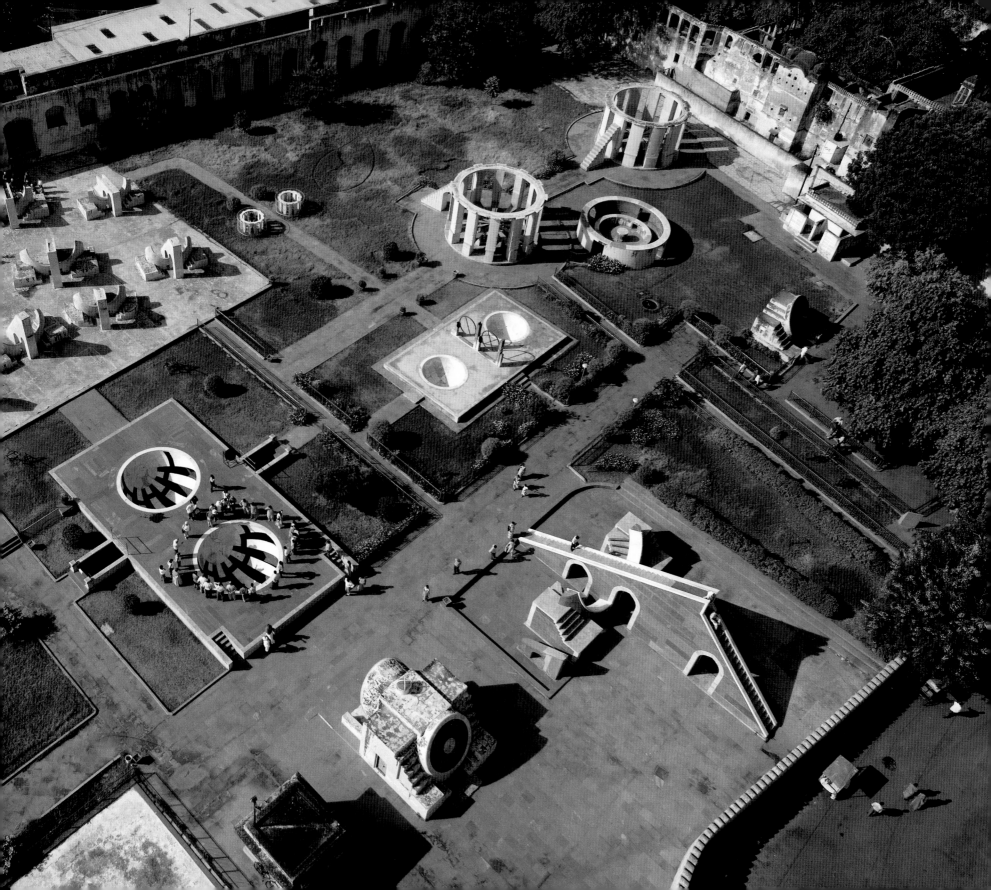

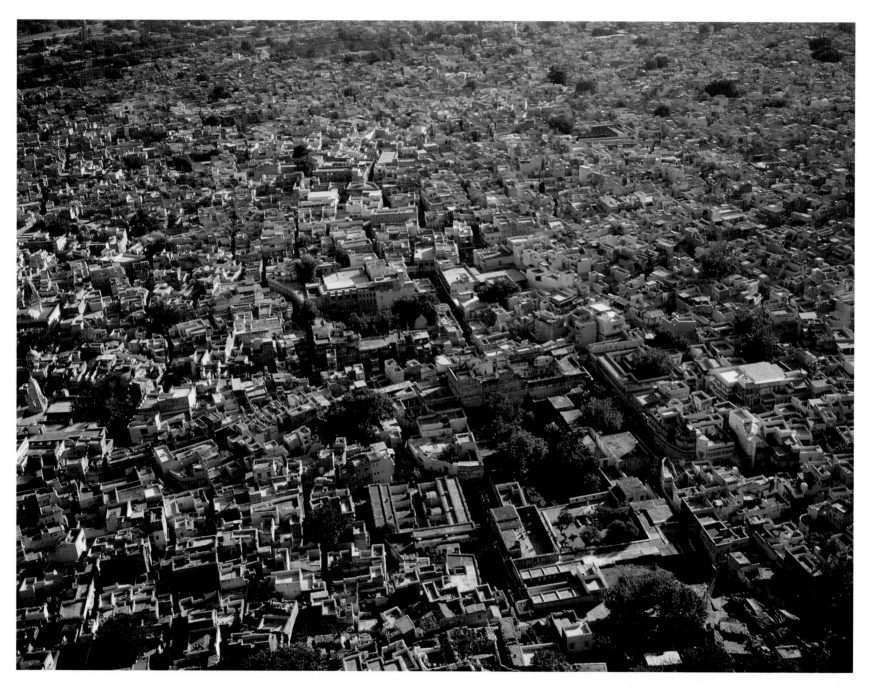

'At noon I survey Jodhpur city from Mehrangarh Fort's walls. Its bustle fills the air. All sorts of sounds reach me: from workshops, wedding bands, makeshift stereos blasting the latest hits, rickshaws honking...The south wind softly blows the dust away and the colours of the town gradually get brighter and more distinct. The colour blue spans the whole space.'

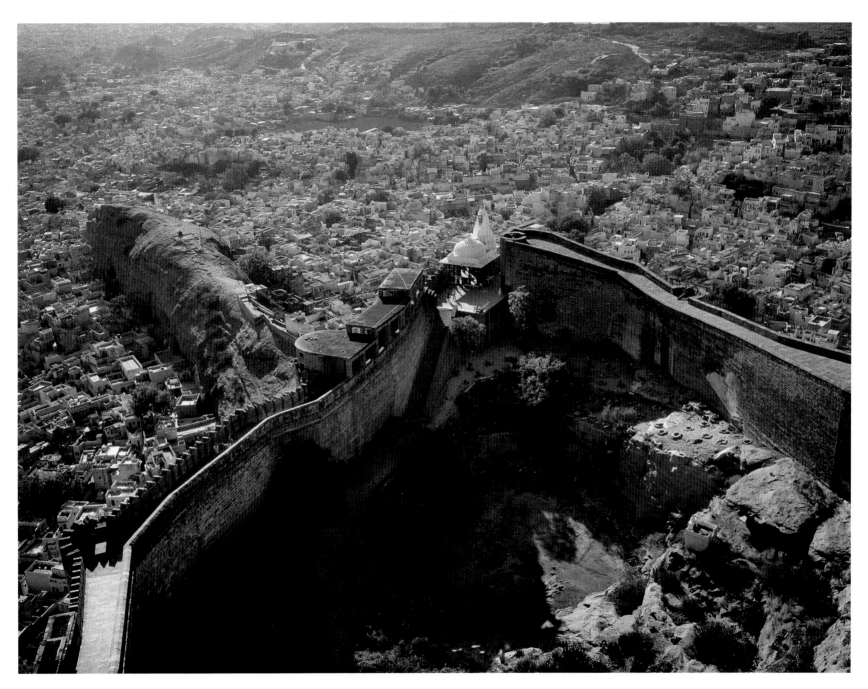

Founded by Rao Jodha in 1459, the Mehrangarh Fort was expanded by his successors between the mid-seventeenth and mid-nineteenth centuries. The fort has seven gates, including Lohapole (iron gate), beside which are the hand prints of Maharaja Man Singh's widows, who committed sati (self-immolation) by jumping onto his funeral pyre.

JODHPUR

Spread along the Great Thar Desert (331 km west of Jaipur), Jodhpur is dubbed the 'Blue City' after the colour of its old town houses. It is overlooked by the mighty Mehrangarh Fort, perhaps the most majestic in Rajasthan, whose ramparts rise from a 125-metre sandstone outcrop.

Founded in 1459 by Rao Jodha, Jodhpur was once the centre of Marwar, the largest princely state in Rajputana. Its merchant class – called the Marwaris – is known for its business acumen. The city's immense Umaid Bhavan Palace commemorates Umaid Singh, Jodhpur's last maharaja before independence, who had commissioned the palace to provide employment to his famine-stricken subjects.

Jodhpur's famed cubic roofscape is a photographer's delight. Traditionally, blue signified the home of a Brahmin but now non-Brahmins use it too.

Top: *Canons along the bastioned walls of Mehrangarh Fort.*
Facing page: *A detail of Mehrangarh Fort.*

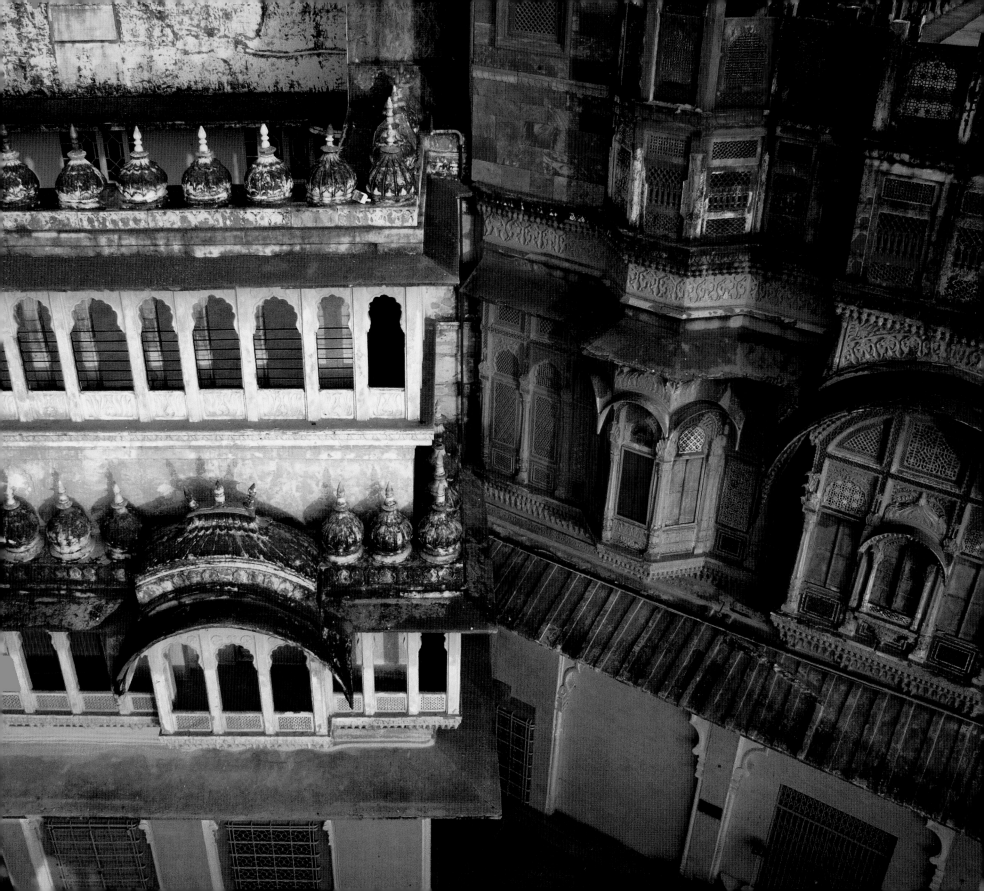

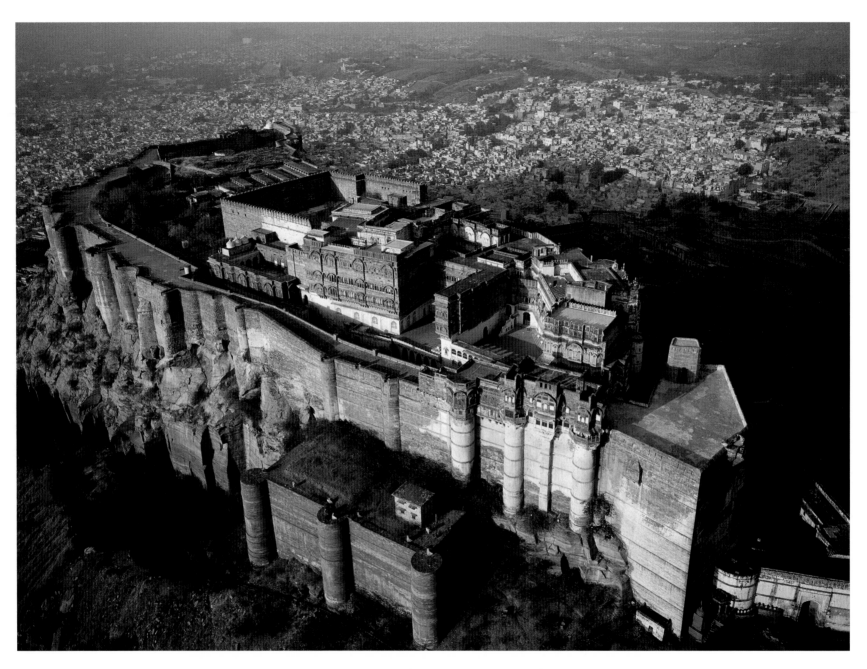

'The vultures are back, after a two-year unexplained absence. They are soaring over the city, playing in the wind, indifferent to human presence. I count over twenty of them. New nests are showing up on the west side of the fort, and the local authorities are hoping their number will soon reach the 200 mark they had but a few years back... Each time I fly my kite they fly alongside it. Some of these huge beasts (they measure up to eight feet across) come so close as to brush the kite with their wings.'

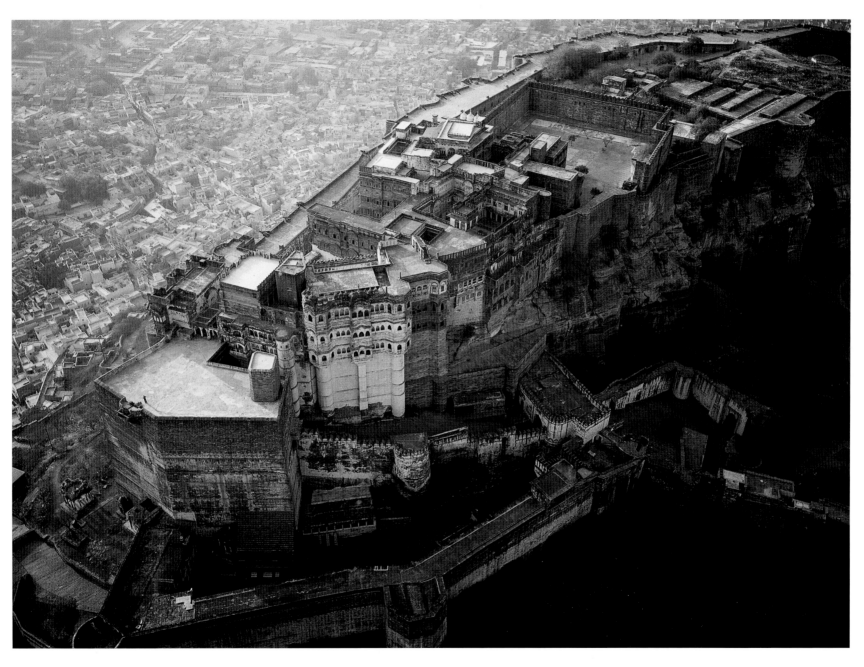

'My last day in Jodhpur. At 7 am, I go up to the northern wall of Mehrangarh Fort for one last try. The wind, still cool and smoothly blowing, is perfect. I wish I could absorb every last picture showing up on my monitor.'

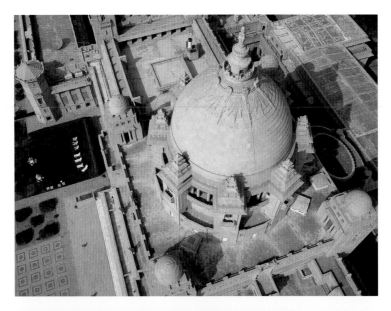

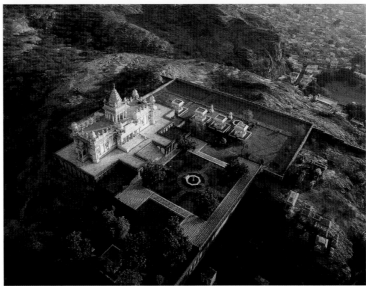

Top and facing page: 'My kite seems to enjoy flying close to the dome of Umaid Bhavan, as if mocking that symbol of royalty still standing in the twenty-first century.' *Begun in 1929, it took three thousand workers fifteen years to complete the 347-room sandstone and marble Umaid Bhavan Palace. Umaid Singh's grandson, Gaj Singh, still lives in a part of the palace, while the rest has been converted into a successful heritage hotel.*

Above: *Jaswant Thada, the cenotaph of Maharaja Jaswant Singh II built in 1899. The tomb has beautiful* jali *(carved marble lattice screen) work and offers a great view of Mehrangarh Fort.*

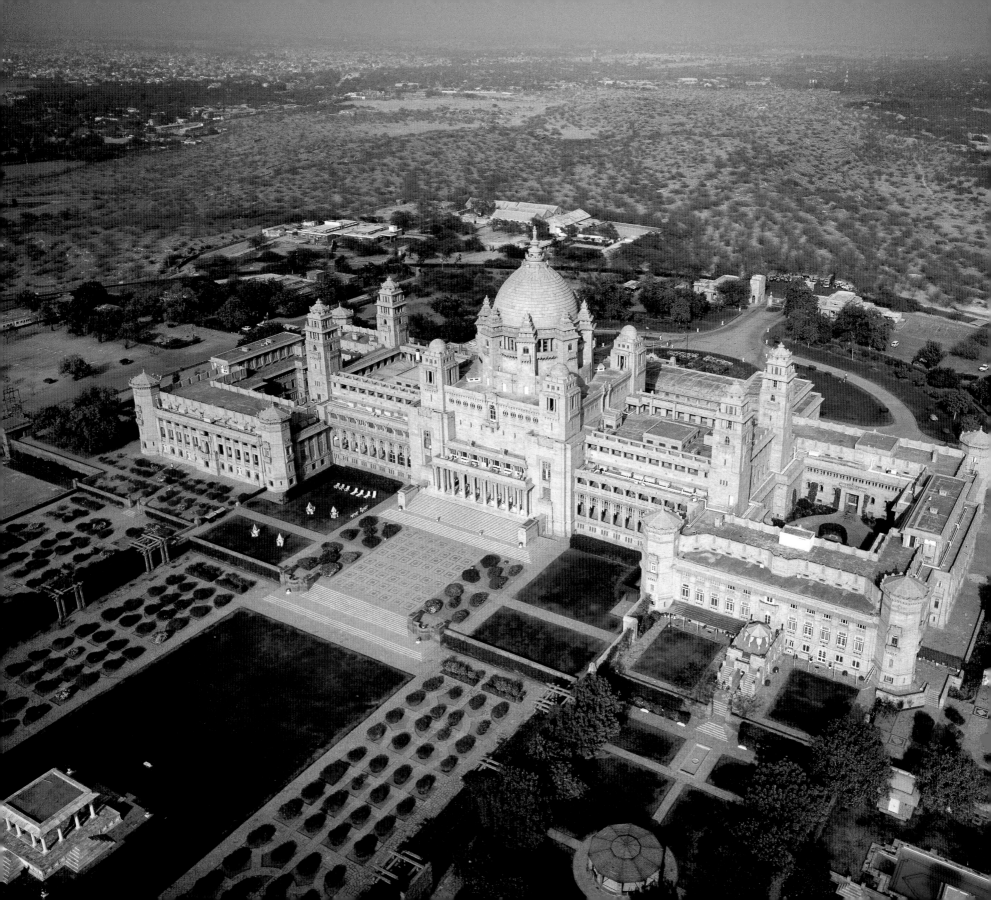

Above and facing page: 'When seen from the kite, the gateway and ramparts of the amazing twelfth century Ahhichatragarh Fort complex reveal many secrets that one can't see from the ground, such as how new structures and walls have been added to the original...' Located in Nagaur, near Jodhpur, the fort is a large complex housing palaces, pleasure pavilions, gardens, courtyards, service buildings, temples, a mosque and an elaborate water system. Neglected for years, it is now being restored. **Following pages:** View from the Ahhichatragarh Fort.

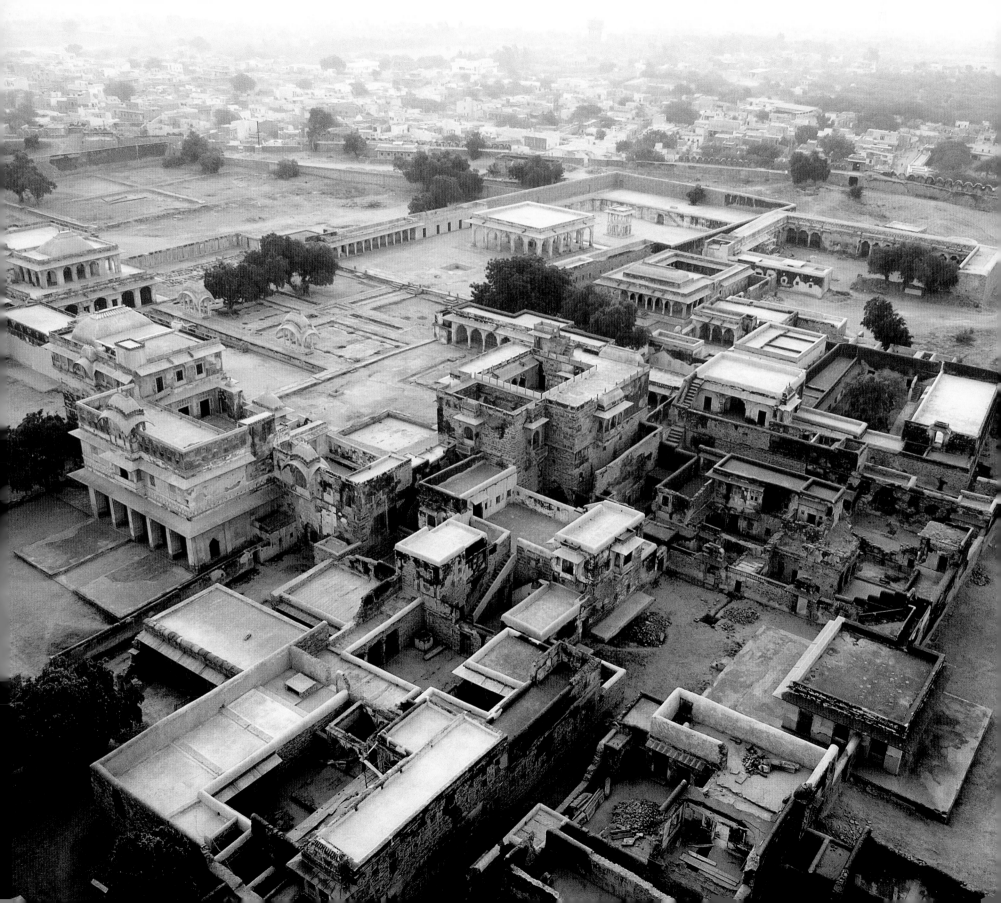

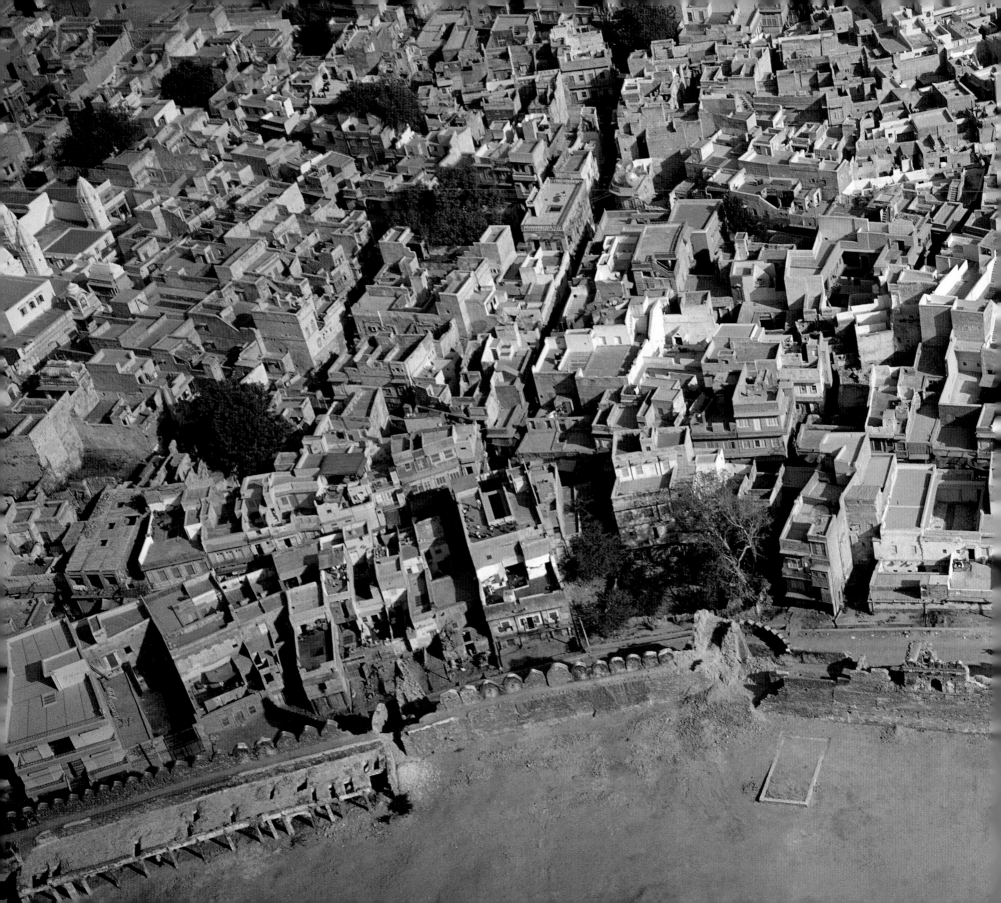

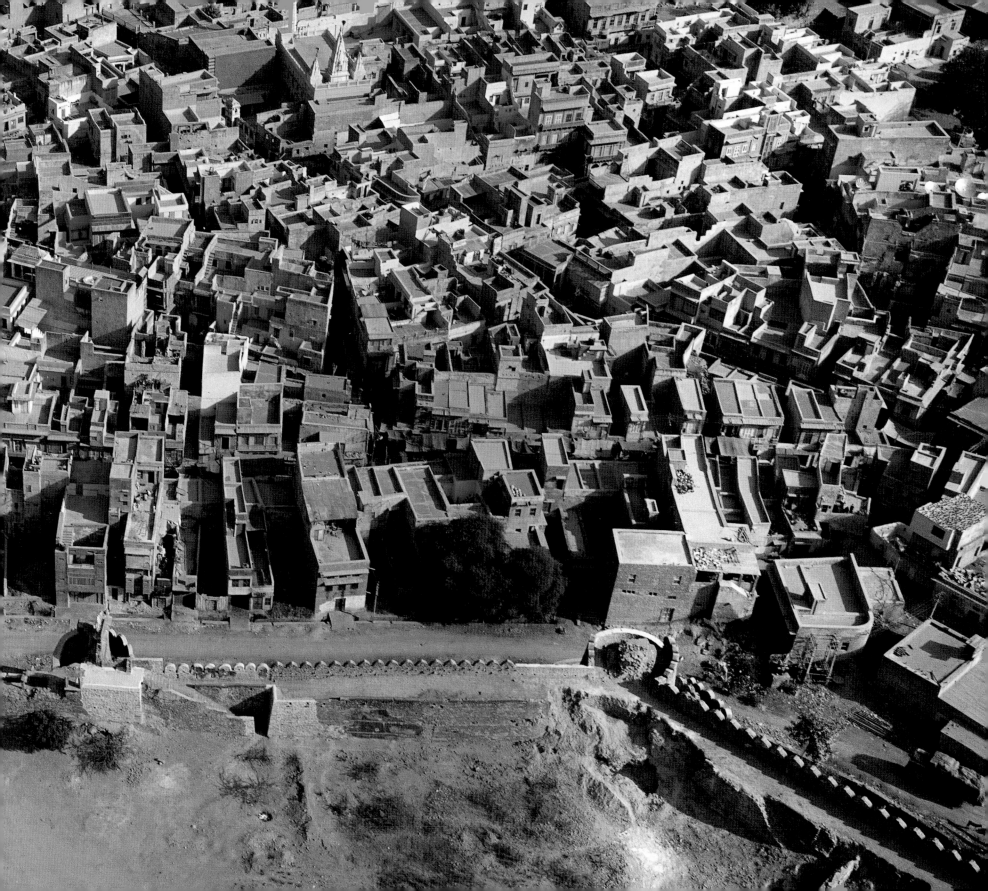

Above and facing page: 'I walk along the ramparts of Ahhichatragarh Fort, keeping an eye on every movement of the wind. I reach the main gate. Its big structure attenuates the sounds coming from the market outside the fort. It's still chilly, the sun comes up slowly, and the breeze comes in from the east. I need to run a few metres with my kite to help it rise higher and catch the desert wind.'

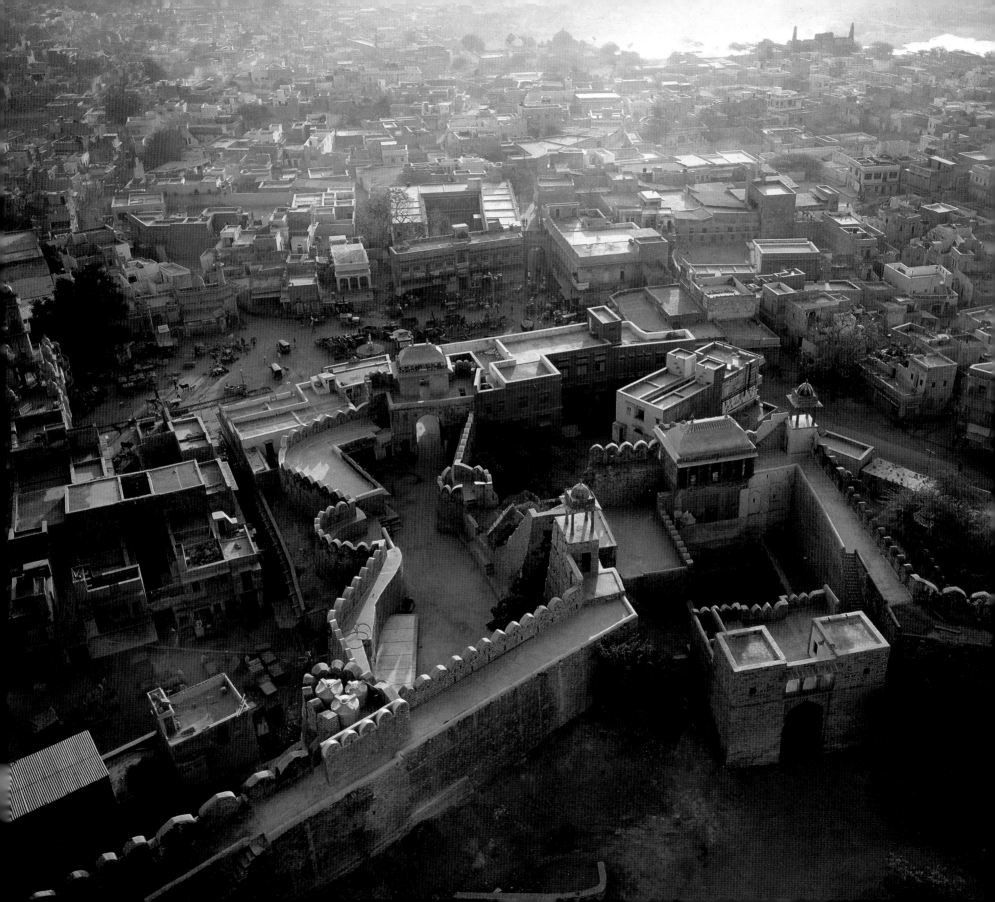

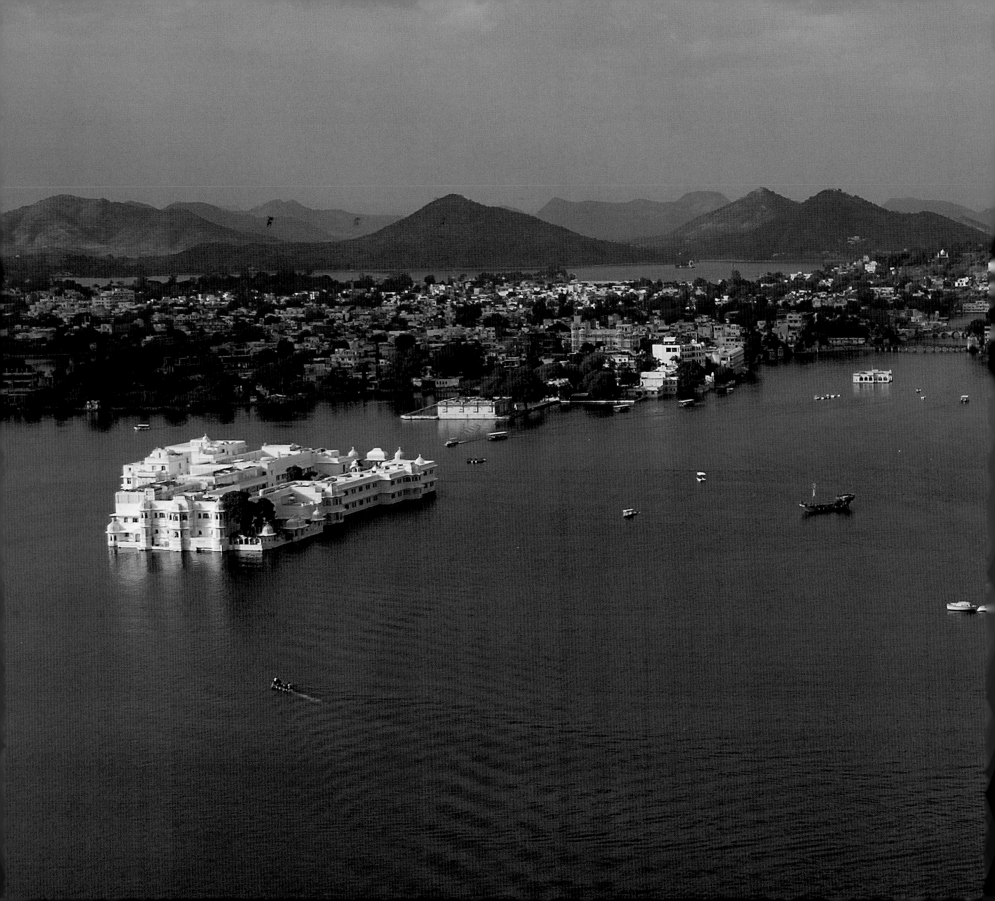

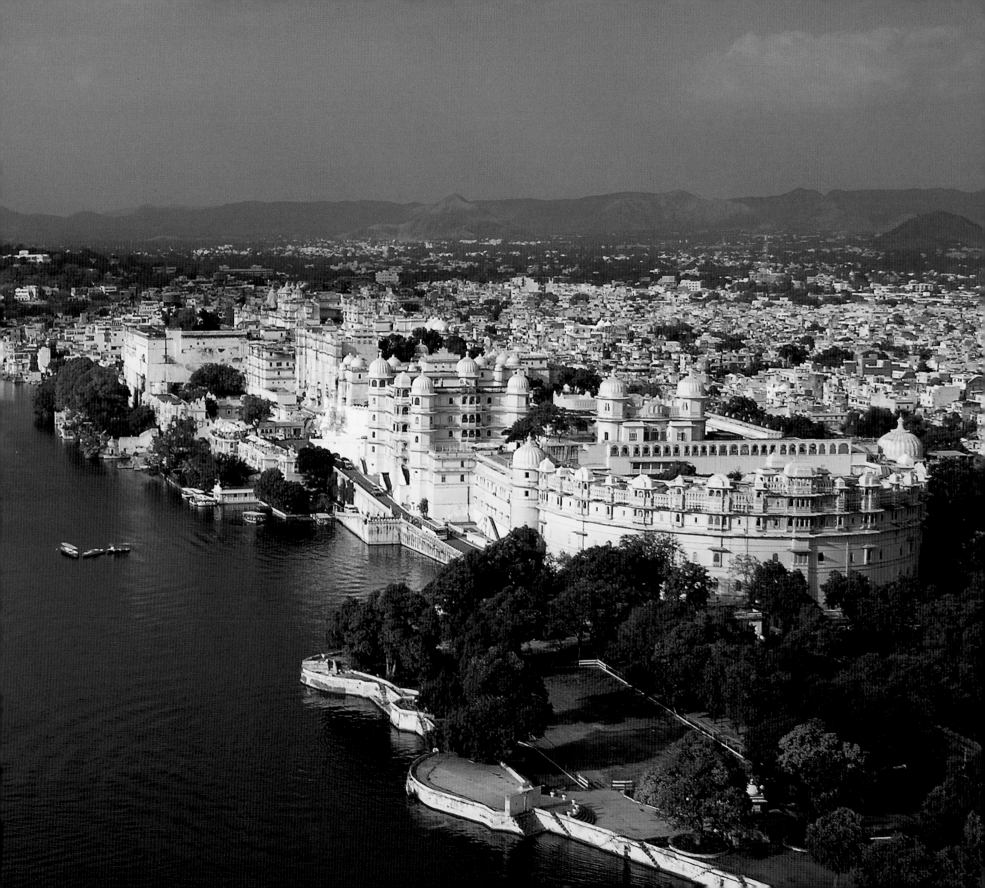

UDAIPUR

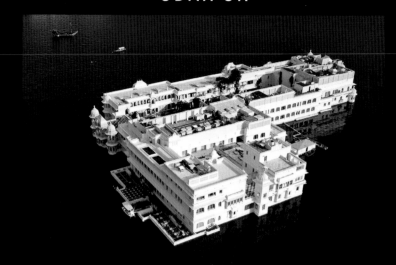

With its marble palaces and lakes and surrounded by a ring of ochre-shaded hills, Udaipur is Rajasthan's most romantic city. Founded in 1559 by Maharaja Udai Singh II, Udaipur became the capital of Mewar after the fall of Chittorgarh in 1567. The fiercely independent rulers of Mewar, who belonged to the Sisodia clan of Rajputs, resisted alliances with the Mughals, and took great pride in their lineage.

Udaipur is dominated by the massive City Palace, a fascinating combination of Rajput and Mughal architecture. The palace overlooks Lake Pichola, which has two islands with a palace each – the Lake Palace and the Jag Mandir.

Preceding pages: '*Flying my rig from a small motor boat is the only way to shoot Lake Pichola. But as the wind speed combines with that of the boat, each turn changes the flight parameters from one extreme to another, minute by minute. The boat trajectory must be well anticipated for getting the camera in the desired position with a correct pull on the string... As I juggle, it's like I'm playing a piece for some mysterious music director, only a part of a whole process...* '
Top: Built between 1734 and 1751, the Lake Palace was once a royal summer retreat, and is now one of the world's great hotels.
Facing page: Built in 1620 by Maharaja Karan Singh, Jag Mandir palace hosted Mughal emperor Shah Jahan in 1623-24 while he was leading a revolt against his father, Jehangir.
Following pages: Rajasthan's largest, the City Palace was begun by Maharaja Udai Singh II and added to by his successors. The palace houses a museum as well as luxury hotels.

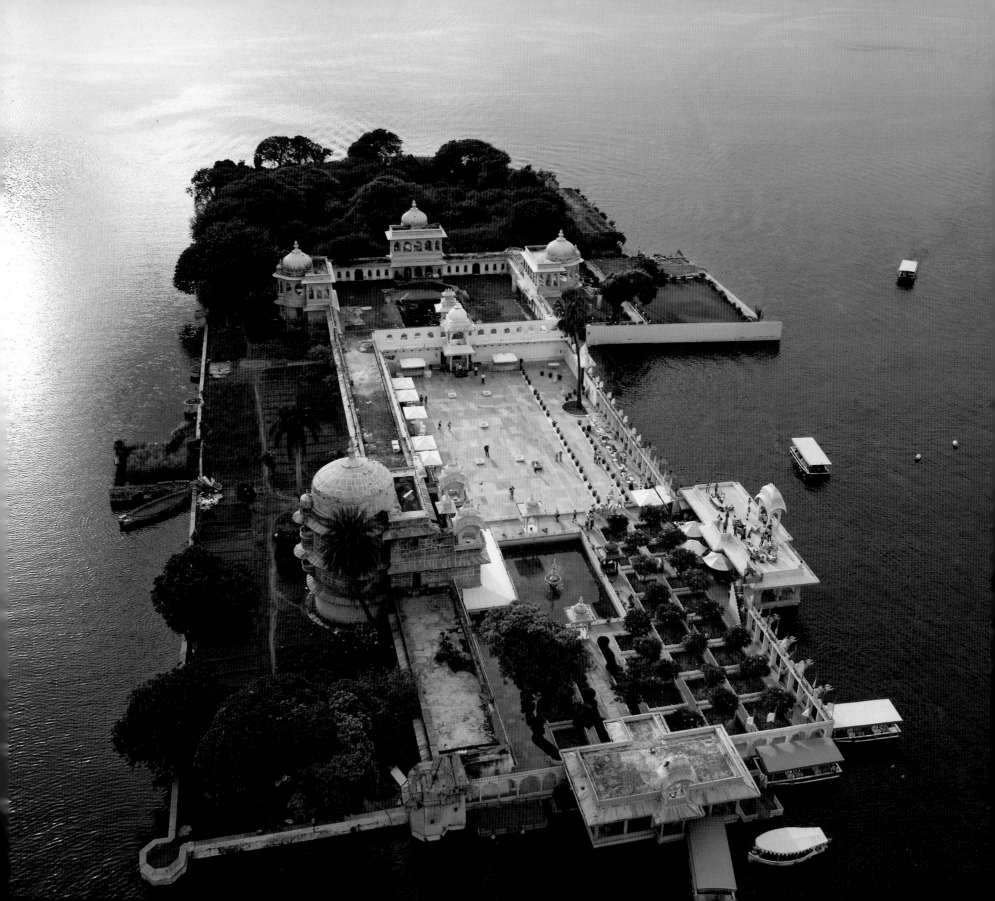

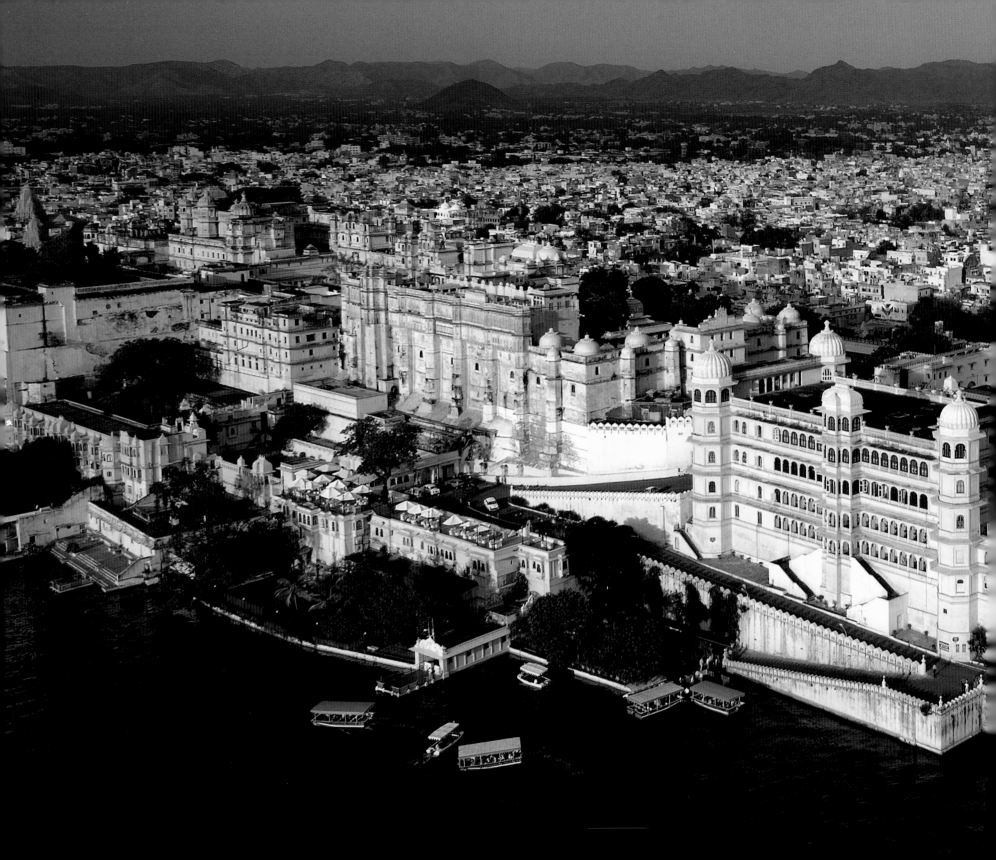

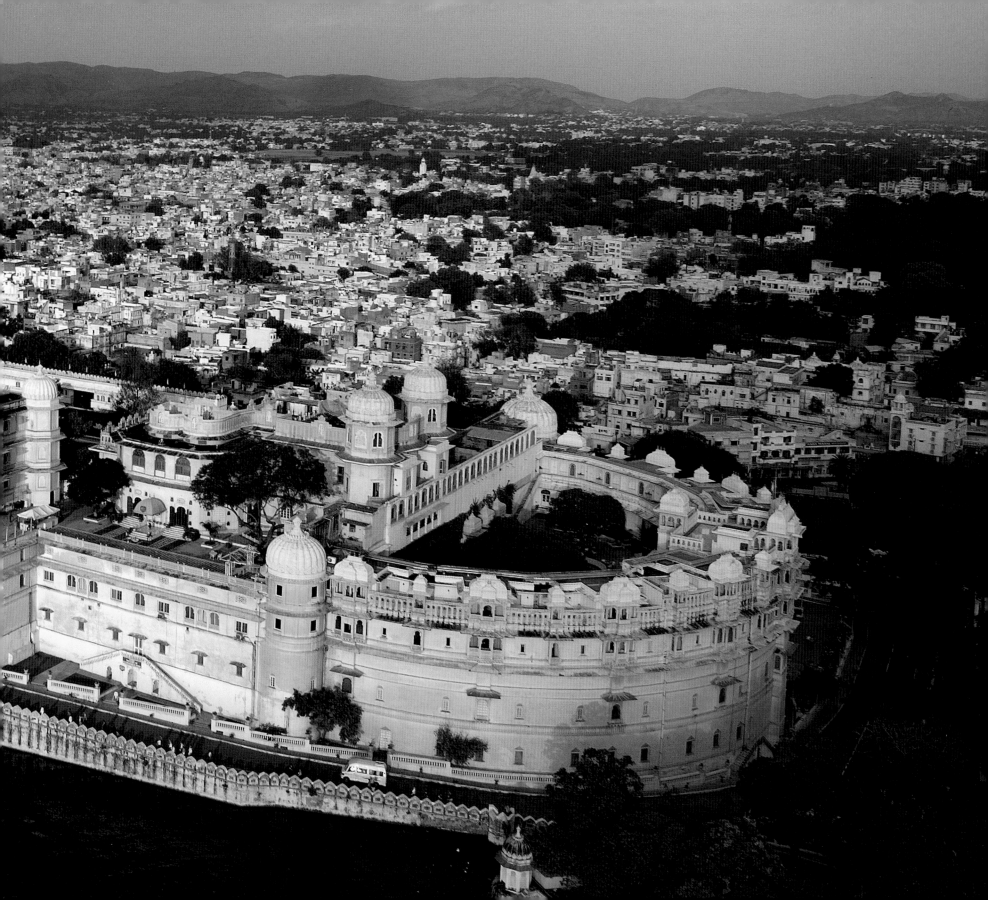

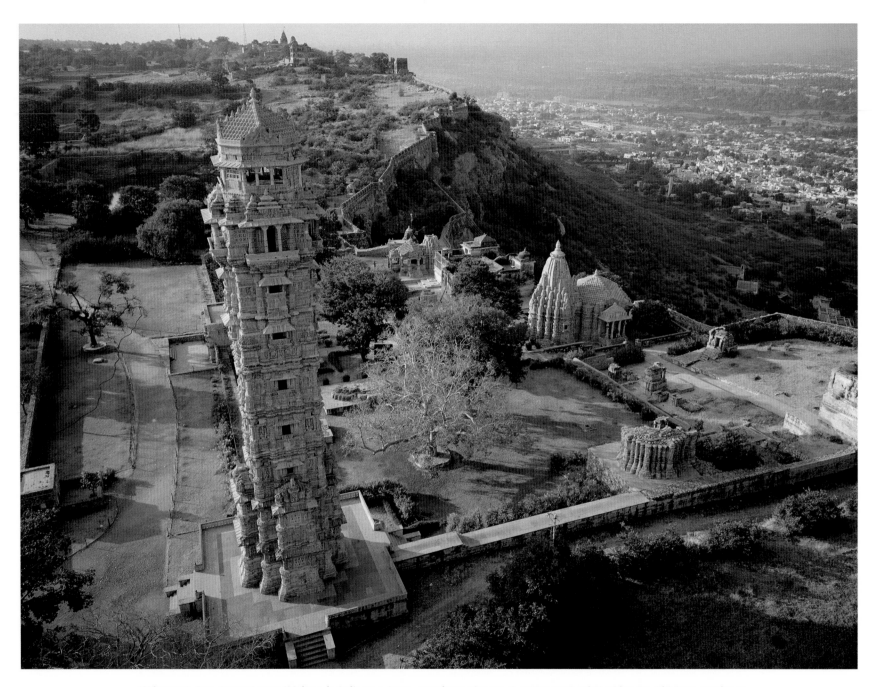

'Chittorgarh Fort, located near Udaipur, is built on a large, prominent plateau. A strong north wind whips the hill from sunrise to sunset… I must fly my kite up to 400 feet to escape the turbulence and find a steady stream, before hooking my camera on the string.'
Chittorgarh's soldiers and inhabitants chose death before dishonour when defeat at the hands of Mughal emperors was certain.
Above and facing page: The Tower of Victory erected in Chittorgarh Fort by Rana Kumbha between 1458 and 1468.

'I walk with my gear all around the fortress, from one temple and tower to another, sidestepping stray cattle and bushes, trying to avoid electrical wires and telephone poles...'
A Jain temple *(top)* and the remains of a building *(below)* in Chittorgarh Fort.
Facing page: *The twelfth century Kirti Stambha (Tower of Fame), built by a Jain merchant, is dedicated to the Jain saint Adinath.*

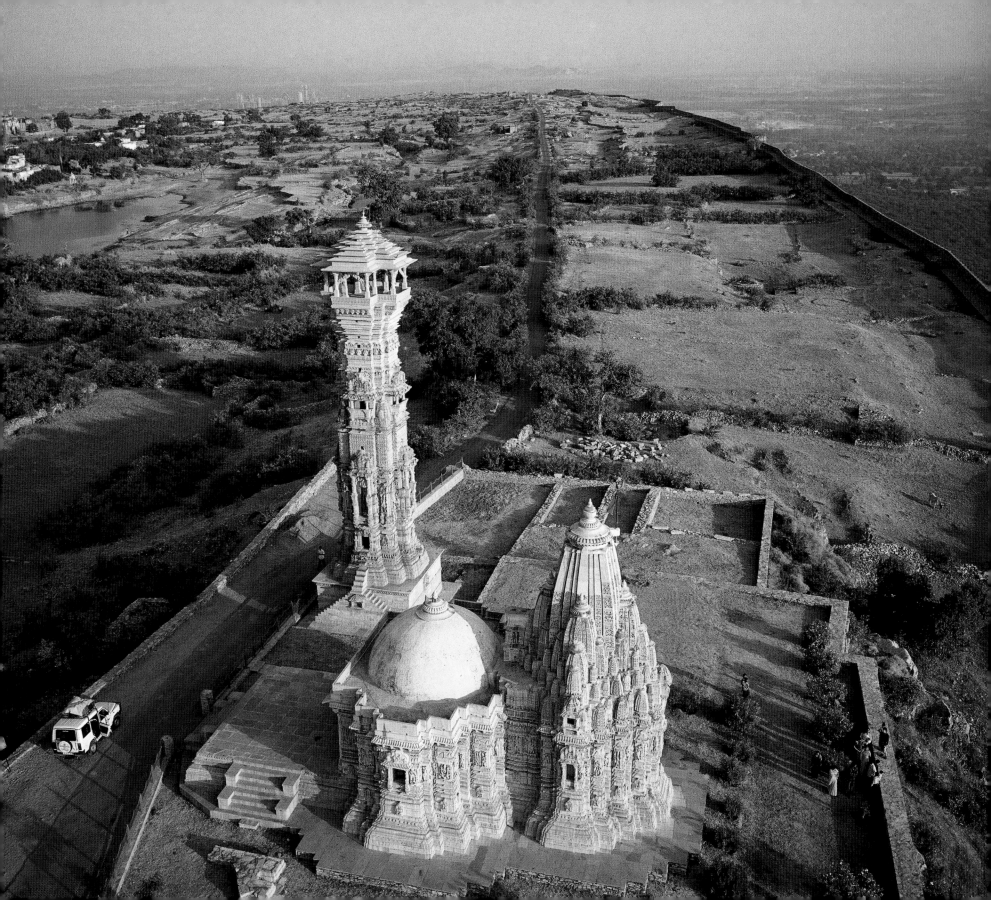

PUSHKAR

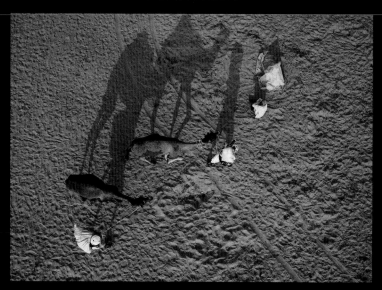

Amagical, mystical place of pilgrimage 144 km southwest of Jaipur, Pushkar is a town of lakes and four hundred temples. It derives its name from *pushpa* (flower) and *kar* (hand) – legend has it that its lakes were created by the petals that fell from the hand of Lord Brahma, the Creator. Not surprisingly, Pushkar has one of the world's few Brahma temples.

A magnet for tourists, Pushkar has as many budget hotels as it does temples! For travellers, spirituality here coexists with *bhang* (hemp), and the town's main bazaar is a pleasure to explore.

The biggest attraction of Pushkar is its camel fair, which transforms this quiet little desert town into a bustling market. The fair reaches its climax on the night of the full moon (*purnima*), when pilgrims take a dip in the holy lake.

'Early morning I walk to the camel land that is Pushkar. The air is still fresh and clear from the night, before the heat of the sun and dust fill the space. My kite flies as the sun rises. Camel traders are having their breakfast, feeding the animals... I stroll around them, taking my camera for a ride, for a flight above this desert community preparing for the day. Visitors start passing through the field riding camel carts. It smells good – of nans and chai, and the pungent smell of the beasts.'
Top, facing and following pages: *The two-week Pushkar camel fair, held in October/November every year, is attended by around 200,000 people, who bring with them some 50,000 camels and cattle.*

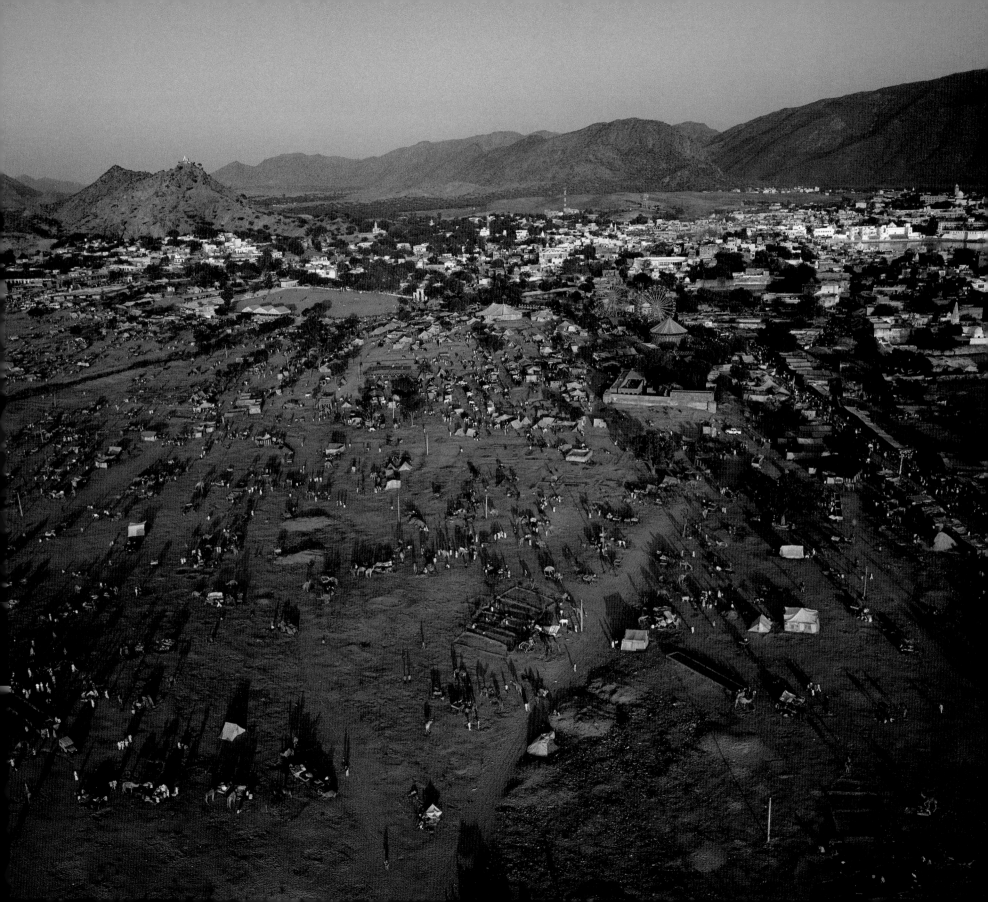

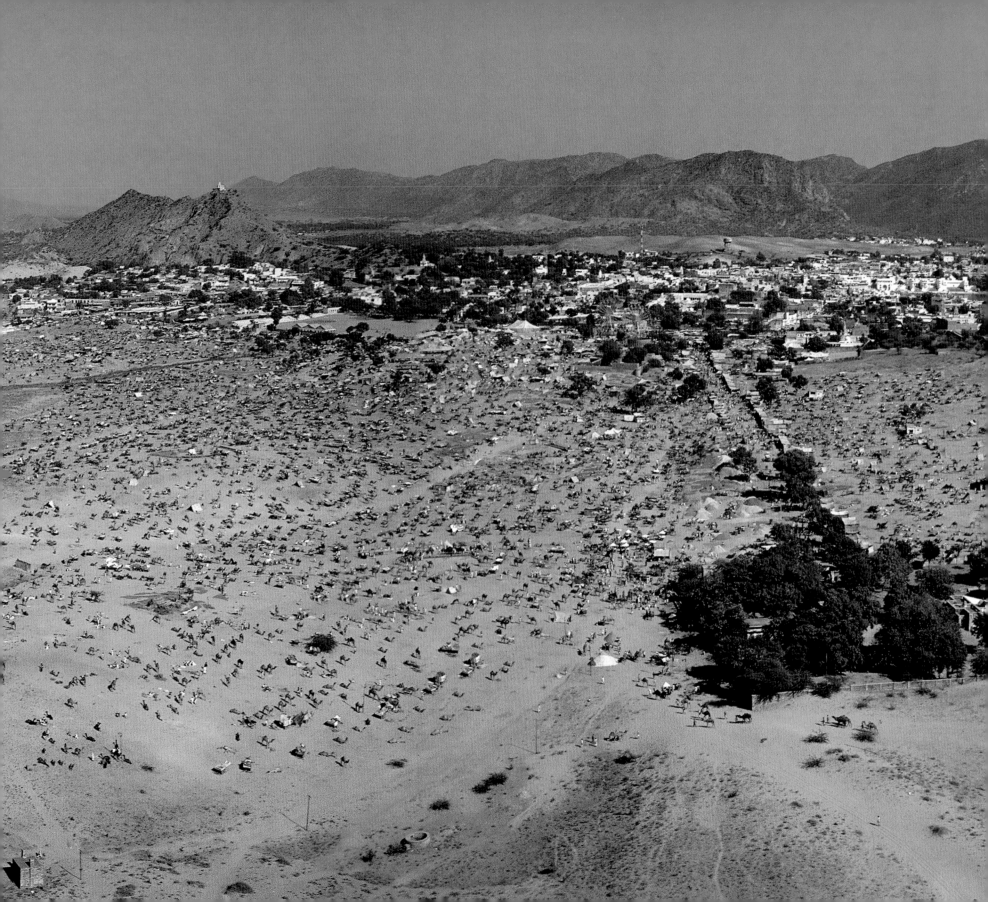

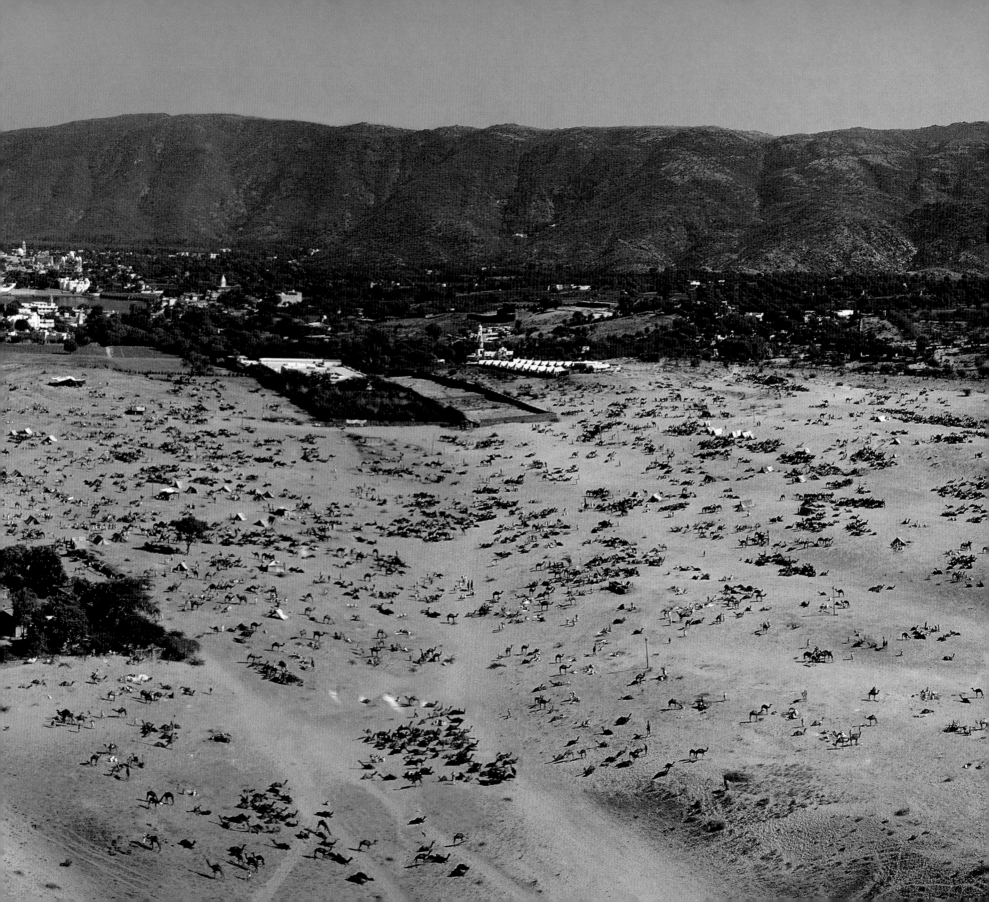

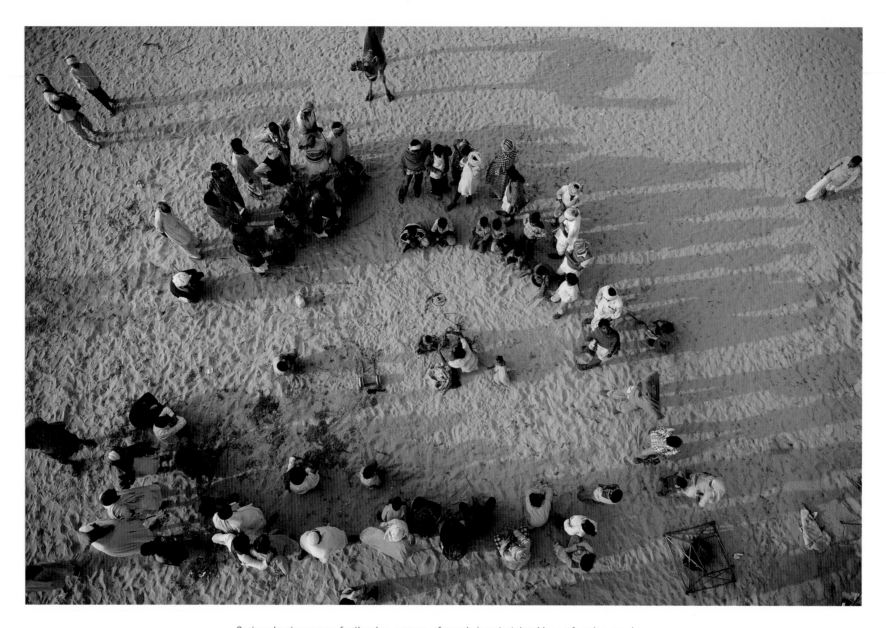

Serious business over for the day, a group of people is entertained by performing monkeys.

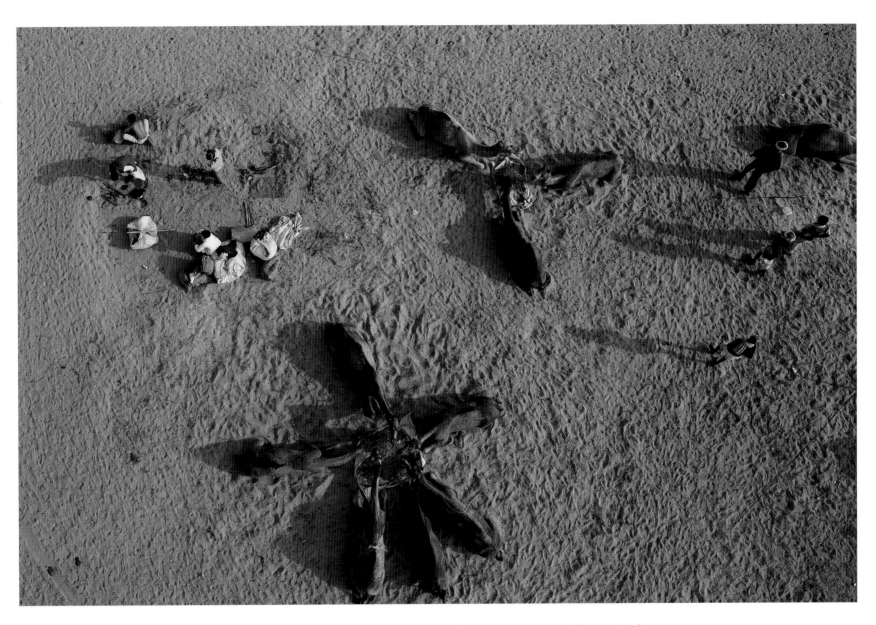

Just sitting around waiting to be picked up: A well-earned supper and rest for camels after a hard day's work.

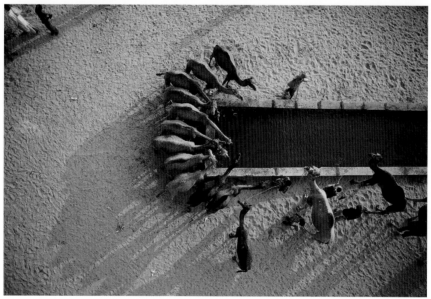

Above and facing page: *Views of the Pushkar fair.*

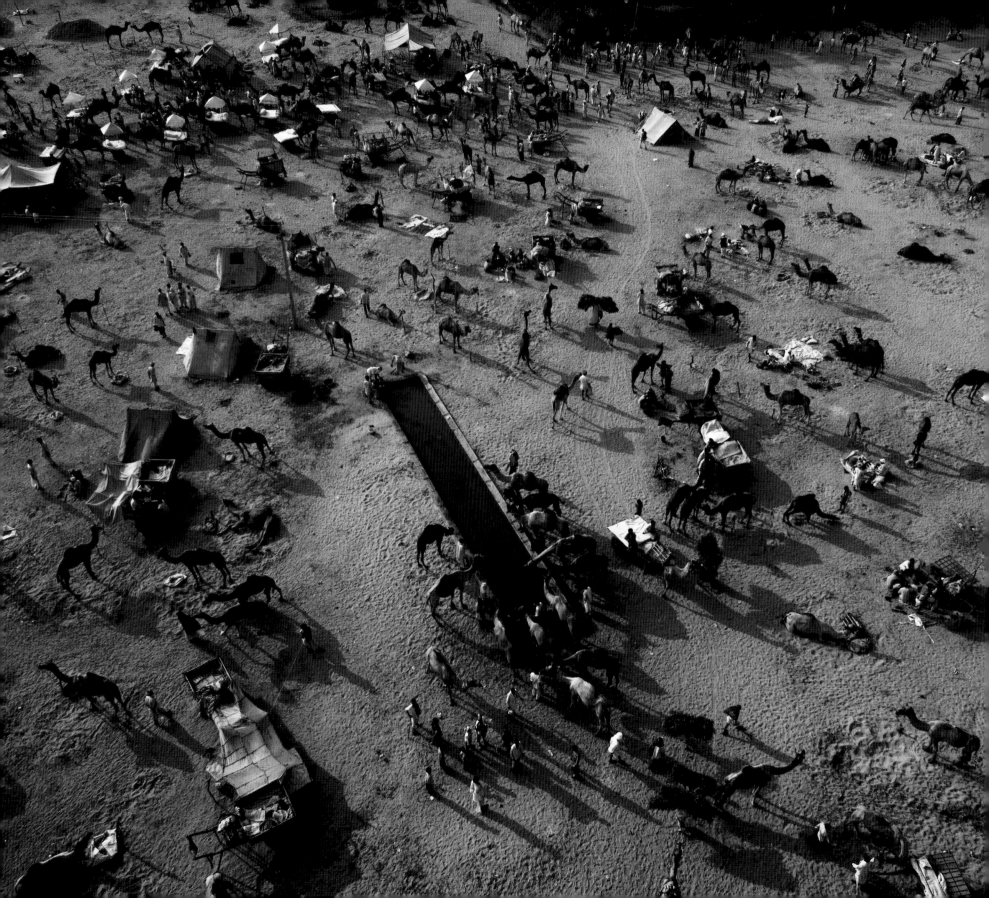

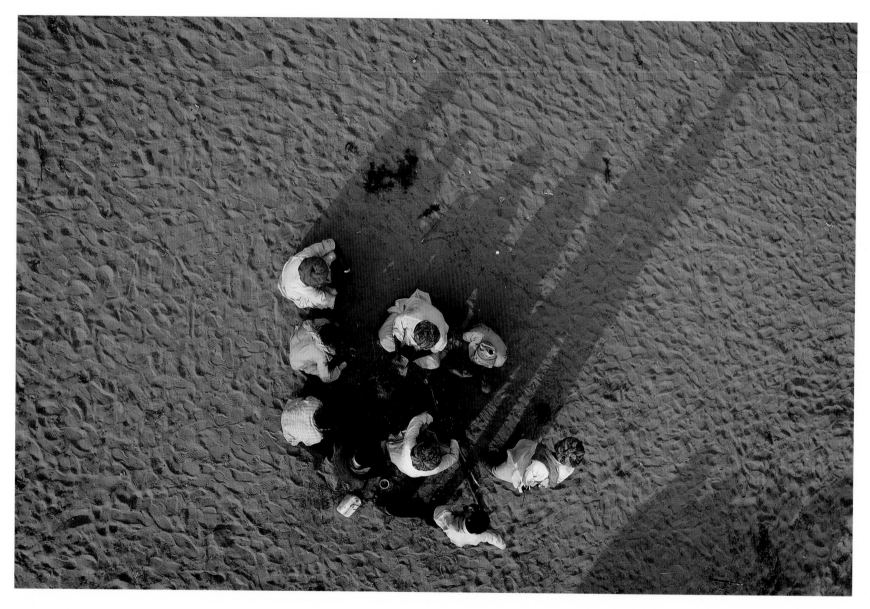

*Rajasthani turbans **(above)** and camel carts **(facing page)** add colour to the desert landscape.*

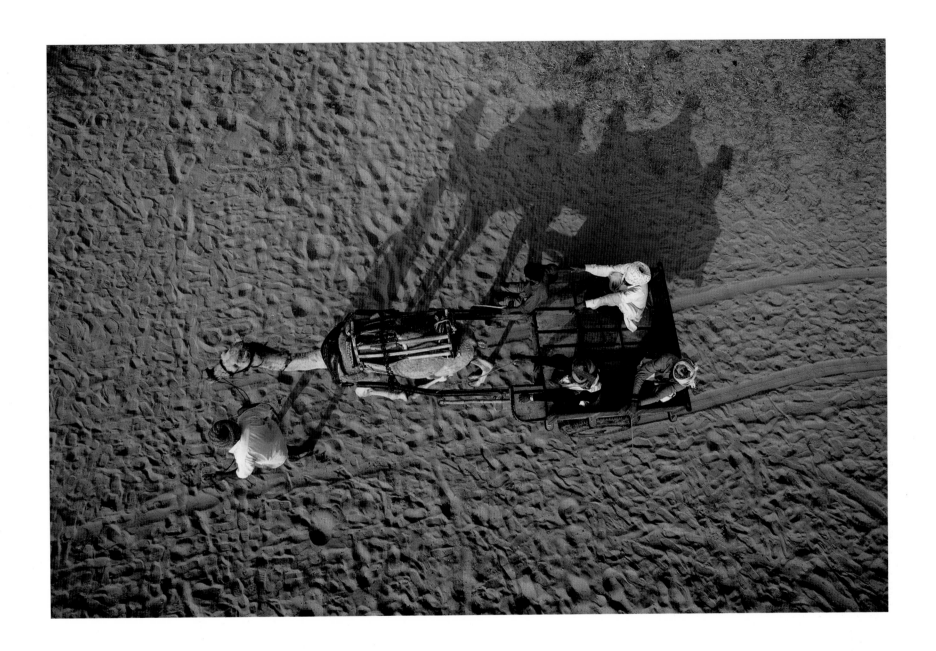

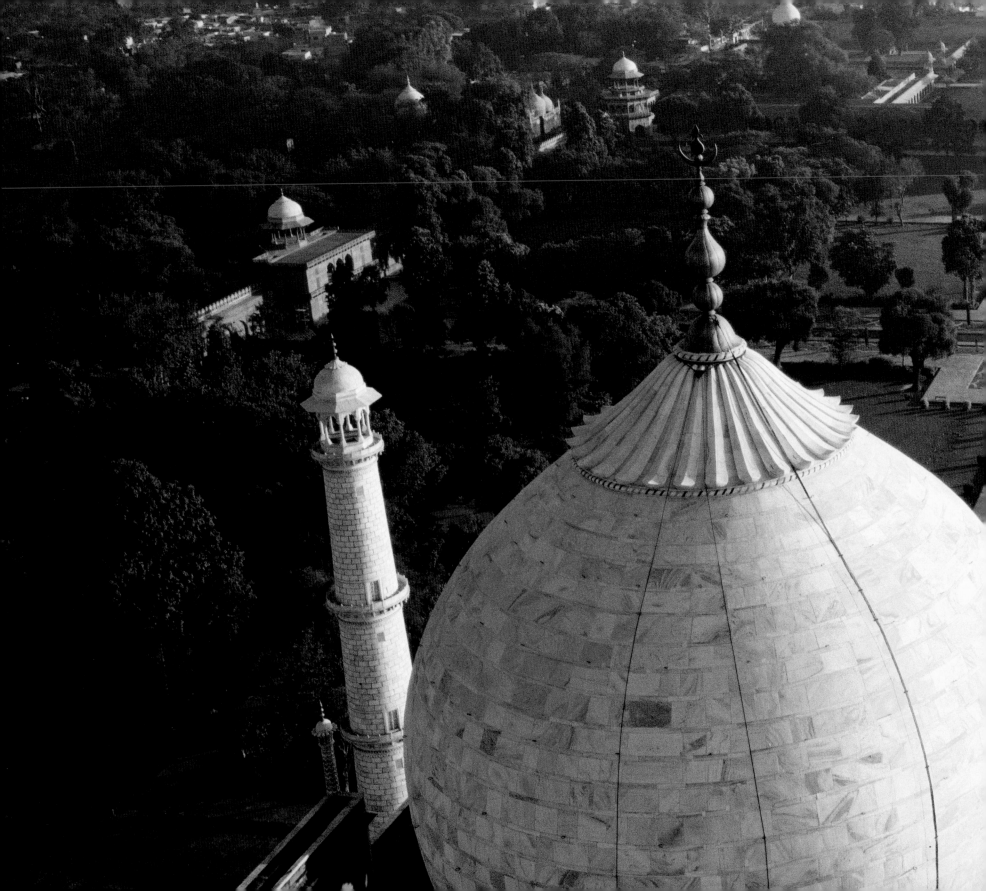

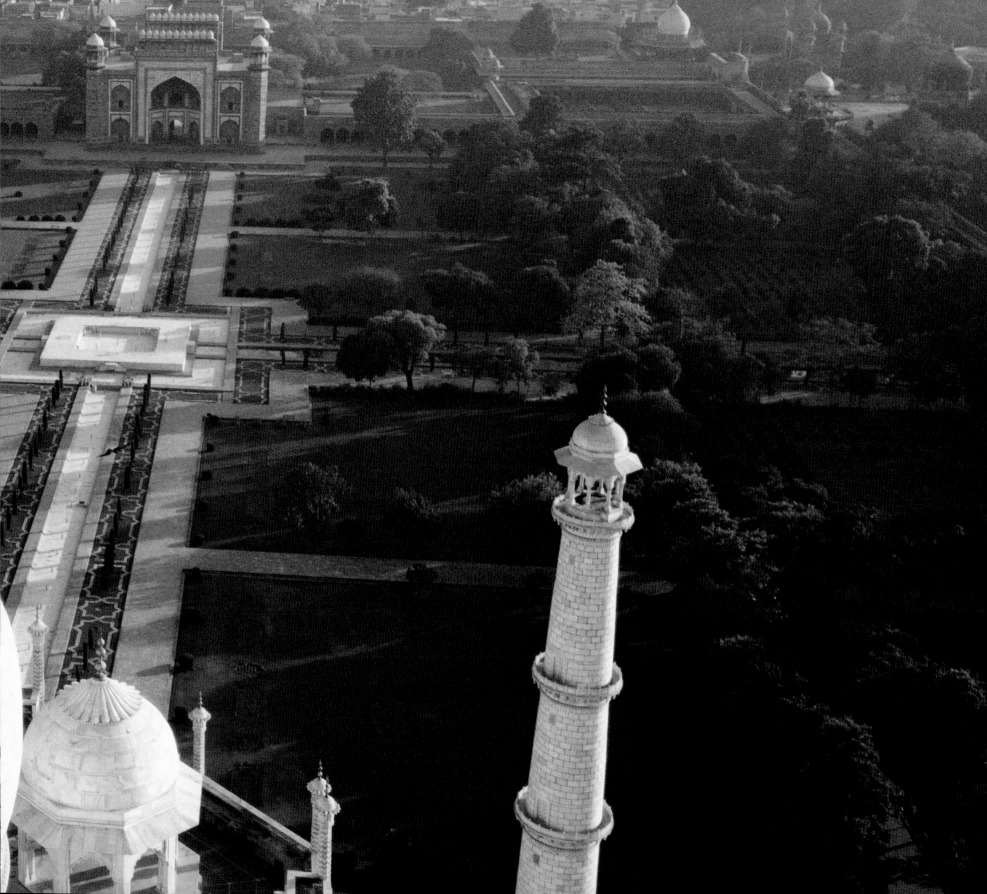

TAJ MAHAL, AGRA

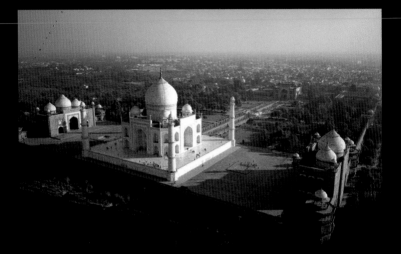

One of the world's most beautiful monuments, the Taj Mahal in Agra (223 km southeast of Delhi) has been described as 'a tear drop on the face of eternity' (Rabindra Nath Tagore) and 'the embodiment of all things pure' (Rudyard Kipling). Built by Emperor Shah Jahan in memory of his wife Mumtaz Mahal, its construction was begun in 1631, the year Mumtaz died while giving birth to the couple's fourteenth child. Shah Jahan was so devastated by this that his hair is reported to have turned grey overnight.

The Taj is ingeniously constructed on a raised marble platform so that only the sky is seen as a backdrop. Its central structure is perfectly symmetrical, with its four identical faces featuring vaulted arches and quotations from the Koran. Below the main domes are the cenotaphs of Mumtaz Mahal and Shah Jahan, who was interred here without much ceremony by his son Aurangzeb, who toppled him in 1666.

'I fly my kite from the bank of the Yamuna river, at the back of the Taj Mahal, but I can get my camera so close to the dome that I can feel no distance anymore between the monument and myself. The conditions are perfect, like a dream come true, until some policemen come and stop me just before I can shoot. However, I am able to return with proper permission a few weeks later, and again I feel like a blessed bird touching the white marble dome.' It took 20,000 workers from India and Central Asia – with specialists brought in from Europe for the marble screens and pietra dura (marble inlay work) – twelve years to complete the construction of Taj Mahal in 1643.

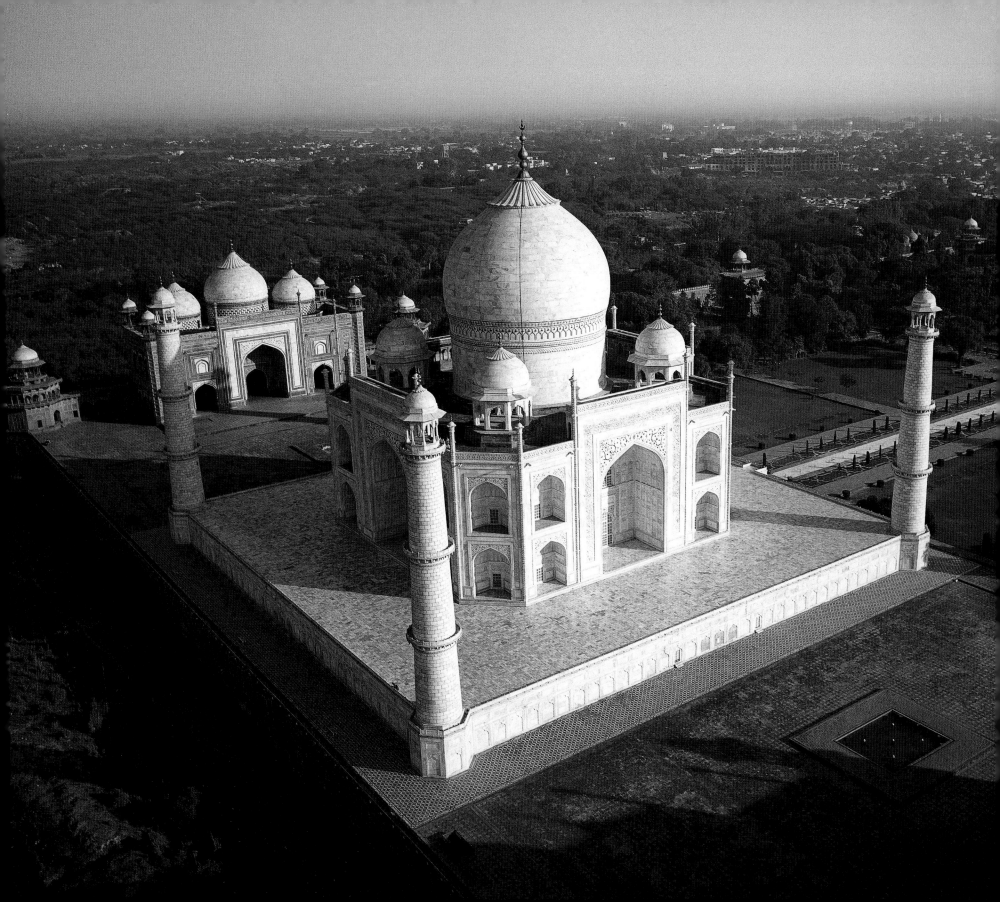

FATEHPUR SIKRI

The great Mughal emperor, Akbar, built this city to honour a Sufi saint, Sheikh Salim Chishti, with whose blessings a son was born to the emperor. The city is a brilliant and unusual blend of Hindu, Islamic and Jain architectural styles, in keeping with the liberal, secular personality of the emperor, who was tolerant of other religions. In fact, in his harem he had Hindu as well as Christian wives.

The city (40 km west of Agra) was the Mughal capital for fourteen years (1571-1585) but had to be abandoned, it is believed, because of shortage of water. It was realised only too late that the region did not have enough water to support a city.

Above and facing page: '...Finally I find access to a roof top, after asking the butcher at the corner. Two men jump with me upstairs, so curious to see my kite. Their eyes sparkling, they show me three of their own patangs, on a shelf since the last kite festival. They know what a kite is, how to catch the wind, how to deal with the string, how to balance the kite. With their help, after many acrobatics on the roofs, my kite is launched above Fatehpur Sikri's monumental gateway, the Buland Darwaza. I only have a few square feet to walk on, and the wind picks up fast. The pull is amazing. More than 20 kg, most probably. But my camera flies, and it is inside the complex...'

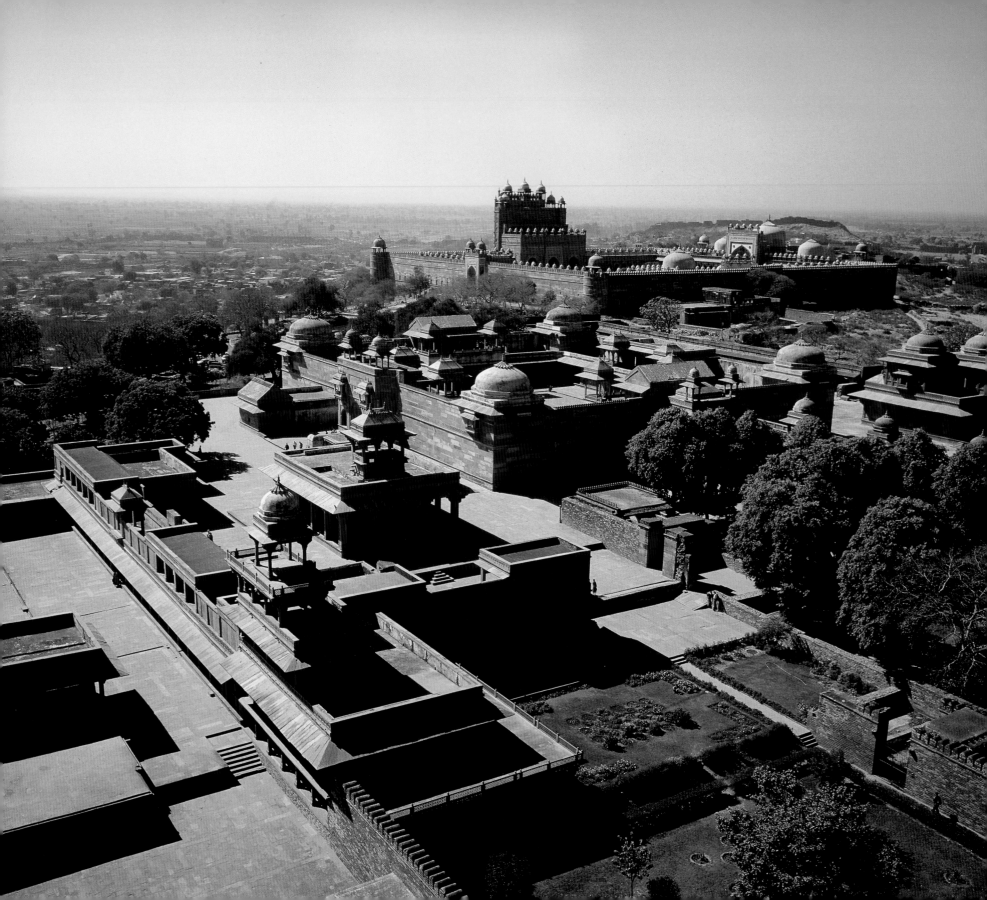

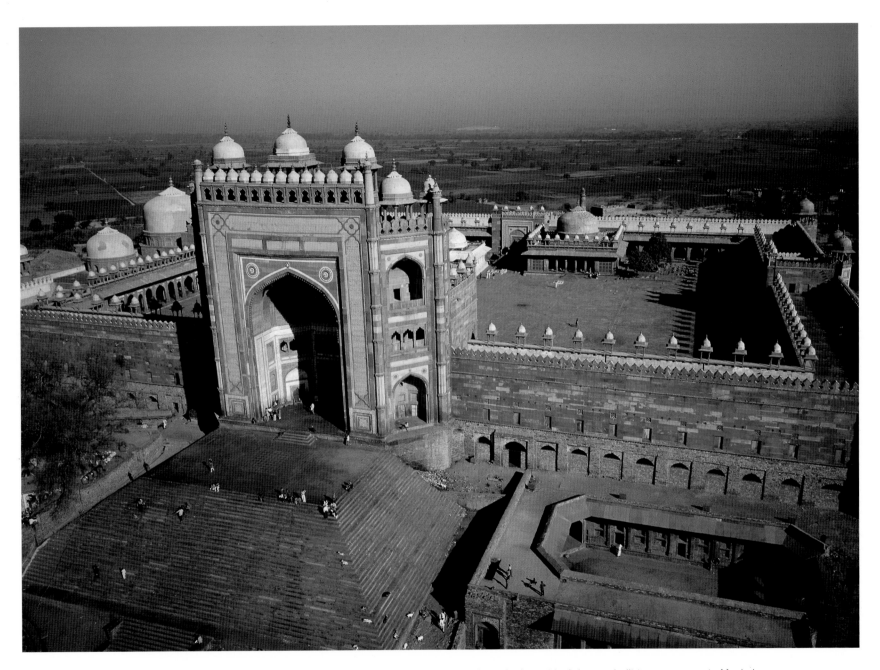

Above: *Fatehpur Sikri's Buland Darwaza (Victory Gate), at 54 metres perhaps the largest in Asia, was built to commemorate Mughal emperor Akbar's military victory in Gujarat. Inside the archway is a Quranic saying quoting Jesus: 'The world is a bridge, pass over it but build no house upon it. He who hopes for an hour may hope for eternity.'*
Facing page: *A view of the Fatehpur Sikri complex showing the Panch Mahal, where Akbar's queens and their attendants used to relax.*

LUCKNOW

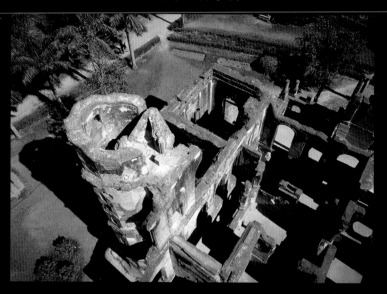

With the decline and fall of the Mughal empire, independent kingdoms came up, such as the one in Avadh, whose nawabs ruled for about a century before being deposed by the British. Lucknow became the capital of Avadh when the fourth nawab, Asaf-ud-Daula, shifted his court here from Faizabad in 1775.

The nawabs were great patrons of music, dance and the culinary arts, and till today Lucknow is identified with a refined taste. The last nawab of Lucknow, Wajid Ali Shah, was an aesthete who was not much interested in governance, and is believed to have introduced the *thumri* (a form of light classical music). In 1856, the British deposed Wajid Ali Shah and annexed Lucknow, and this was a factor that instigated the 1857 Indian Mutiny.

Above and facing page: Ruins of the Residency, a fortified house that belonged to the British Resident. During the Siege of Lucknow in 1857, the British residents of the city, along with many Indians, took refuge in the house. For eighty-seven days the residents, including many women and children, were holed up inside as the house was bombarded by the sepoys. A British relief party that broke through was itself trapped inside and the siege continued for another sixty days. In the end around two thousand people were dead.

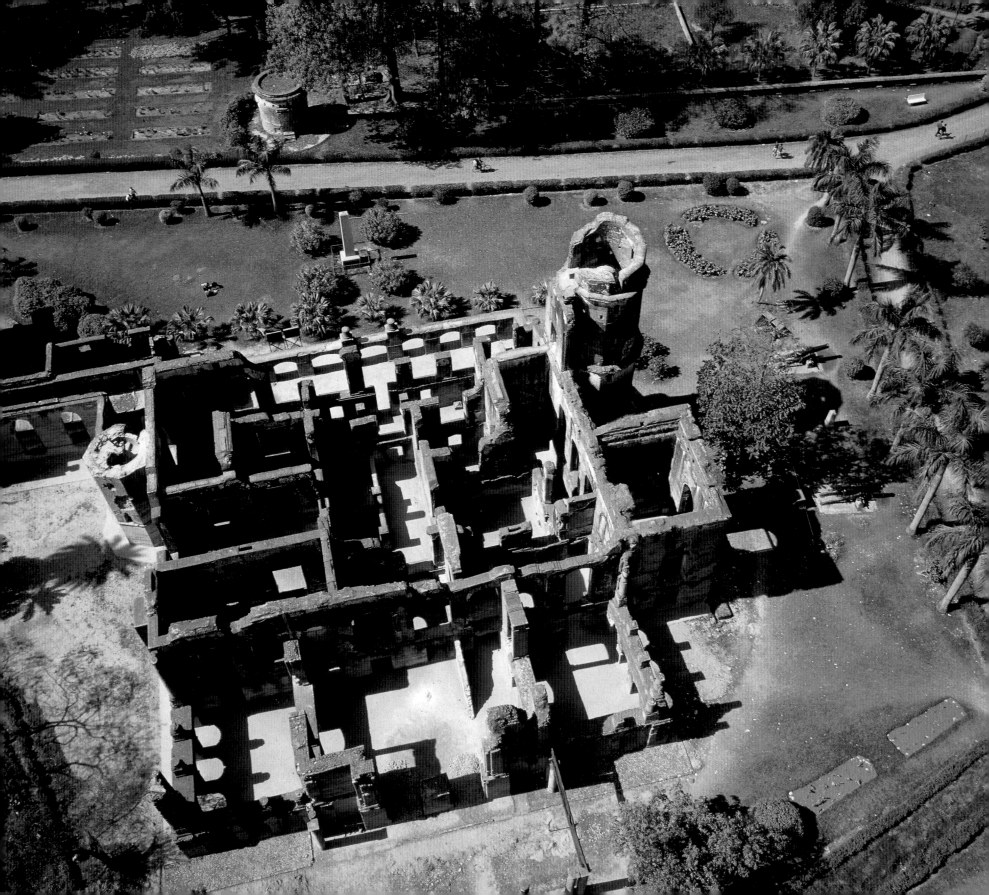

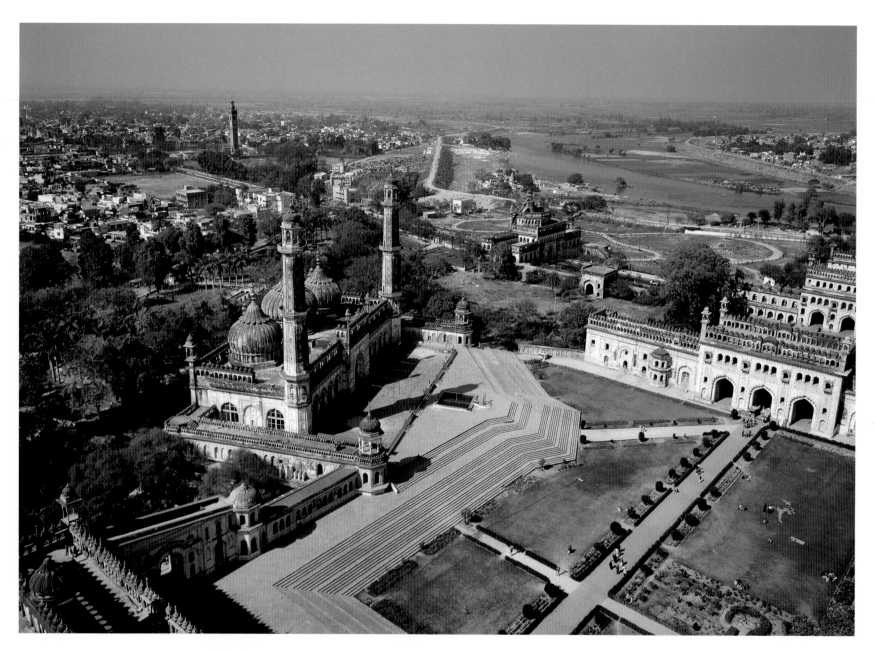

Asafi Mosque forms the western part of the Asafi Imambara complex built by Asaf-ud-Daulah in 1784 as a famine relief measure. The building became a watershed in Nawabi architecture as mosque designs started changing dramatically in its wake.

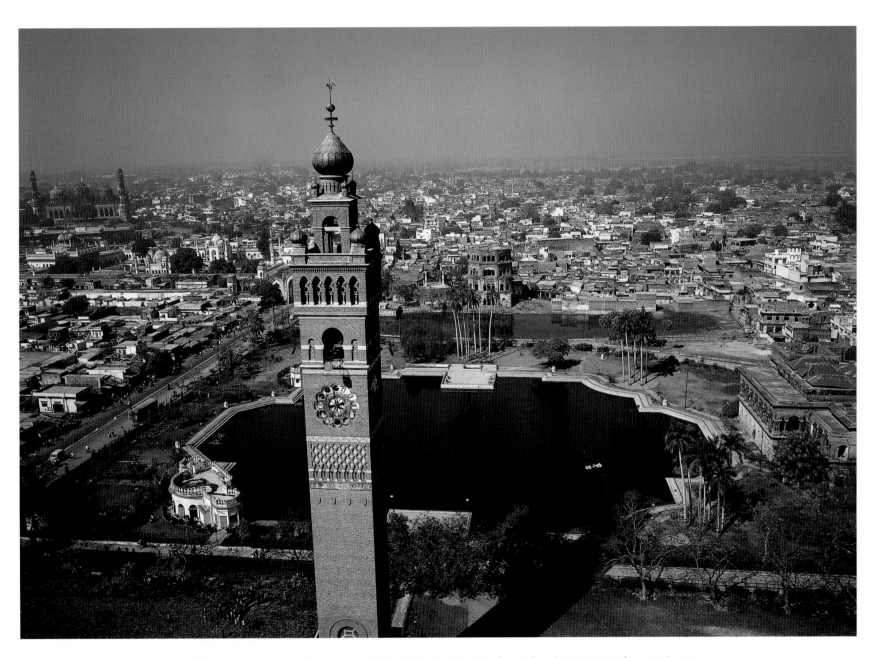

'This afternoon, we're off to fly over the Clock Tower. The mood is playful, almost provocative: people are getting their patangs up, with threatening lengths of sharp string (manjah). I abstain from flying my kite – I'd hate to lose it and miss tomorrow's sunrise.... Early the next morning, the wind is great, and the people are more subdued... a lot of them are off to work already. As soon as the sun rises, I take off.' *The 221-feet Clock Tower was built in the 1880s in honour of Sir George Cooper, first Governor of United Provinces.*

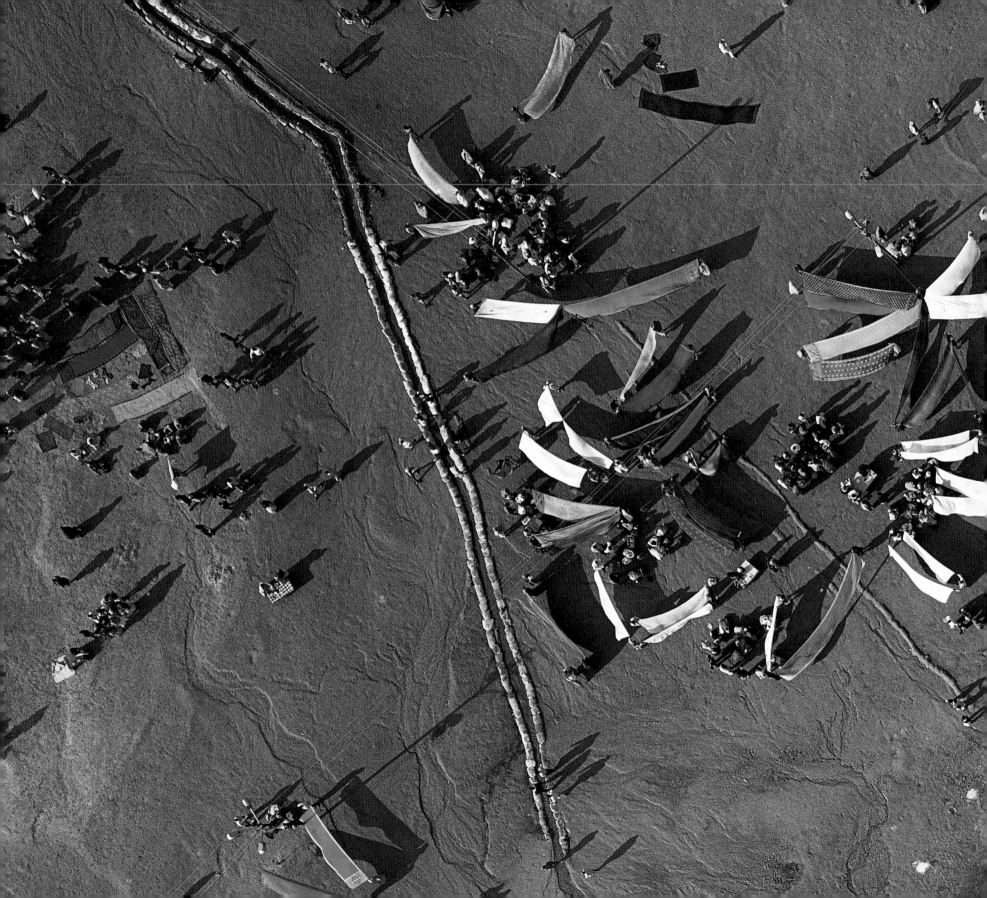

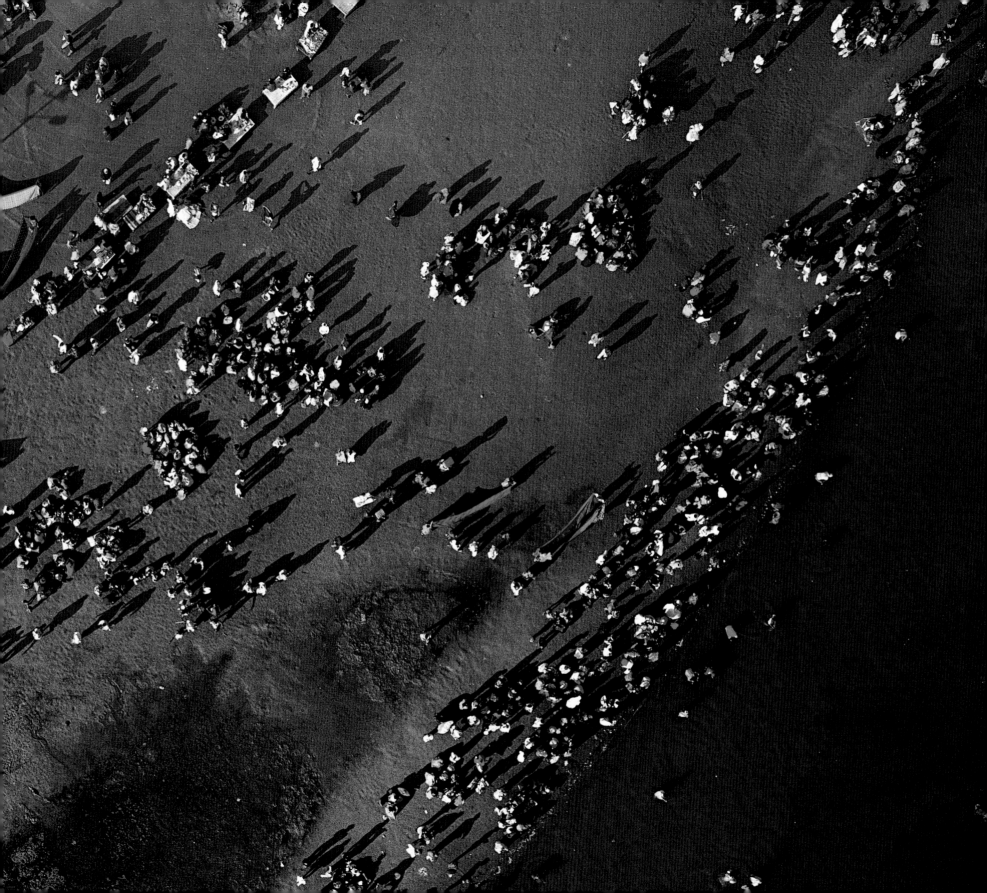

KUMBH MELA

Situated 227 km southeast of Lucknow, at the confluence *(sangam)* of three holy rivers – the Ganges, the Yamuna and the mythical Saraswati – Allahabad has been a sacred historical, cultural and religious town for three thousand years. It is home to the world's largest religious gathering, the Kumbh Mela, every twelve years, and an Ardh Mela (half mela) every six years. Millions of devotees and sadhus take a dip in the sangam during the melas, to wash away their sins.

Hindu legend has it that during a war between the gods and the demons over the urn *(kumbh)* of immortal nectar *(amrit)*, Lord Indra's son Jayanta made off with the urn. As he flew away, four drops fell at four places – Nashik, Ujjain, Haridwar and Allahabad. The Kumbh Mela is held at all the four places.

Preceding pages: 'A bright and early flight over saris set up to dry in the wind, amid the crowds of incoming pilgrims...'
Above, facing page and following pages: 'It's too hazardous for me to fly my kite on the day of Kumbh Mela, but I have been been authorised to shoot the preparations for the celebrations. All other flying machines – helicopters, airplanes, balloons, even the military – have been strictly ruled out... Around me the smiling crowd shares my joy and marvels at this simple feat: a camera flying with the wind.'

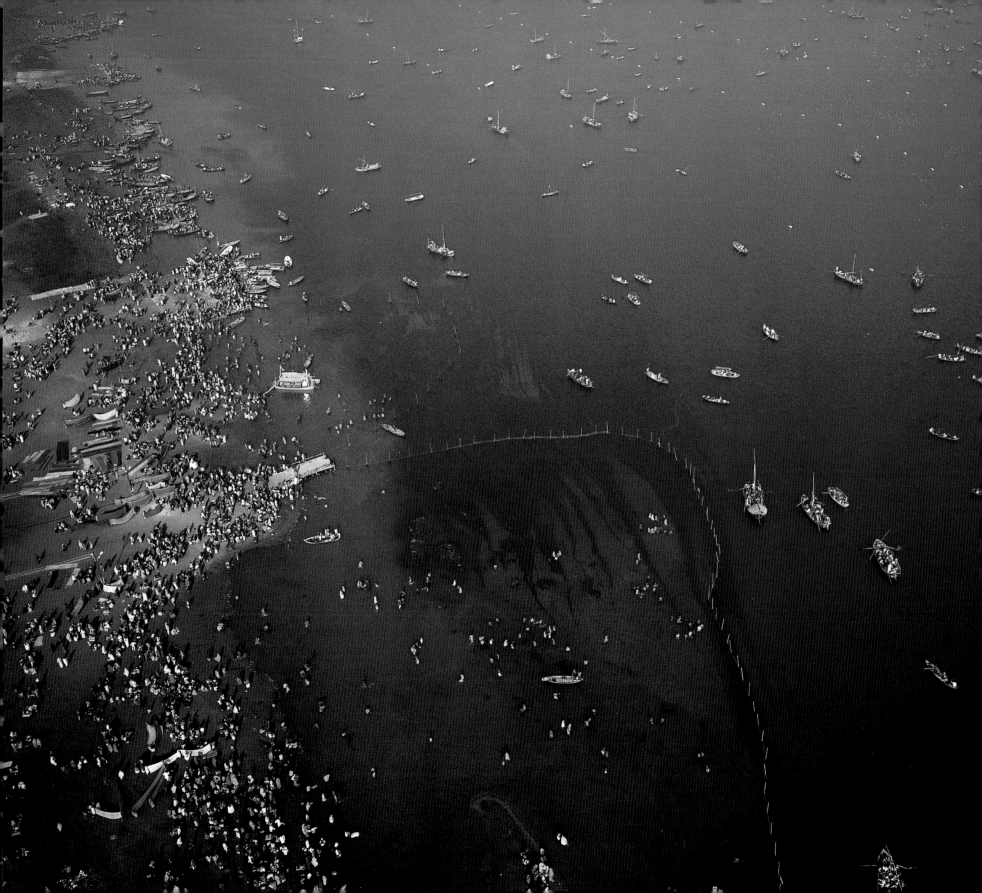

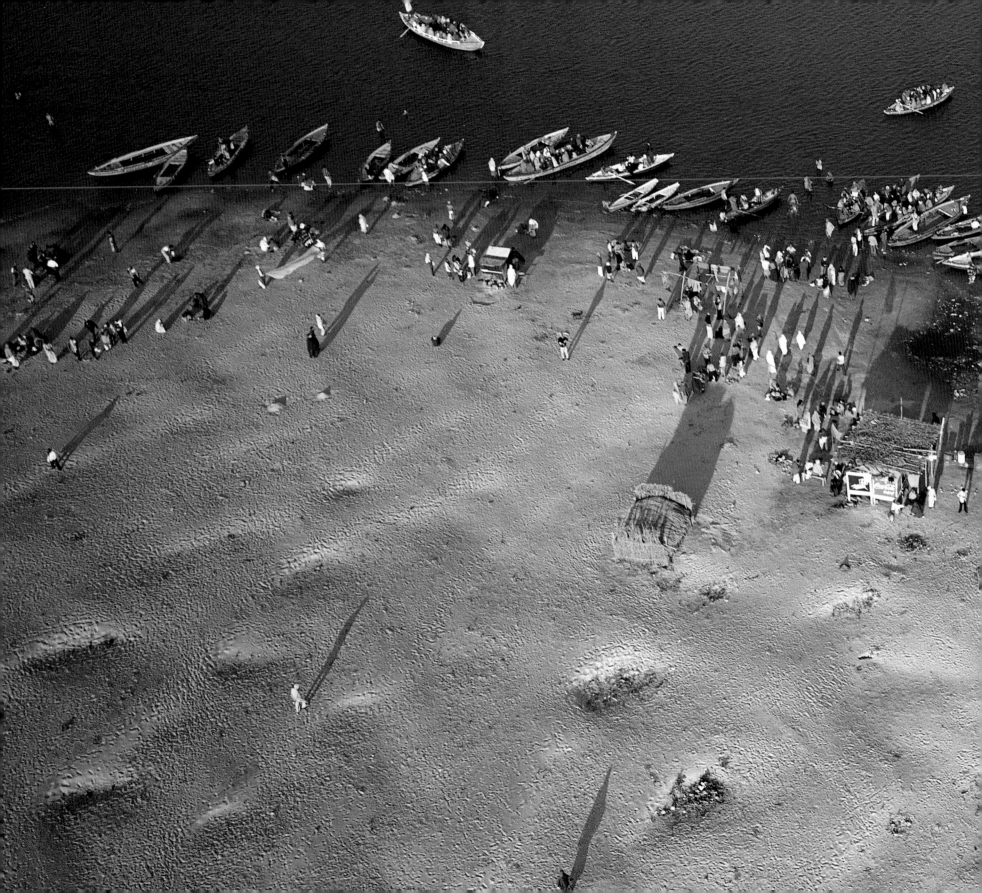

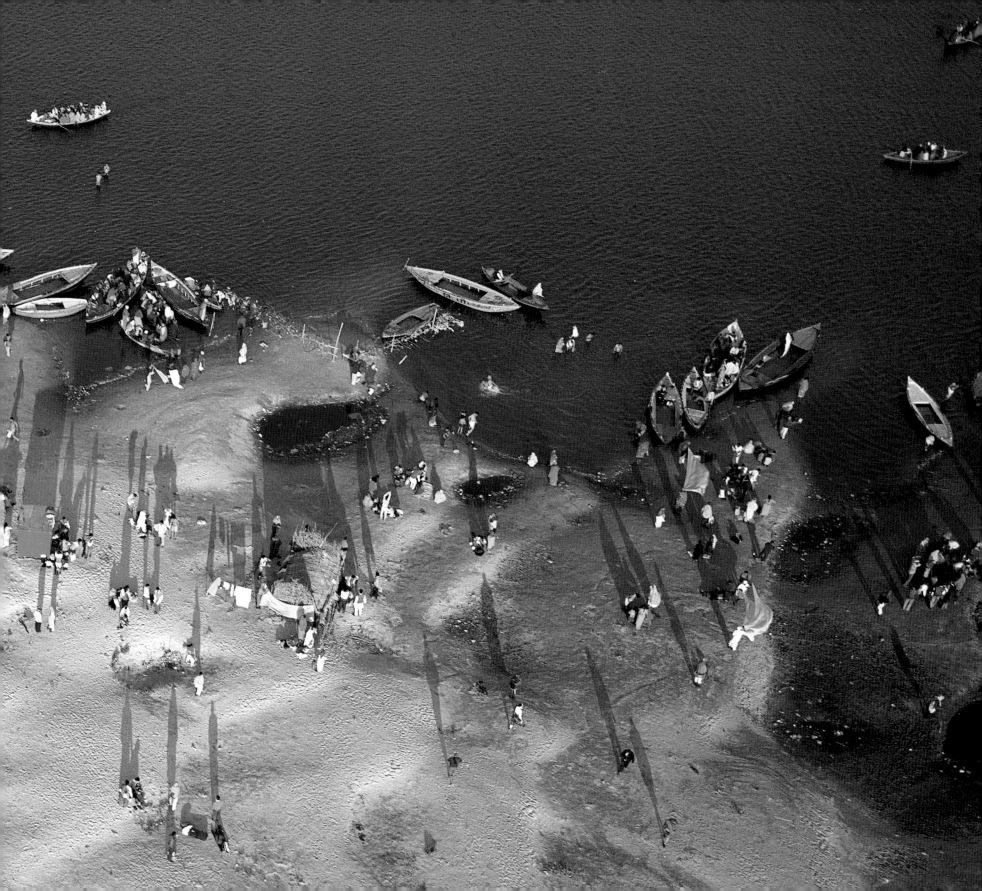

VARANASI

The ancient city of Varanasi, also known as Kashi ('City of Life') or Benares, is the holiest of Hindu cities. Situated on the banks of the Ganges, it has a history that goes back three thousand years. As Mark Twain wrote: 'Benares is older than history, older than tradition, older even than legend, and looks twice as old as all of them put together.'

Known as the City of Shiva, Hindus consider it auspicious to die in Varanasi, as it is supposed to bring moksha (nirvana). The ninety or so ghats (banks) along the Ganges – built under the patronage of India's erstwhile princely states – define the life and identity of Varanasi.

Preceding pages and facing page: 'Up at 5 am, at the busy banks of Benares, facing the ghats. People are getting ready to greet the sun and take their morning bath in the river, some are doing laundry on large slabs... Dogs are barking... The river is slowly waking up.'
Top: The roofs of houses in Varanasi.

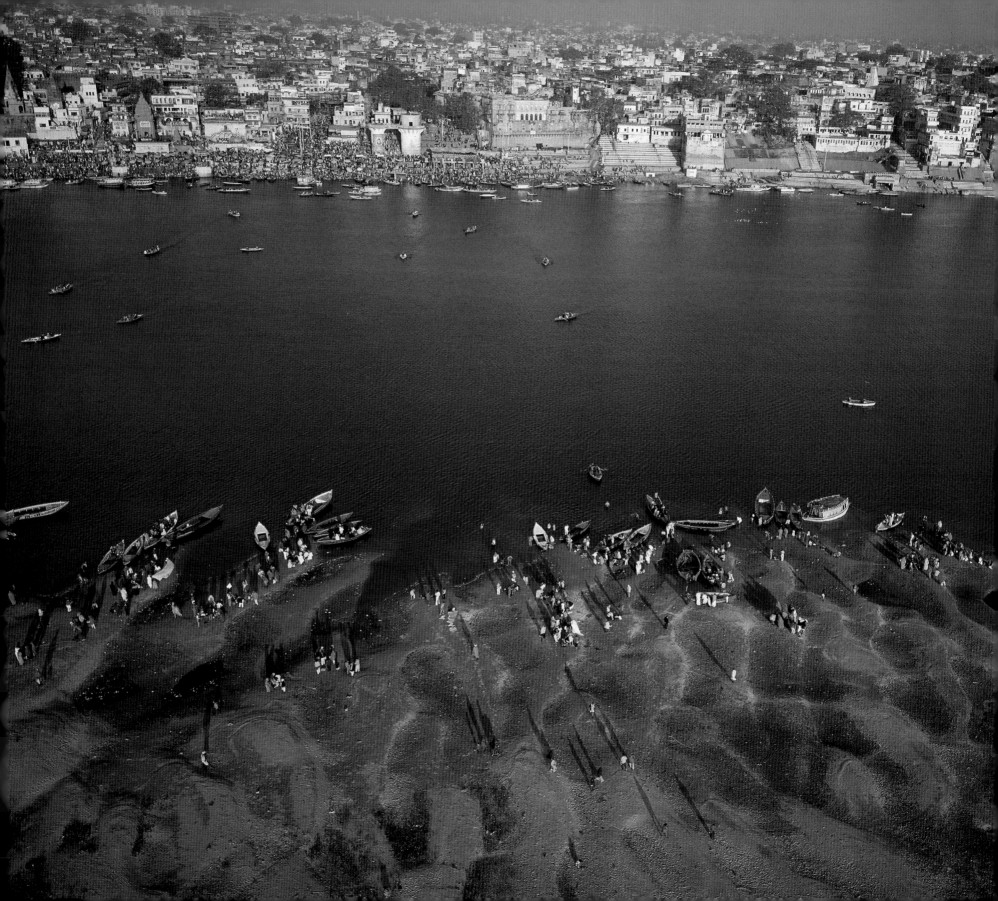

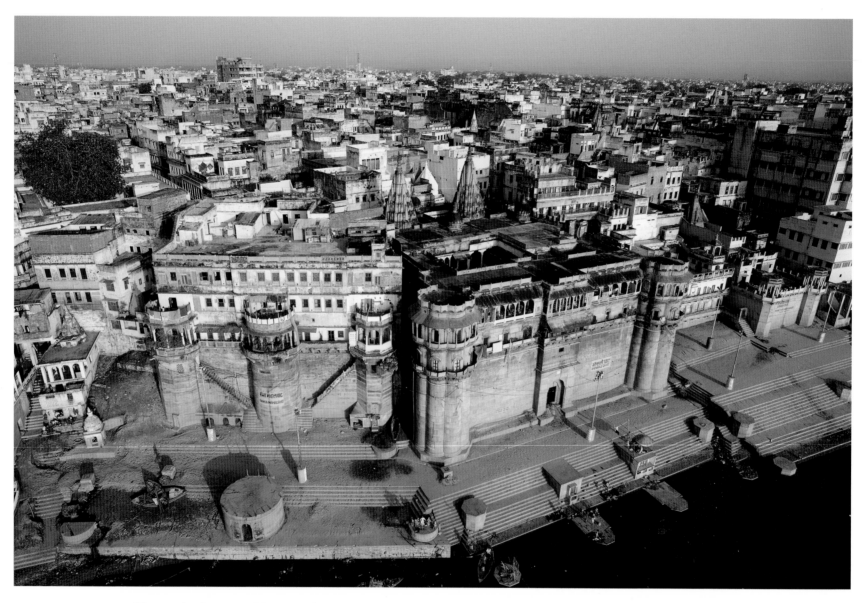

'The next day, I use a small boat to cruise gently up the Ganga all along the ghats, flying my kite from the deck, upwind. I wish this was a never-ending trip, I wish there were ghats for miles and miles... They are all different, each has a style, an ambience, a special piece of architecture reflecting a special light...' Varanasi's ghats, lined with shrines, cover a six-km stretch from Asi Ghat in the south to Adi Keshava Ghat in the north. While most are used for bathing – everyday about 60,000 people take a holy dip – there are also cremation ghats, the most auspicious being Manikarnika Ghat **(facing page),** where funeral pyres burn day and night.
Above: The Ganga Mahal Ghat, built by the king of Gwalior in the early nineteenth century.

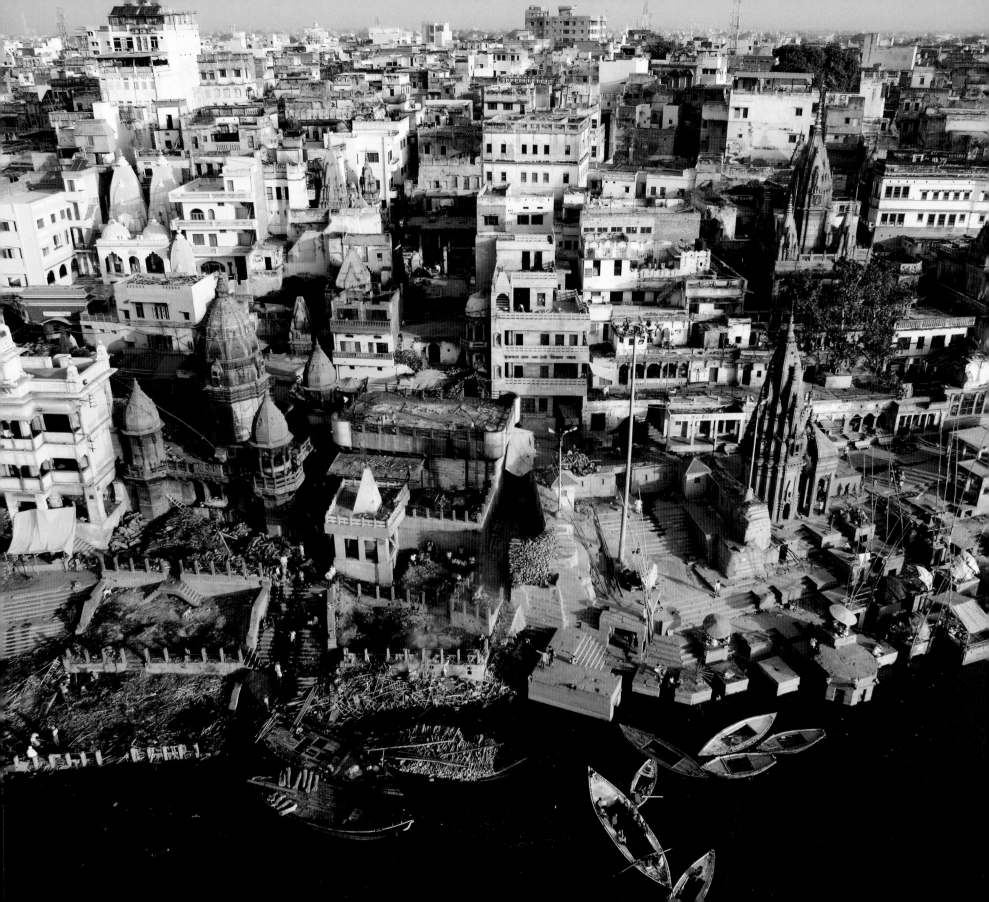

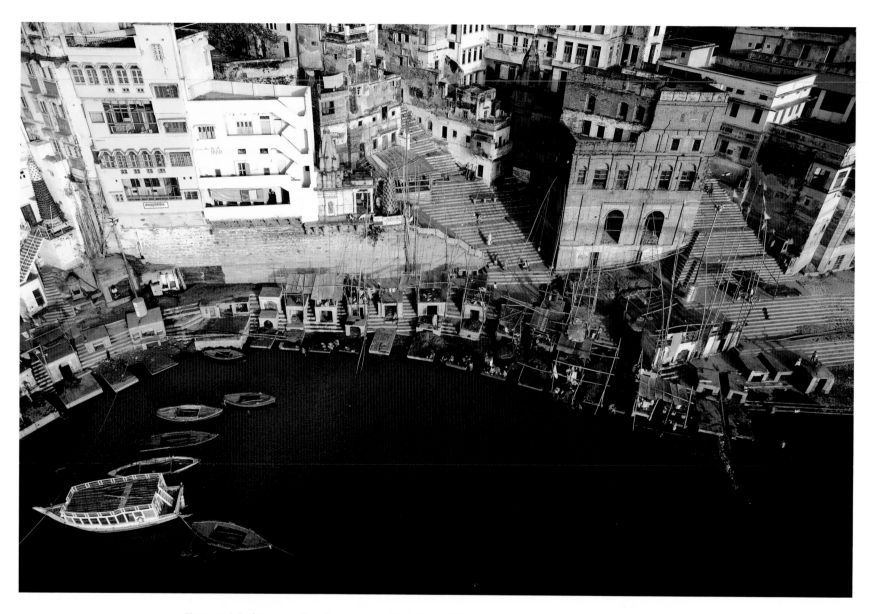

Above and facing page: *The Panchganga Ghat, the mythical meeting place of five rivers – the Ganges, Yamuna, Saraswati, Dhupapapa and Kirana. The ghat also has the Alamgir Mosque, built by Mughal emperor Aurangzeb after destroying a Vishnu temple.*

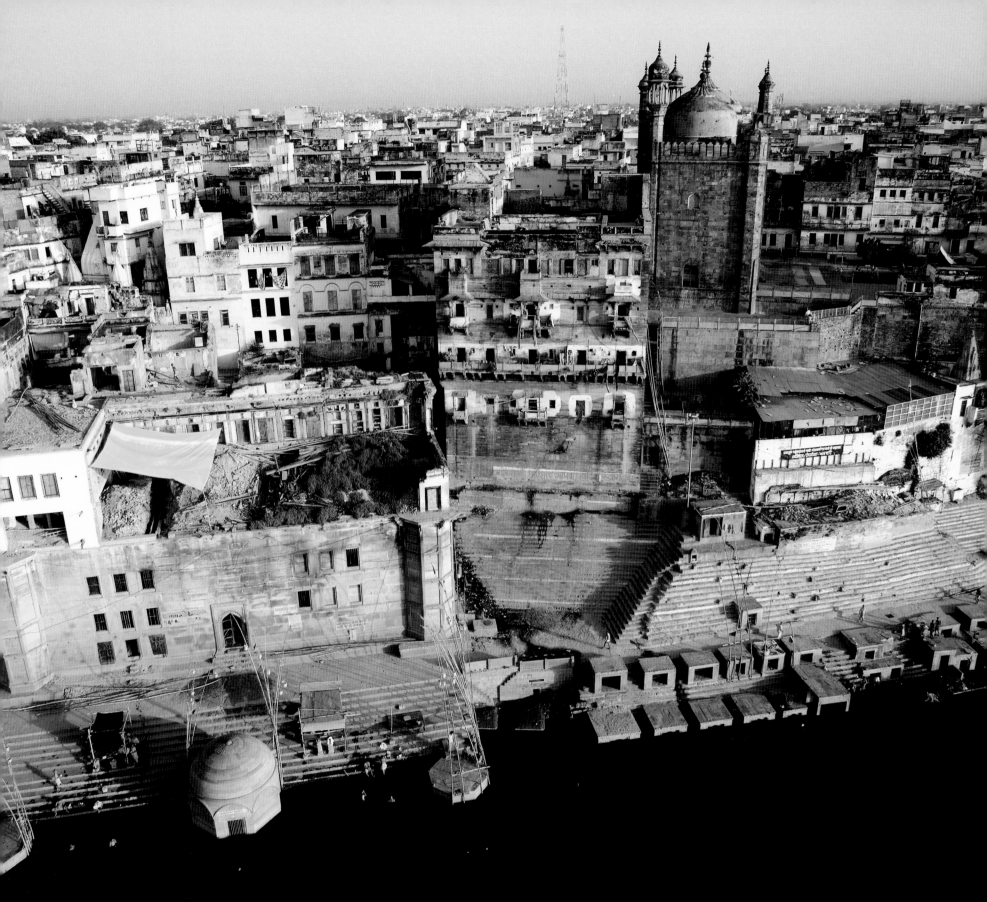

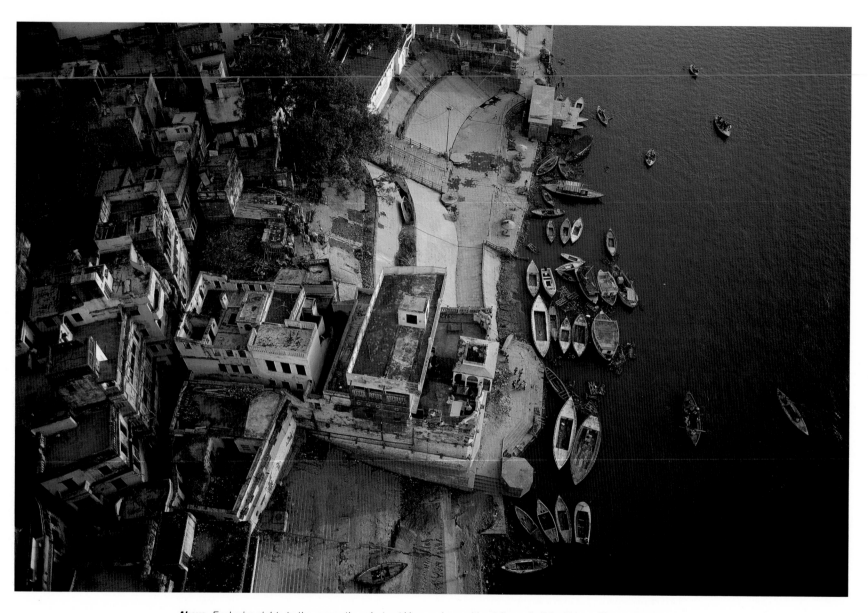

Above: Exclusive rights to the cremation ghats at Varanasi are with a tribe called the Doms. They sell the wood for cremation and collect the ashes. Their king, the Dom Raja, has a palace at the ghats.
Facing page: Varanasi's holiest and busiest ghat is the Dasashwamedha Ghat, where Brahma is supposed to have sacrificed ten horses. Rows of priests sit here, ready to perform religious rites for devotees. Near the ghat is Varanasi's main shrine, the Vishwanath Temple, believed to be over a thousand years old.

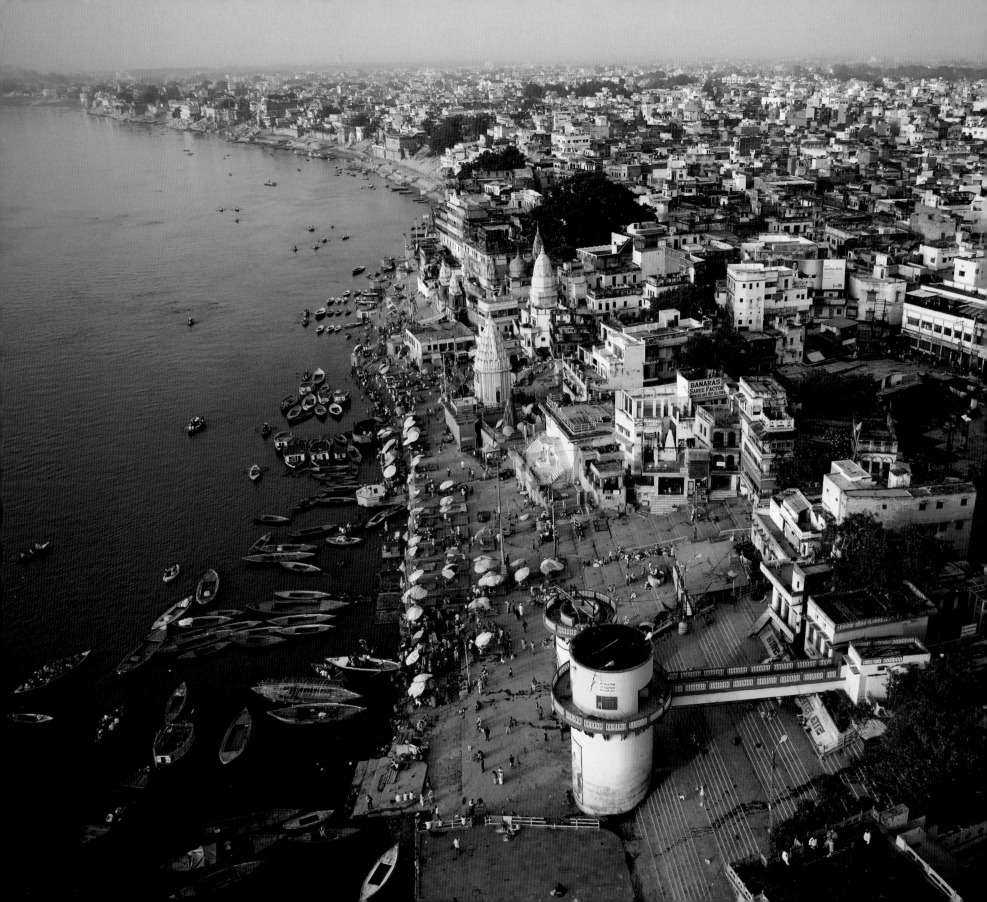

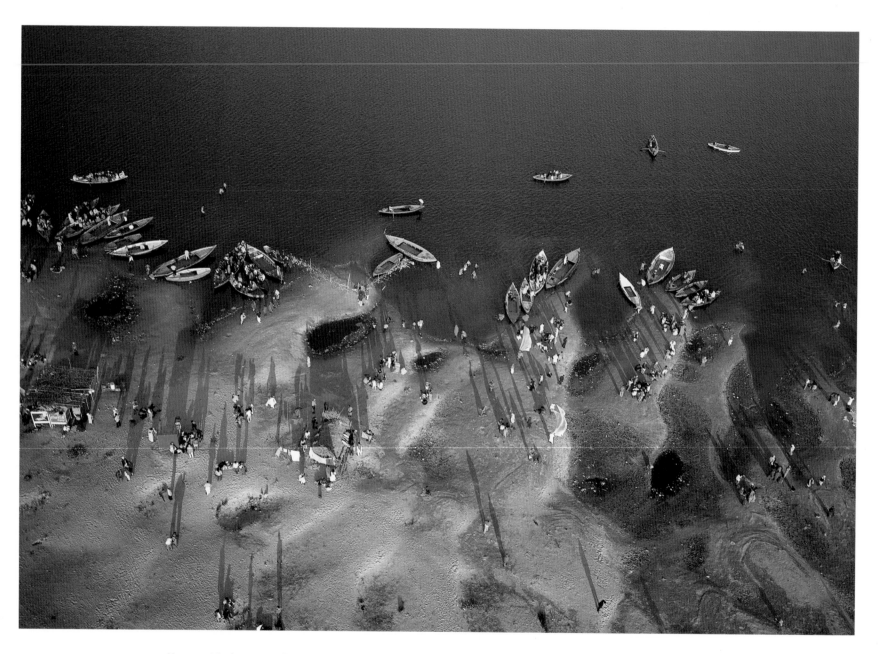

Above and facing page: *Views of the river bank opposite the ghats in the dry season, when the water level is low.*

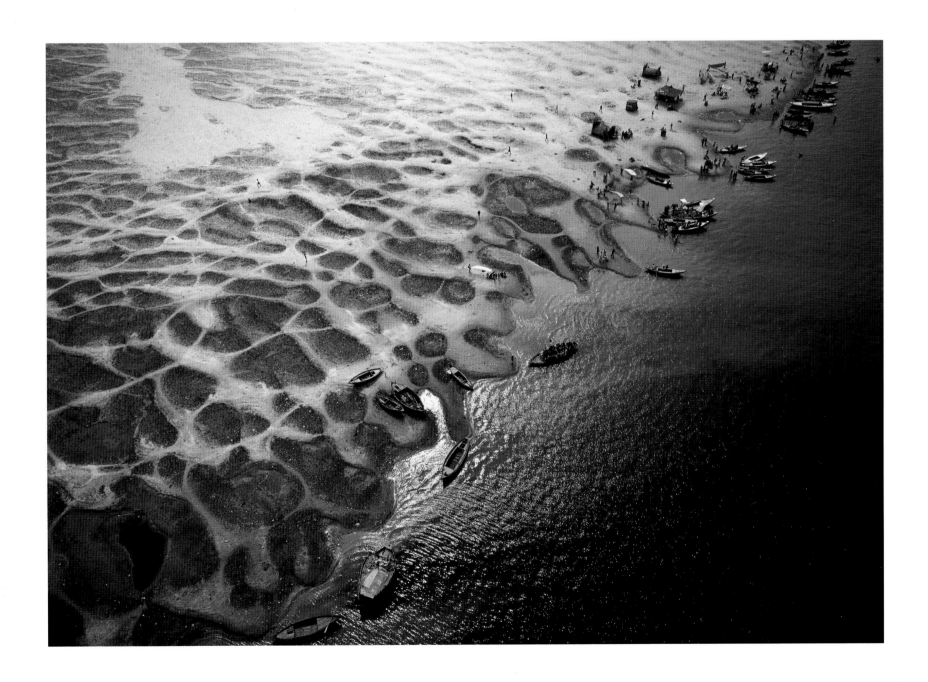

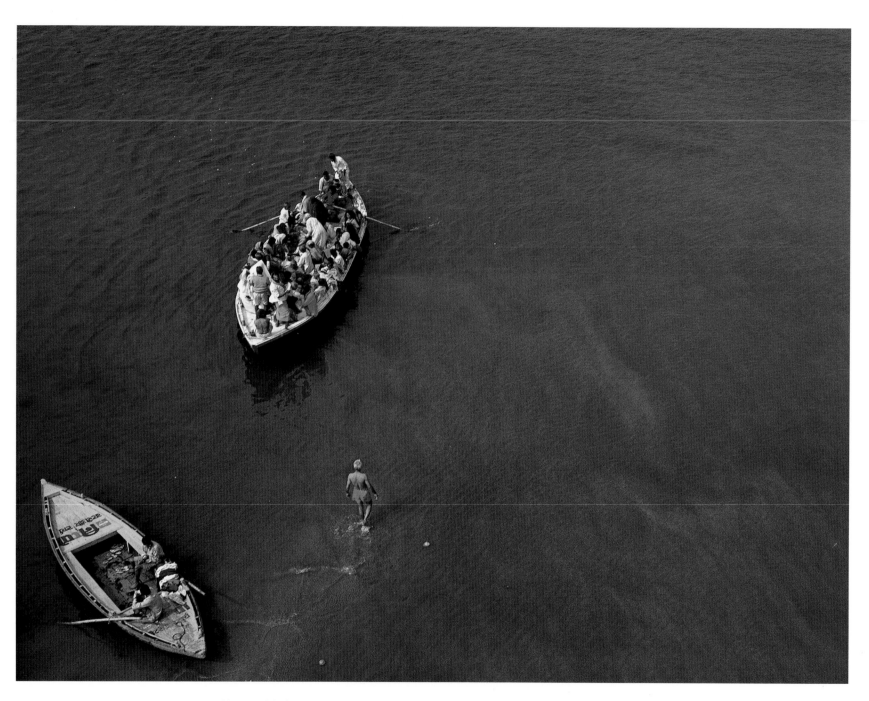

Above and facing page: *People boating and bathing at the river bank opposite the ghats.*

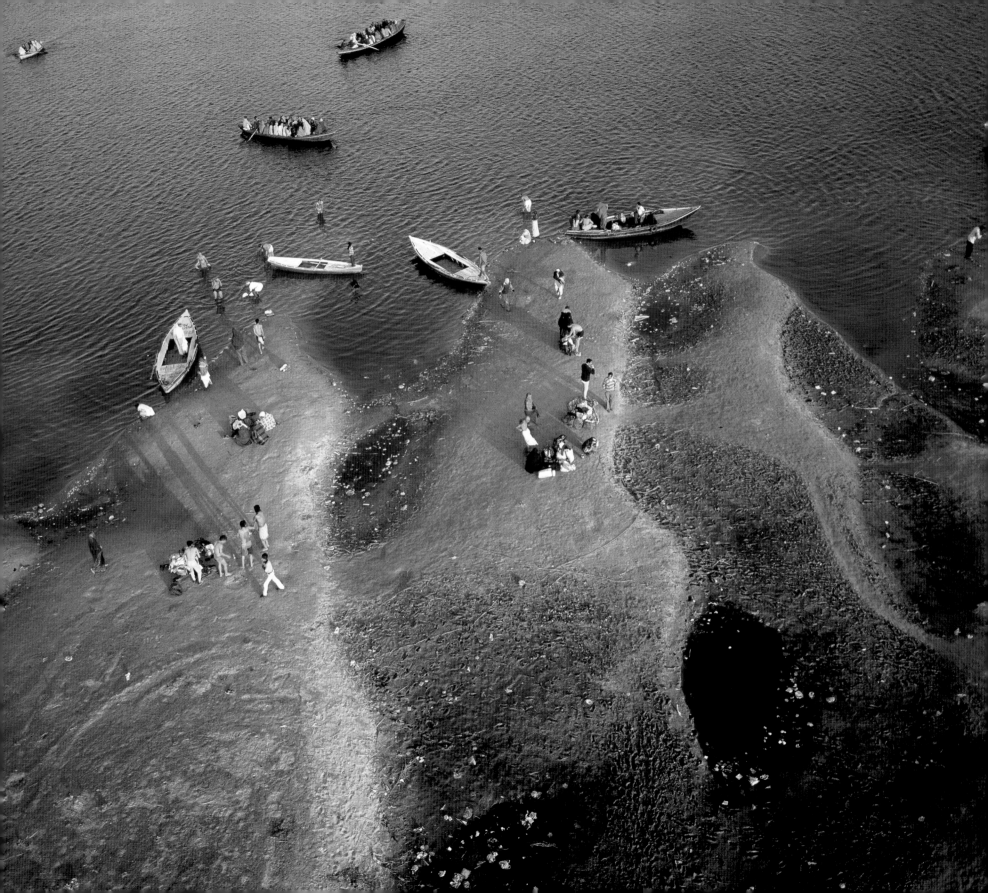

SARNATH

Located ten km from Varanasi, the cluster of ruins and temples at Sarnath is as important to Buddhists as Varanasi is to Hindus. Sarnath is where in 528 BC Gautam Buddha gave his first major sermon – the Dharmachakra, or the Wheel of Law, about the middle way to nirvana – to five disciples after having attained enlightenment in Bodhgaya.

At that time Sarnath was a flourishing centre of learning. When Chinese traveller Xuan Zang visited Sarnath in AD 640, he found it had a 100-metre-high stupa and 1500 monks living in large monasteries. However, as Islam spread in India, Sarnath was destroyed by Muslim invaders. It was rediscovered only when British archaeologists excavated it in 1835.

Facing page: The pillaged remains of the Dharmarajika Stupa, built by Mauryan emperor Asoka to preserve Buddha's relics.
Top: A Buddhist temple at the Sarnath complex.

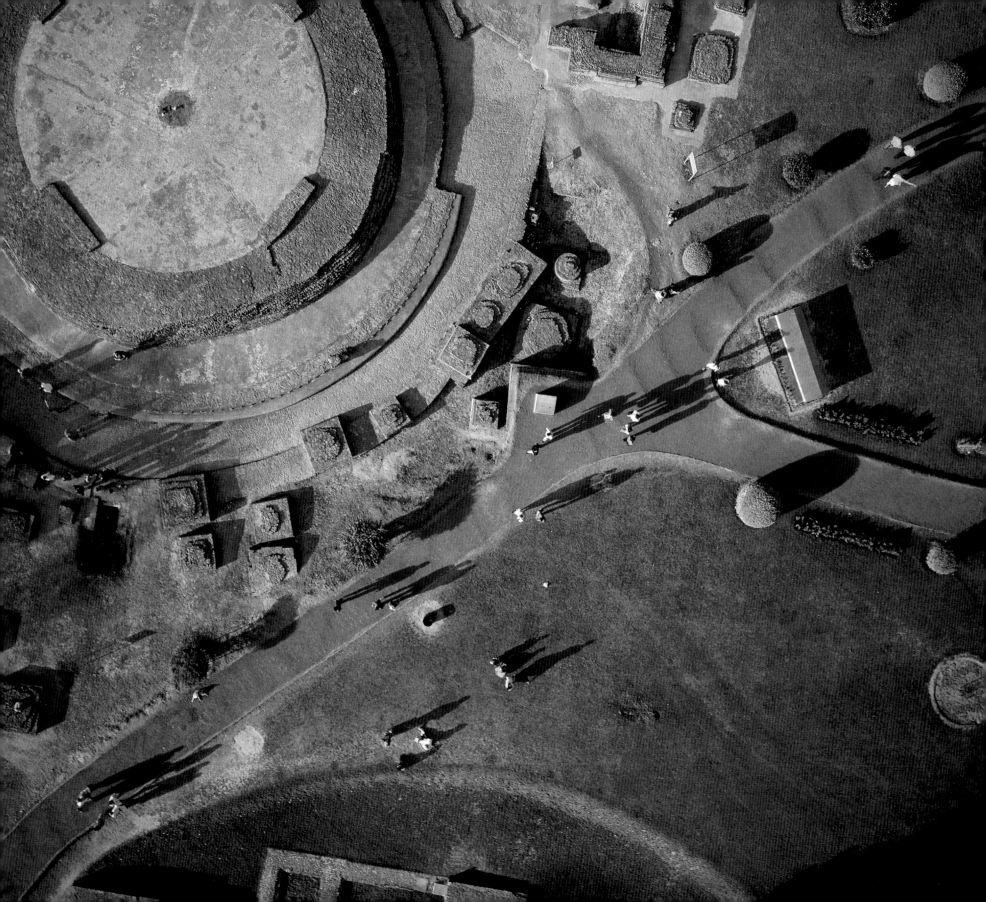

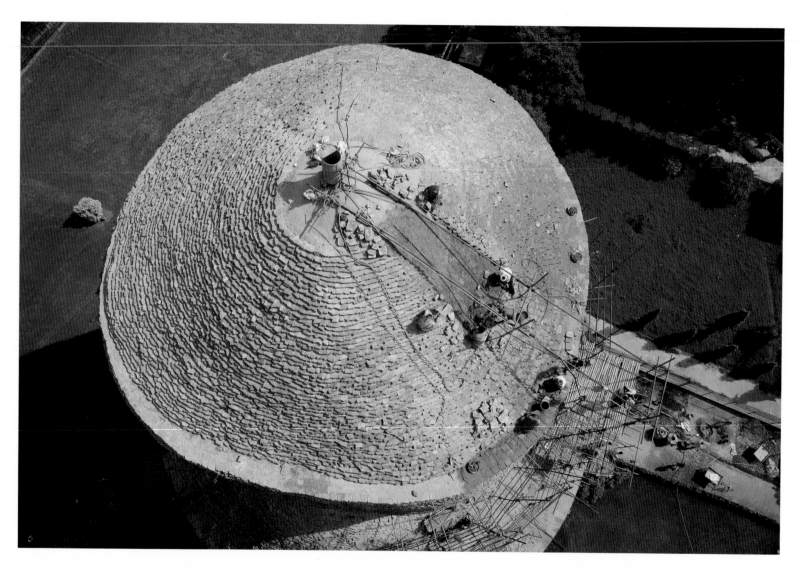

Above and facing page: '7 pm at Sarnath. Only a few minutes left before sunset, the light is perfect. I rush to meet a gentle, helpful wind... Five years later, I am back in the Buddhist ruins enclosure, where the Dhamekh Stupa is being restored.' *The Dhamekh Stupa, built at the site of Buddha's first sermon, is a 34-metre cylindrical tower with floral and geometric carvings that date back to the fifth century AD, with evidence of earlier brickwork in 200 BC.*

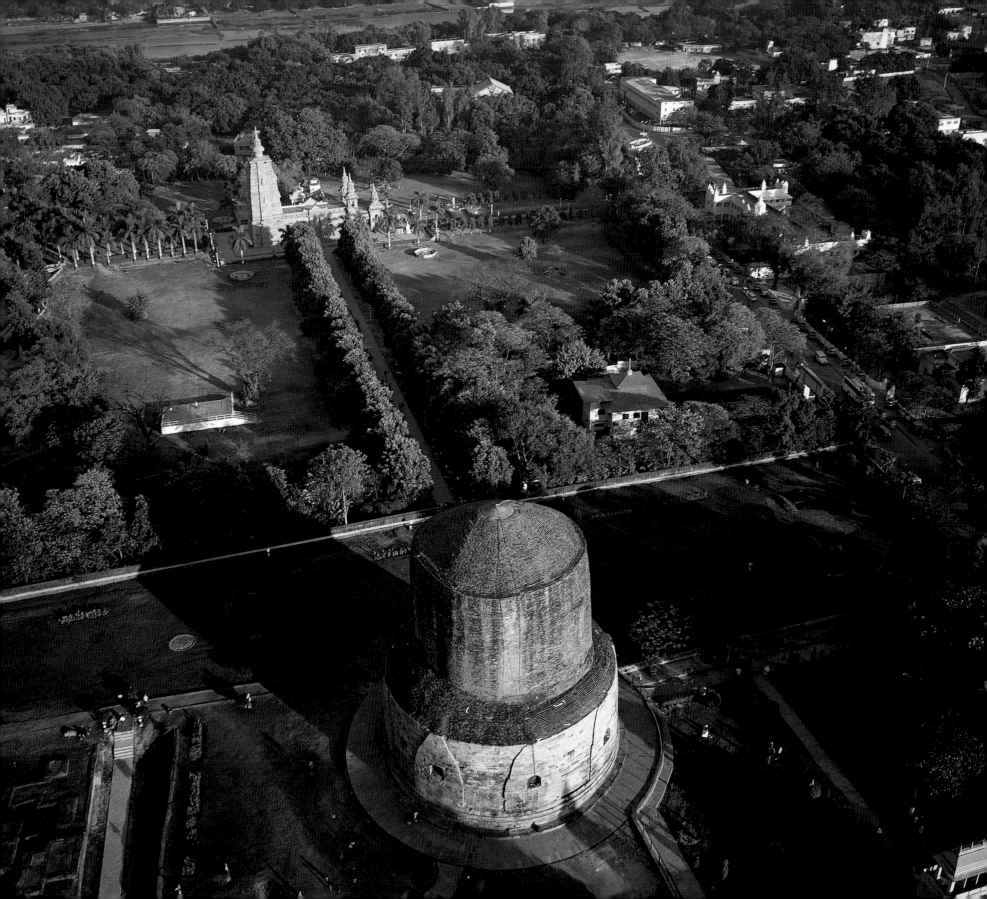

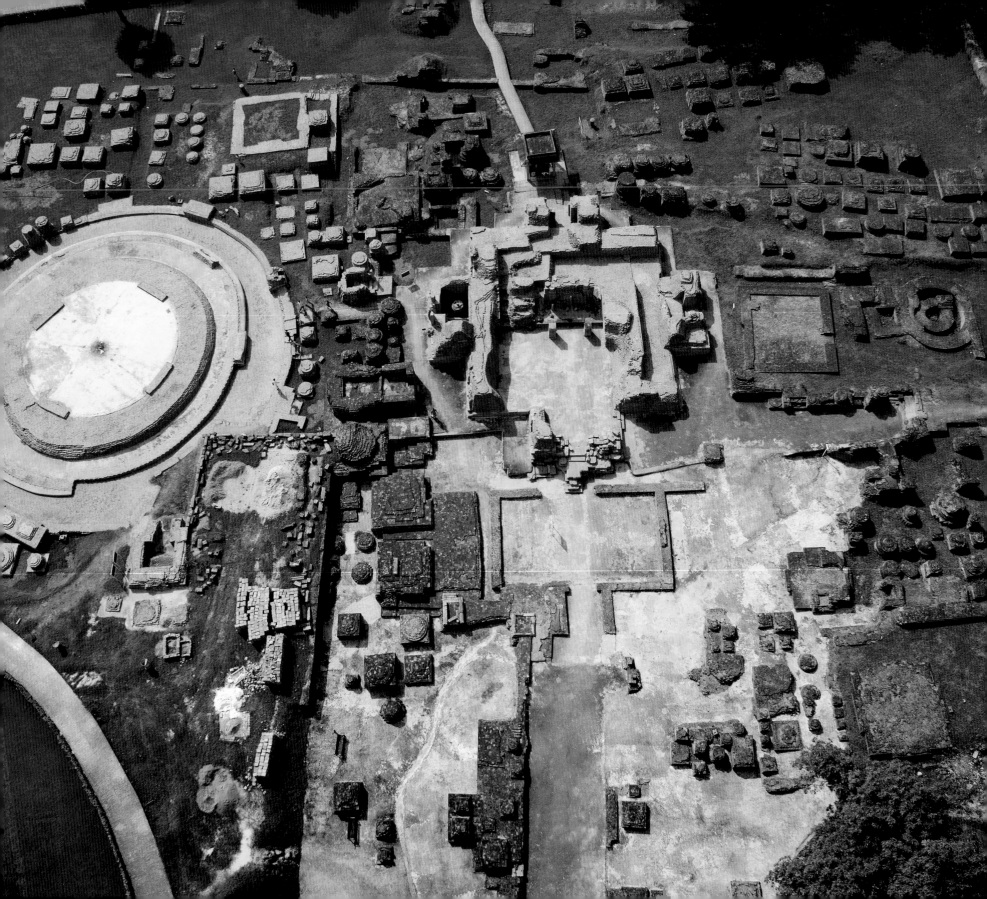

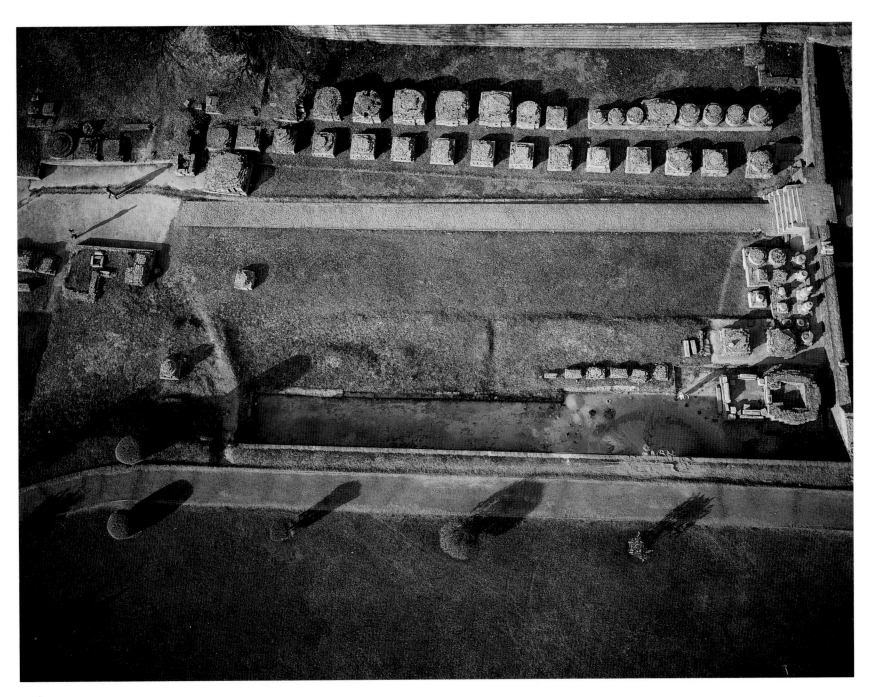

Above and facing page: *Apart from the remains of the Dharmarajika Stupa, the Sarnath complex has the Main Shrine, where Emperor Asoka is said to have meditated, as well as ruins of four monasteries, dating from the third to twelfth centuries.*

LADAKH

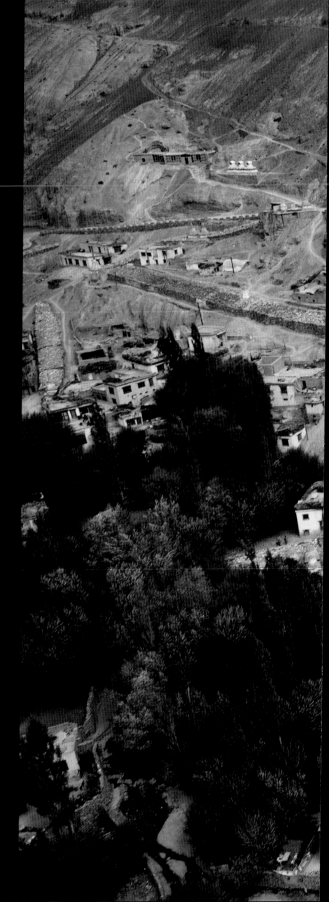

India's most remote and sparsely populated region, this high-altitude desert is hugged by the Himalayan and Karakoram ranges. A window to sublimely beautiful landscapes, this 'land of high passes' was opened to tourism only in 1974. A part of Jammu and Kashmir, Ladakh has been a stronghold of Mahayana Buddhism for a thousand years. The signs are everywhere in the Ladhaki landscape – the prayer flags fluttering in the breeze, prayer wheels and chortens (stupas), and most of all, the region's amazing ancient monasteries – many of them dramatically situated on sheer rock cliffs – that draw tourists from all over the world. These gompas are living centres of worship, and house priceless Buddhist manuscripts and artifacts.

Preceding pages and above: 'I fly my kite for a few minutes on the Khardung La pass, at 18,301 feet the highest motorable road in the world. But I can't lift my rig, due to these amazing gusty winds which make any flight unpredictable and dangereous. Surrounded by a maze of antennae, the military people are staring at me, wondering what's the point of flying a kite here, in minus 15 degrees Celsius... But what a thrill!...A few miles later, at Kardung village in Nubra Valley in Ladakh, at a height of 13000 feet, the air density is so low that every movement of wind is only gusty kicks keeping the kite up like uppercuts...'
Facing page: The eleventh century Lamayuru monastery, dramatically situated on top of a cliff, was part of the old Silk Route.

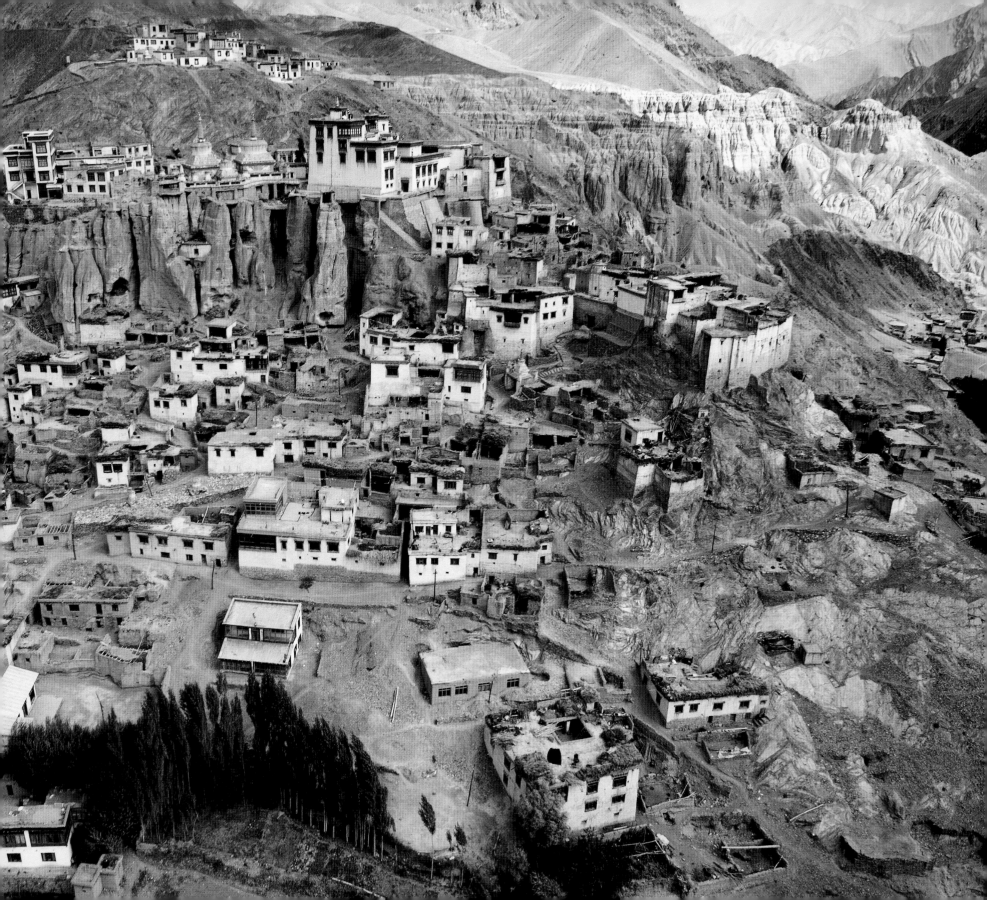

KHAJURAHO

Situated in Central India, the erotic temples of Khajuraho are masterpieces of Indo-Aryan architecture. Built by the Chandela dynasty a thousand years ago, the temples survived the onslaught of Mughal invaders, perhaps because of their remote location. However, they fell into disuse after the decline of the Chandelas in the thirteenth century. For seven hundred years they remained hidden from the larger world, until they were 'rediscovered' in 1838 by an English officer, T.S. Burt, who described the erotica as 'a little warmer than was any absolute necessity for.'

There are twenty-five temples in Khajuraho, though the locals believe that there were originally eighty-five. One theory explaining the erotica is that it sought to depict the love between Lord Shiva and his consort Parvati. Another is that these are Tantric images, Tantra being one way of achieving enlightenment.

'I wonder if my camera can reveal some unseen part of the erotic aspect of the famous temples. But the sculptures were not designed to be seen by the birds…!'
Top: *The Lakshmana temple, one of the largest in Khajuraho, is dedicated to Vishnu.*
Facing page: *The Vishwanath Temple is known for its sensuous apsaras (heavenly nymphs) – one plucking a thorn from her foot and another one playing her flute, while others relax in provocative poses.*

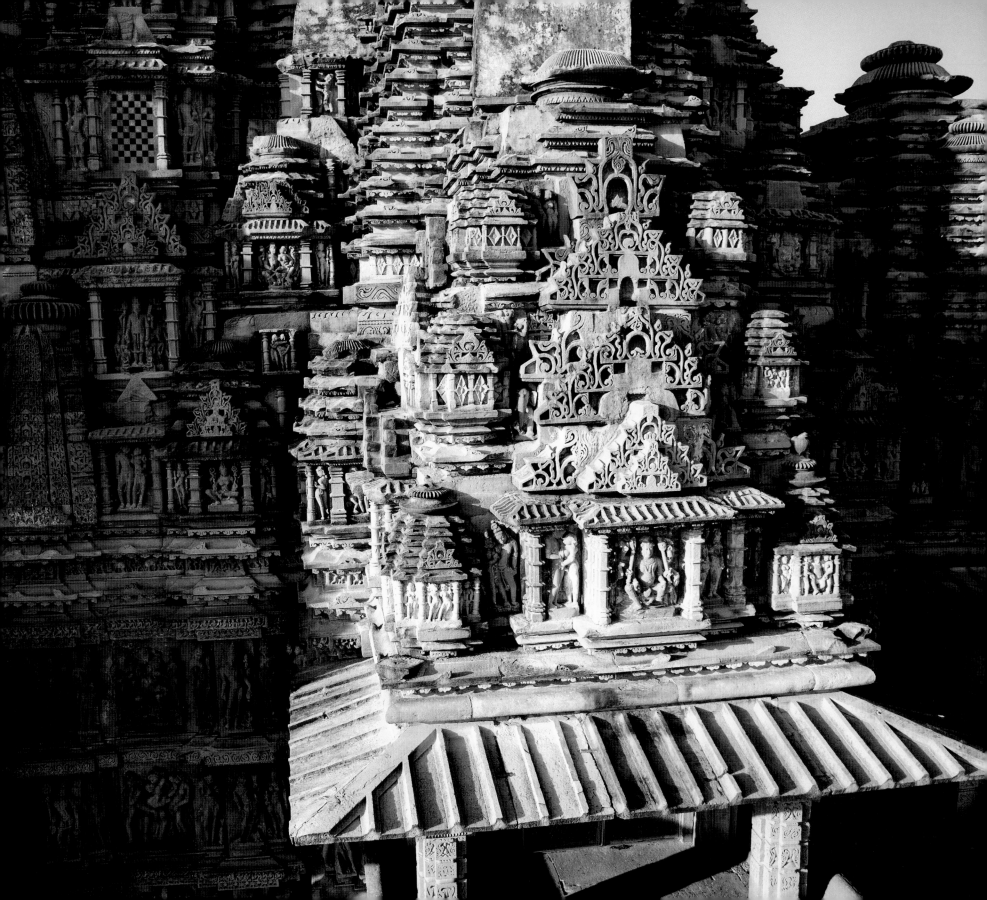

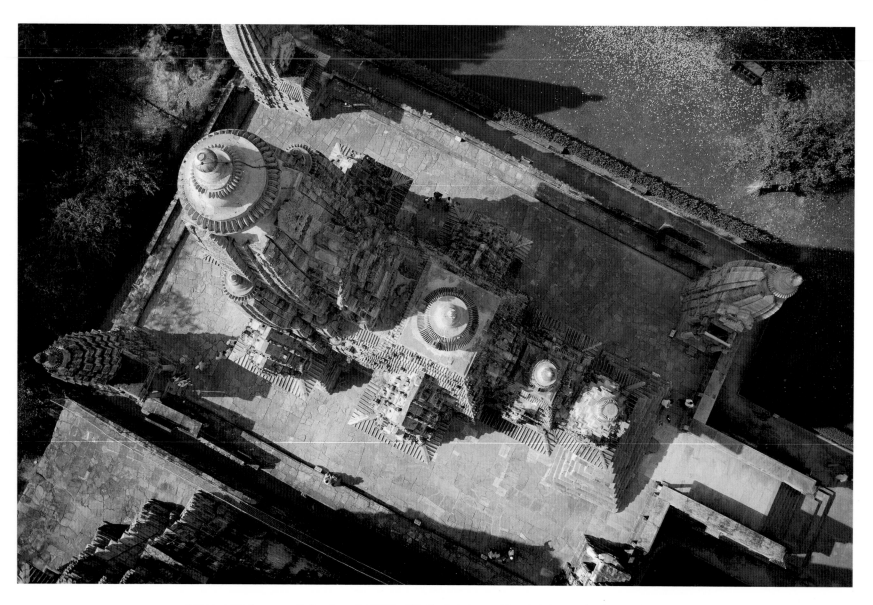

Above and facing page: *Dating from AD 930 to 950, the Lakshmana Temple is known for the exquisite ceiling of its entrance porch, the sculpture of the master architect with his disciples, and the carving of a pair of street singers.*

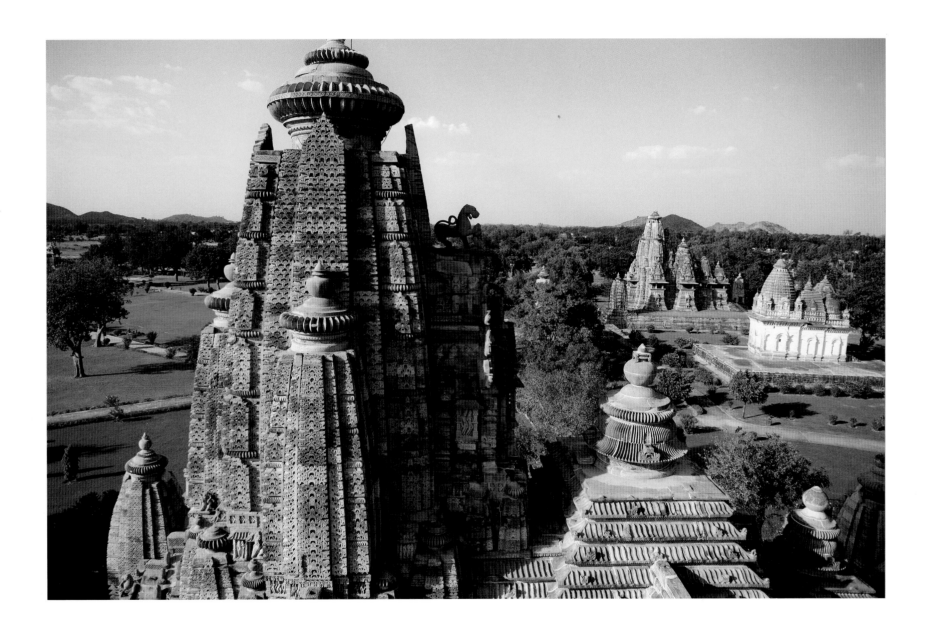

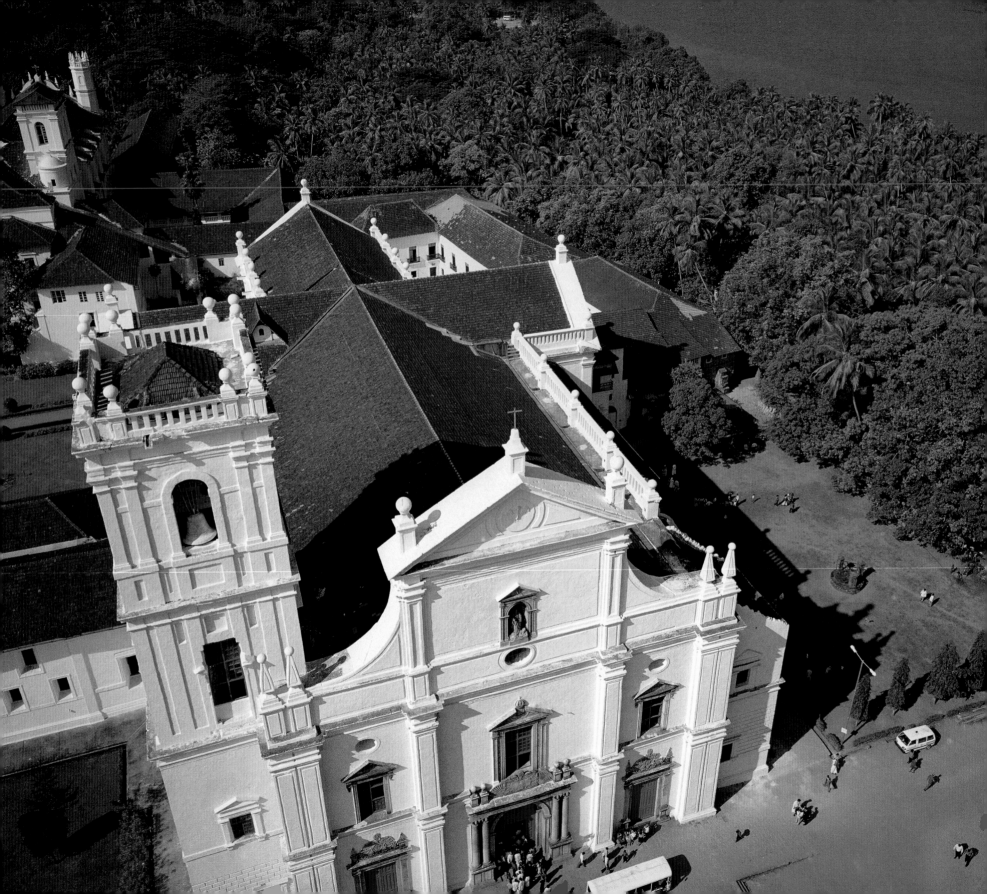

GOA

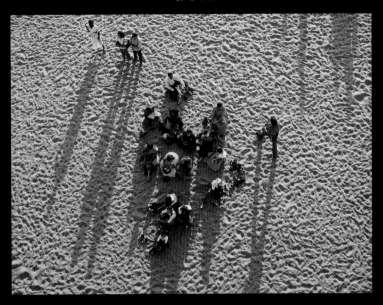

One of India's most popular tourist destinations, particularly with the partying set, Goa is justly famous for its beaches and its laid-back ambience. Ruled by the Portuguese for 400-odd years, Goa has a character and flavour quite distinct from the rest of India.

It was in 1510 that a small but powerful enclave was set up here by seafaring Portuguese on a quest to control the spice route from the East. Jesuit missionaries led by St Francis Xavier arrived in 1542. The Portuguese were almost defeated by the Marathas in the eighteenth century, but their rule ended only in 1961, when the state formally became a part of India.

'Am I still in India? Sometimes I feel I am in South America, in a Portuguese harbour in the nineteenth century, or on any beach anywhere in the world... But yes, I'm in India, with its colourful way of life, and actually, it is the world that comes to Goa – be it for a Christian pilgrimage, or a rave party under the coconuts. As for myself, I am here for an international kite festival.'
Facing page: The sixteenth-century Se Cathedral, believed to be Asia's largest church.
Top: Relaxing on the beach, Indian-style.

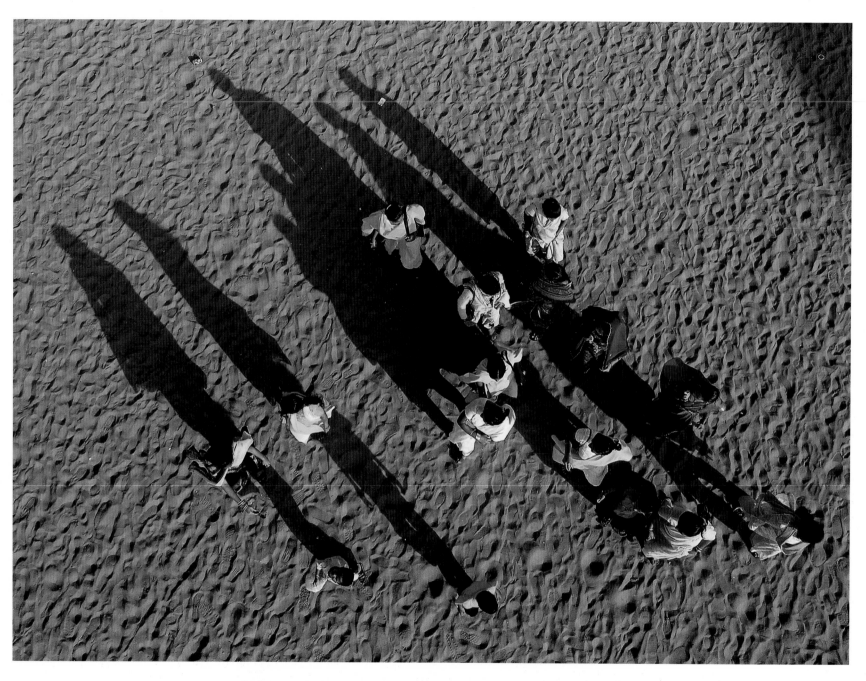

Facing page: *An Indian kite from Mangalore at an international kite festival in Goa.*
Above: *The play of light and shadows on the beach towards the end of the day.*

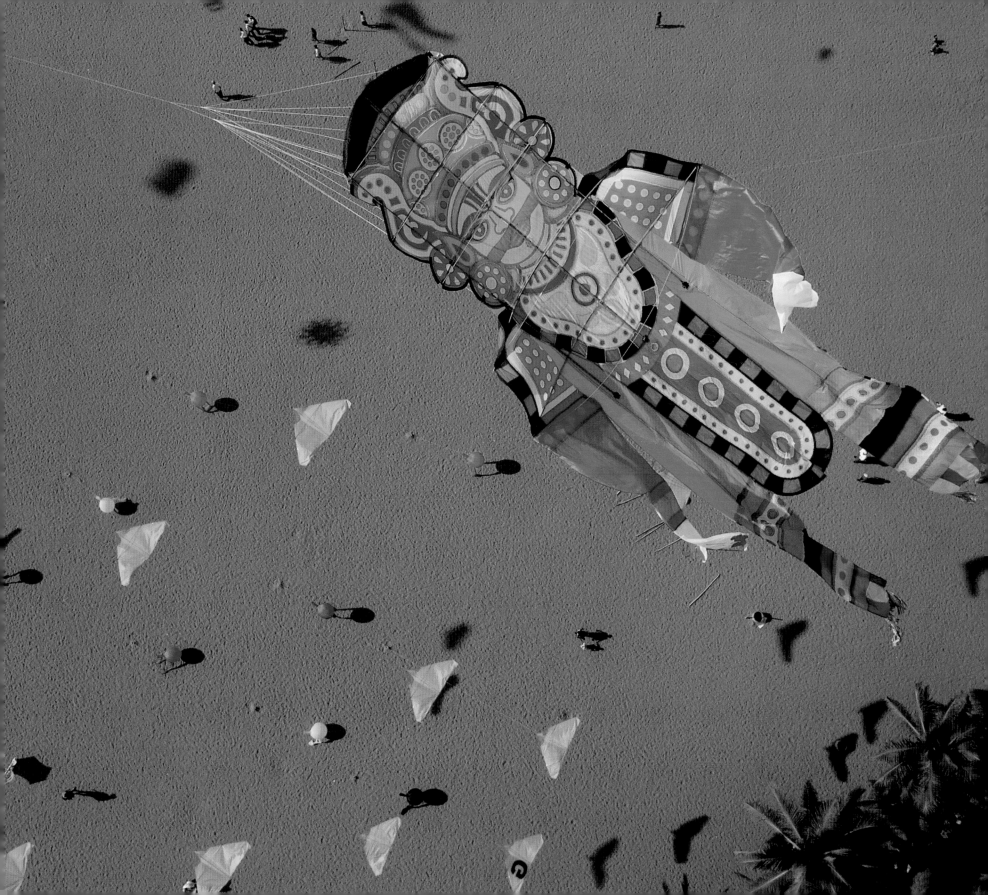

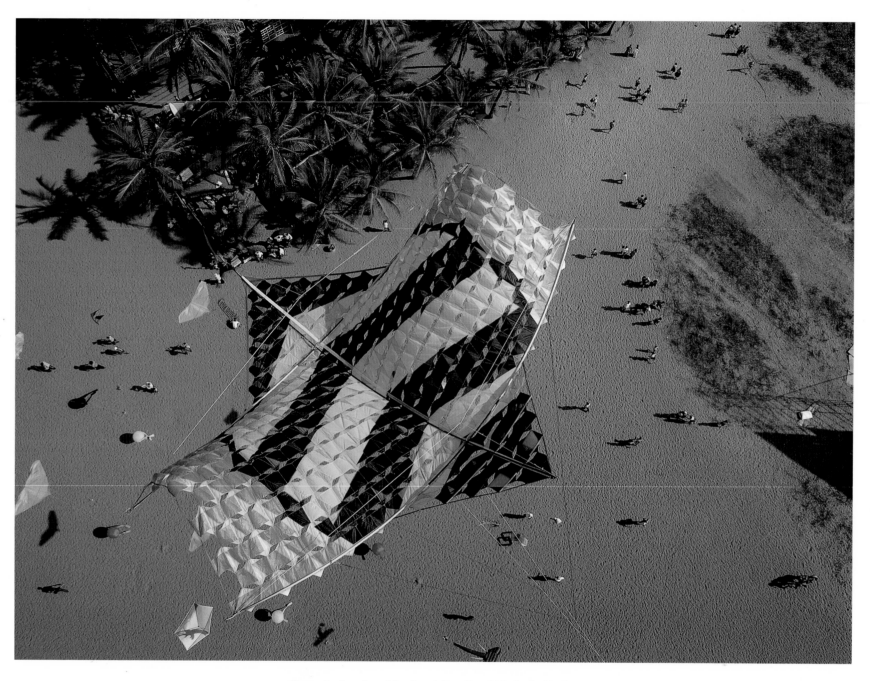

Above: *An American kite at an international kite festival in Goa.*
Facing page: *Interesting shadows on the beach at the kite festival.*

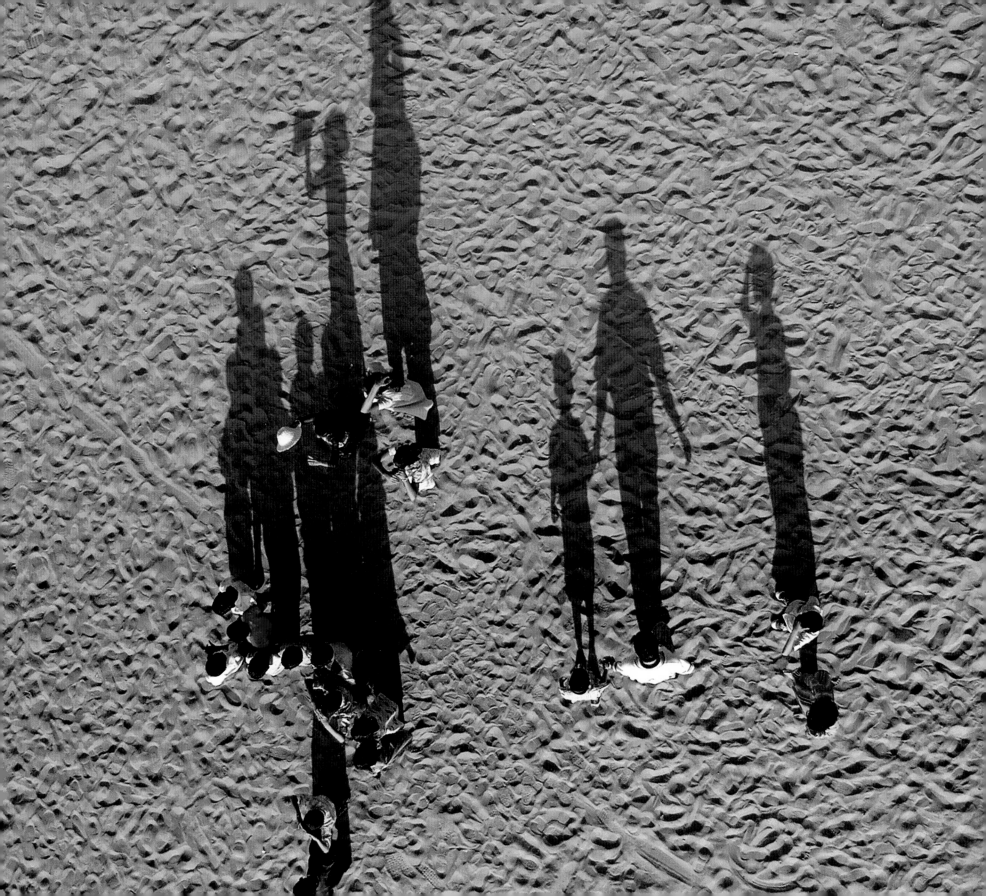

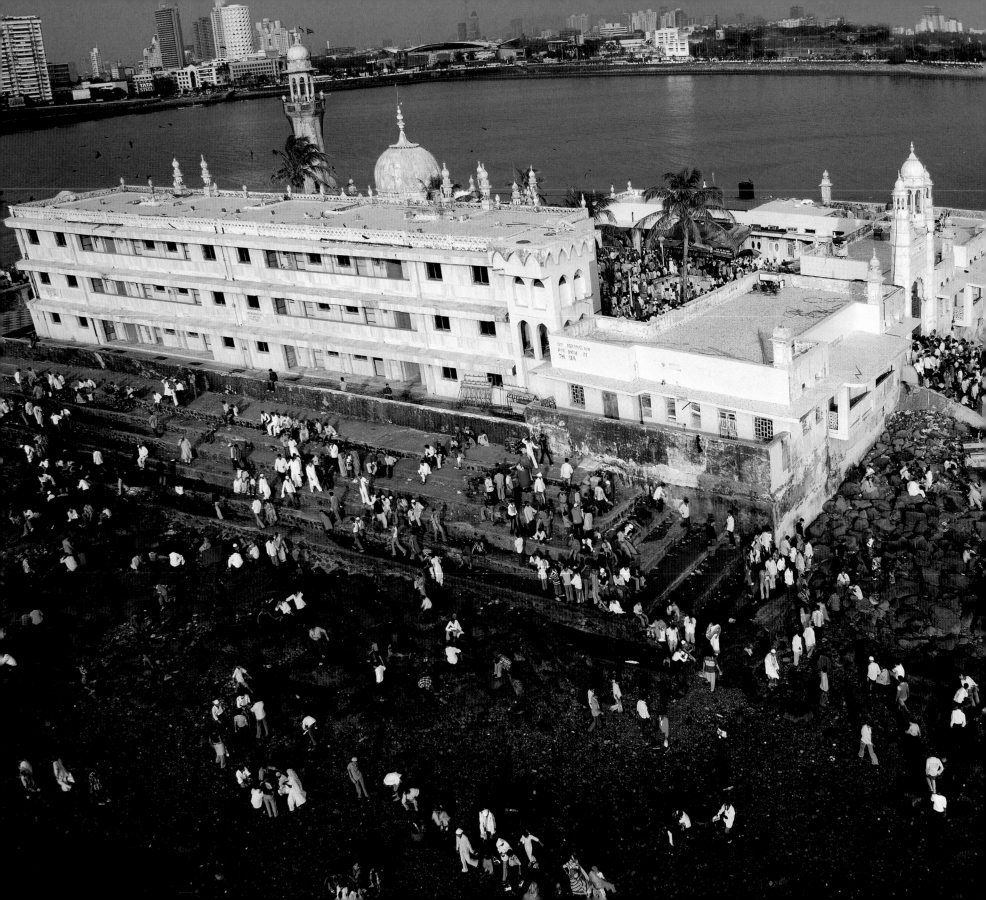

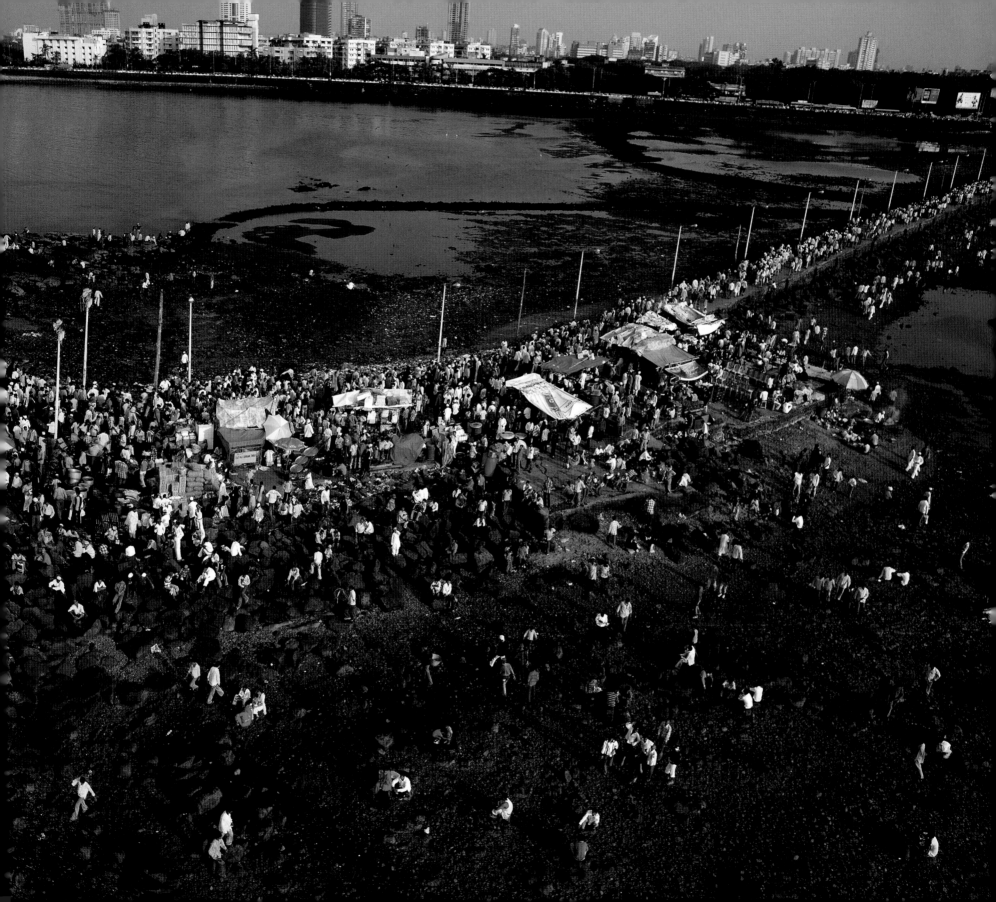

MUMBAI

The melting pot of Mumbai (formerly Bombay), capital of Maharashtra, is also the financial nerve centre of the country. India's biggest port, the dynamic but crowded city, with a population of 15 million, pulsates with life.

Originally a set of seven islands acquired by the Portuguese in 1534, Bombay came to the British Crown as dowry in 1661, when Catherine of Braganza married Charles II. The British, in turn, leased the islands to the East India Company, which saw great potential in it as a natural harbour in the Arabian Sea. By the eighteenth century, Mumbai had become the major city and ship-building yard on the western coast, and by the nineteenth century the seven islands had been joined together. The city attracted traders from all over, giving it its multicultural character.

Today India's financial capital – the Mumbai Stock Exchange is India's Wall Street – the 'city of gold' is also a city of dreams – it is home to a vibrant, thriving Hindi film industry, also known as Bollywood.

Preceding pages, above and facing page: *Haji Ali, the tomb of a rich Muslim merchant, Haji Ali Shah Bukhari, on Eid day. There is a causeway that leads*

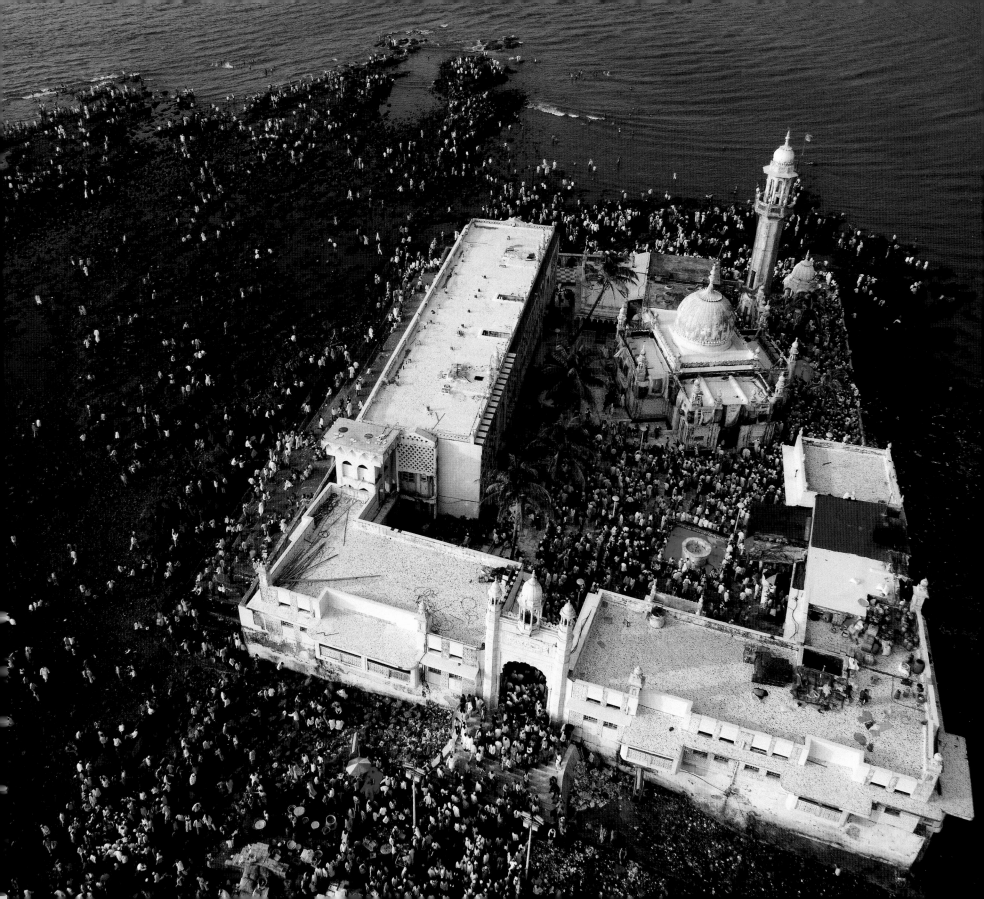

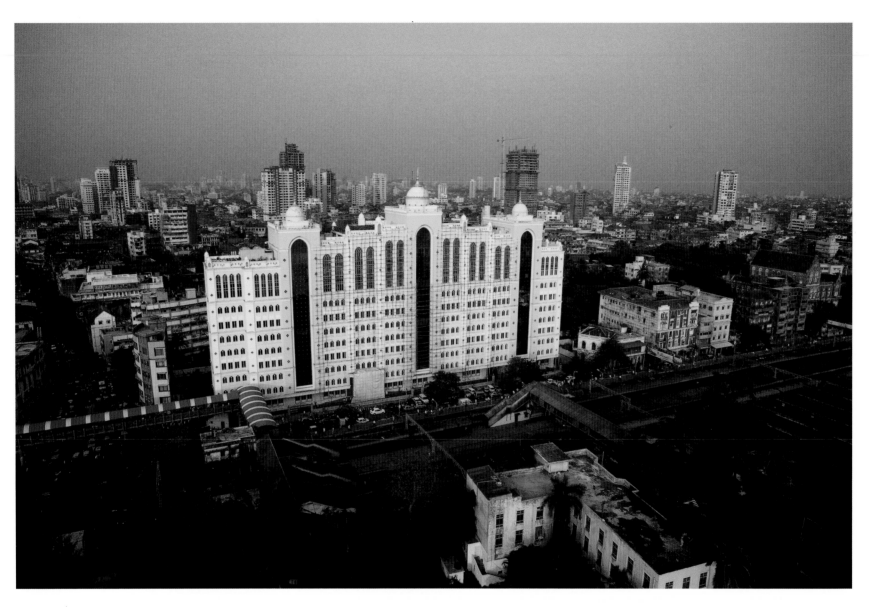

Saifee Hospital, a state-of-the-art hospital built by the Dawoodi Bohra community in Mumbai. A fascinating mix of the old and the new, Mumbai has classy modern enclaves co-existing with Art Deco and Victorian buildings as well as slums.

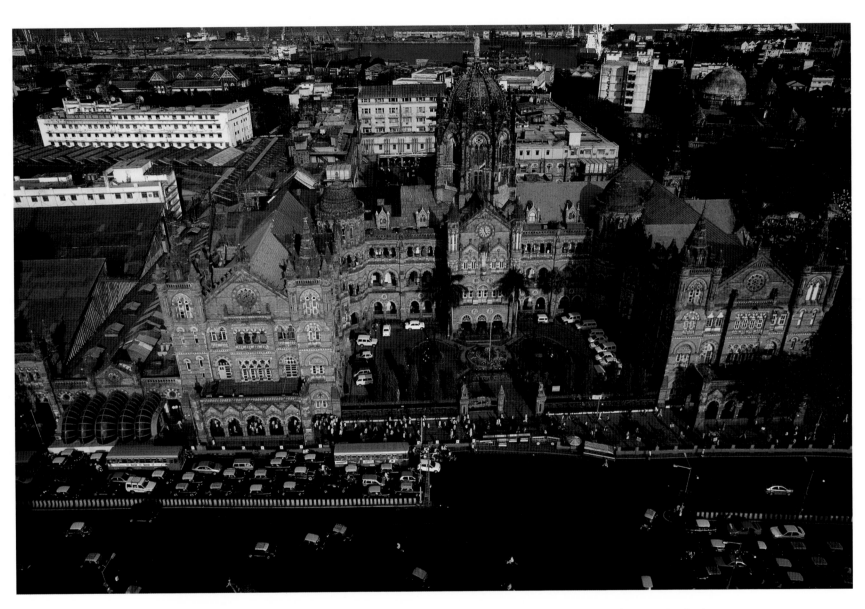

'5 pm, and I rush to the roof of a small yellow building facing the Victoria Terminal, the only possible launch point for the kite. Buildings around us create turbulence, and it's rush hour traffic in the street. Hundreds of black and yellow cabs, in queue at the red light, fill my monitor screen. The wind is too gusty… and picks up when I reach 300 feet… Despite my leather gloves, holding the kite string becomes painful, and I'm aware I'm flying just above the traffic. I snap a few shots and retire…' Built in 1888, the Victoria Terminus is the grandest example of Victorian Gothic architecture in India.

AHMEDABAD

Apulsating industrial centre, Ahmedabad in Gujarat is a charming city with a fascinating old quarter, beautiful mosques, museums and the Sabarmati Ashram, from where Mahatma Gandhi orchestrated the final part of India's struggle for freedom. Ahmedabad was founded in 1411 by Sultan Ahmed Shah. Legend has it that while out on a hunting trip, he saw the astonishing sight of rabbits turning on his hounds and defending their territory. Taking it as an auspicious sign, the sultan decided to build his capital at this site.

'As I drive to Sarkhej on a typically Indian road, I see countless trucks, and wandering cows and buffaloes. I hear honks, smell spices, smile back to little princesses in rags. The car – an old Ambassador with springy seats and a 'Jesus loves you' sticker on the driver's sunshade – speeds through the hustle and bustle of India.'

Top and following pages: *A short distance to the southeast of Ahmedabad is Sarkhej Rosa, a beautiful complex of tombs and pavilions around an artificial lake, built as a retreat for Gujarat's rulers between 1445 and 1461.*
Facing page: *Ali Khan's mosque in Dholka village, near Sarkhej.*

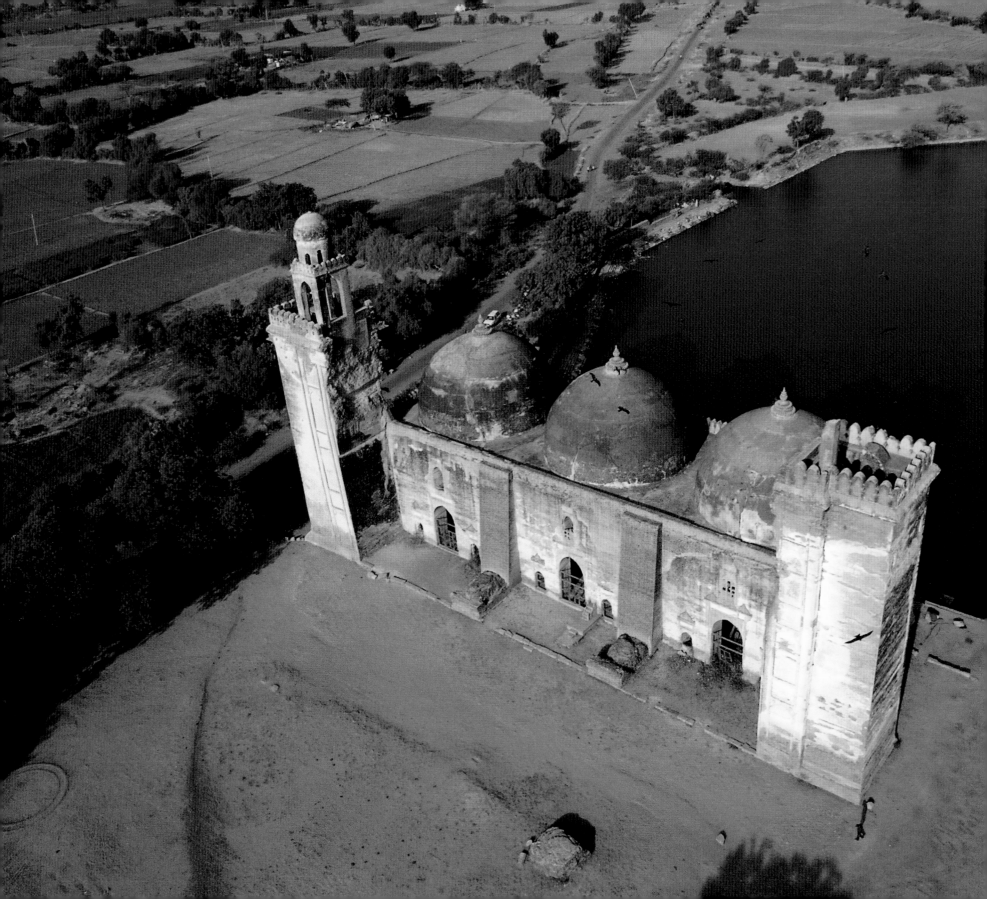

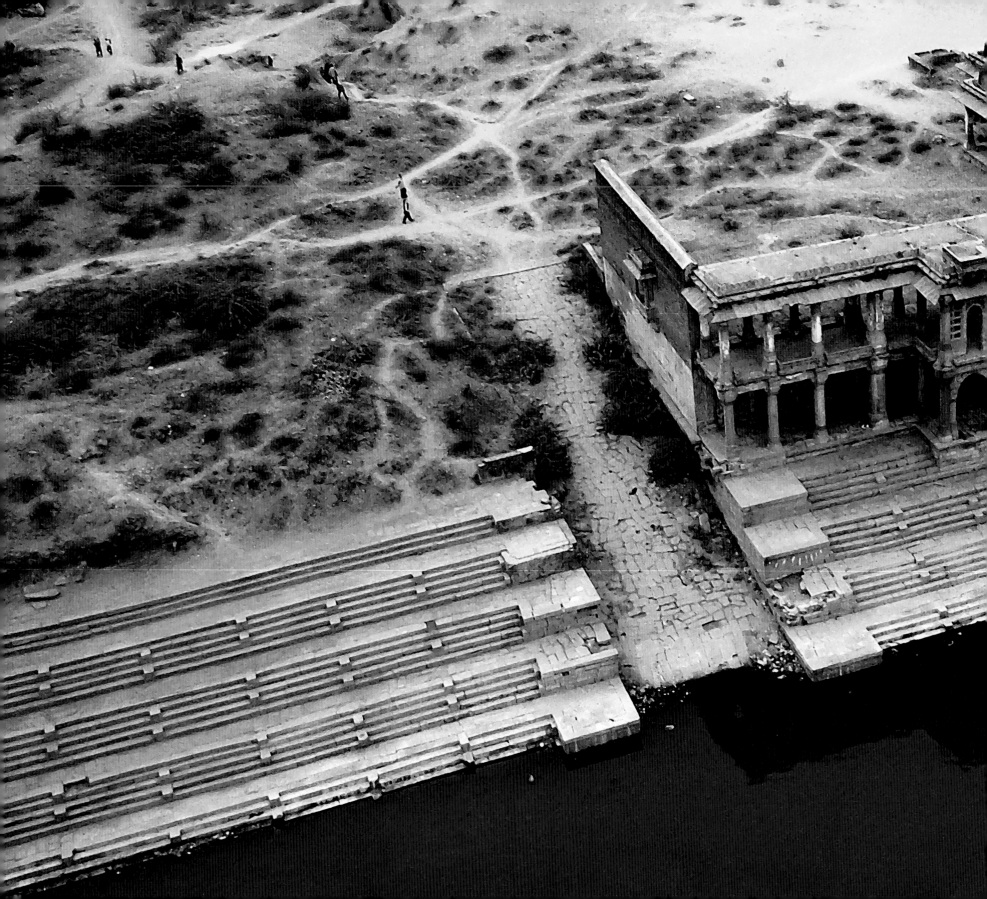

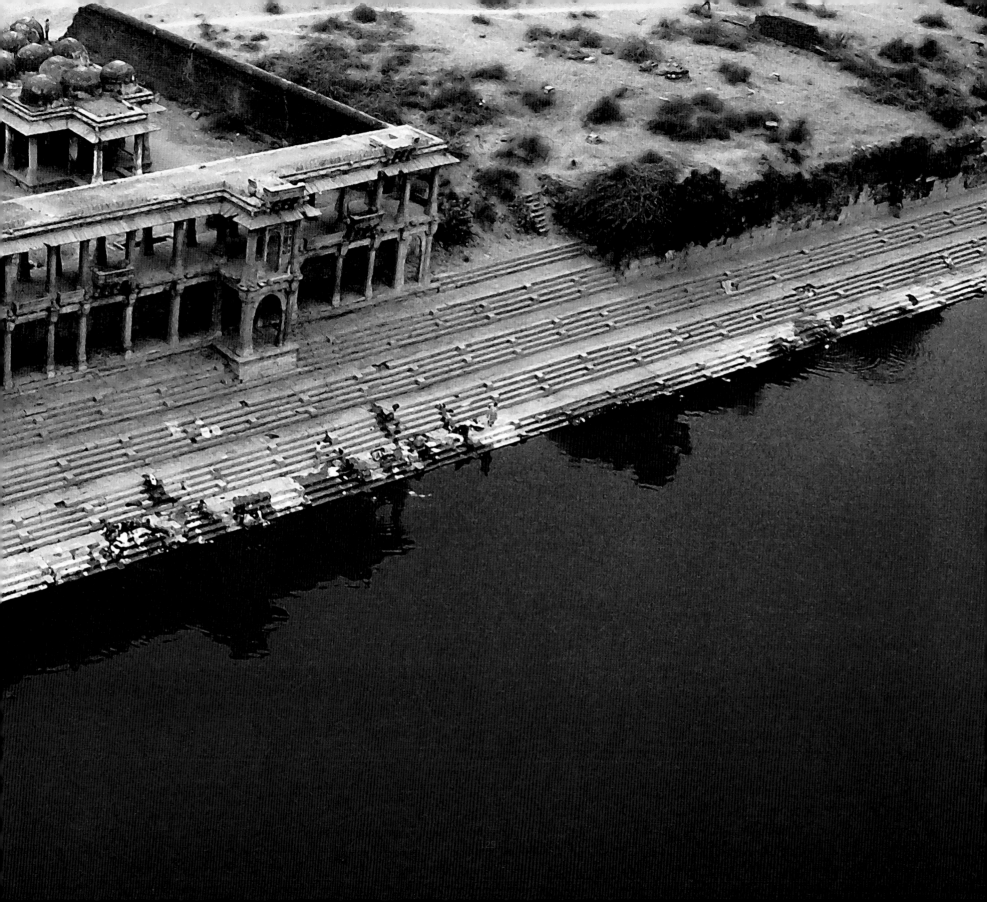

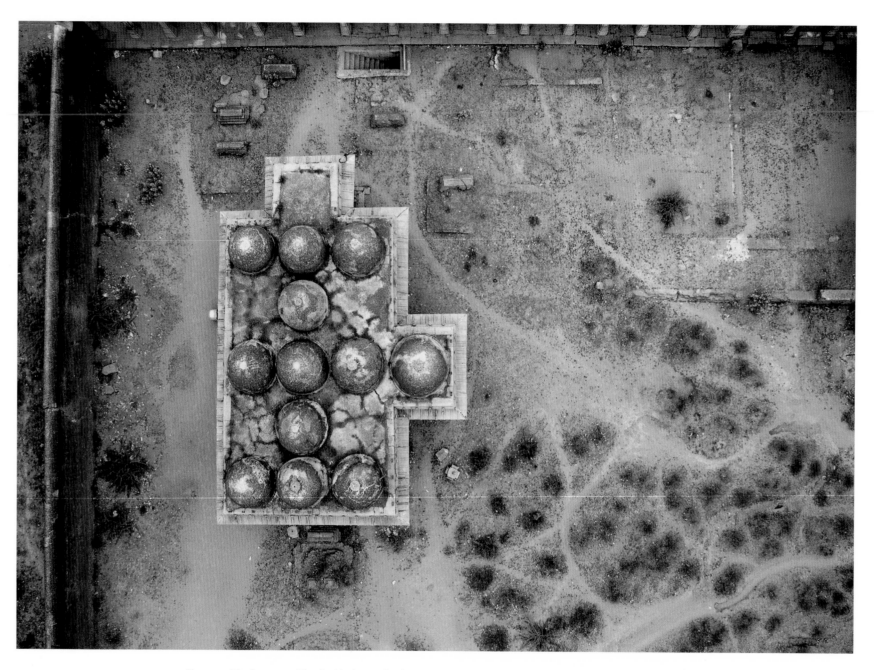

Above and facing page: *The Sarkhej complex is an example of the early Islamic architectural culture of the region, which fused Islamic stylistic influences from Persia with indigenous Hindu and Jain features to form a composite Indo-Saracenic architectural style. Now in ruins out of neglect, the site is slowly being restored.*

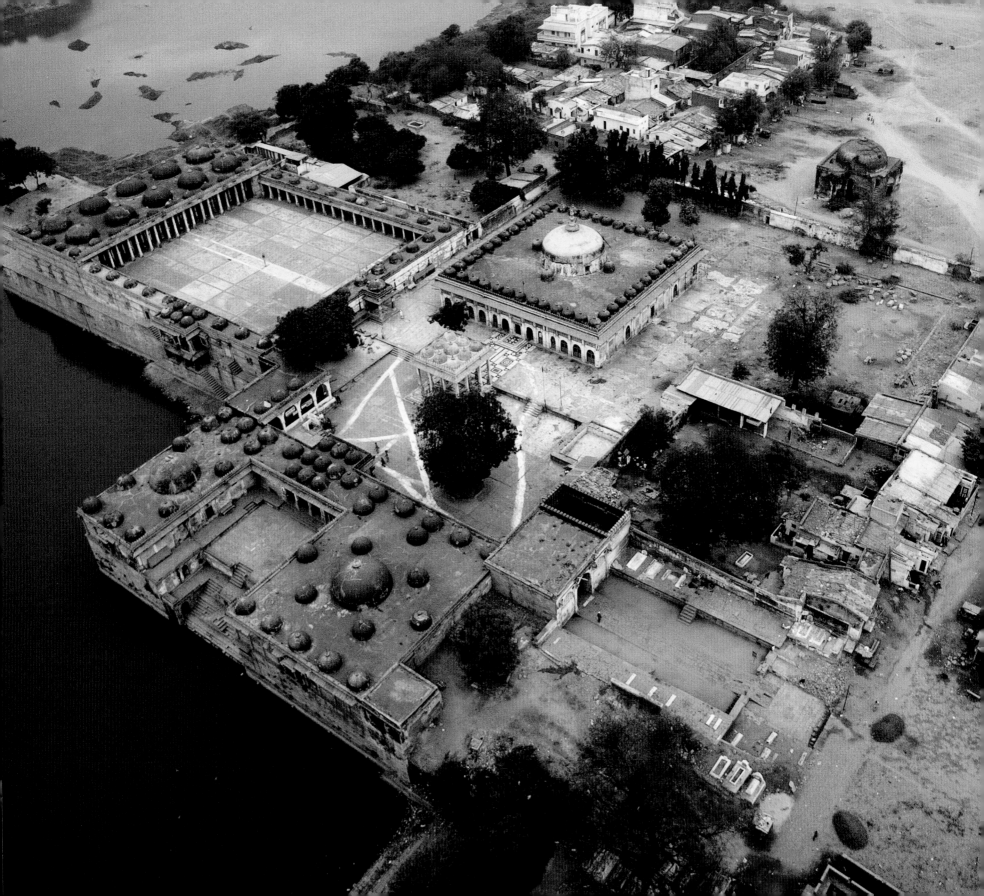

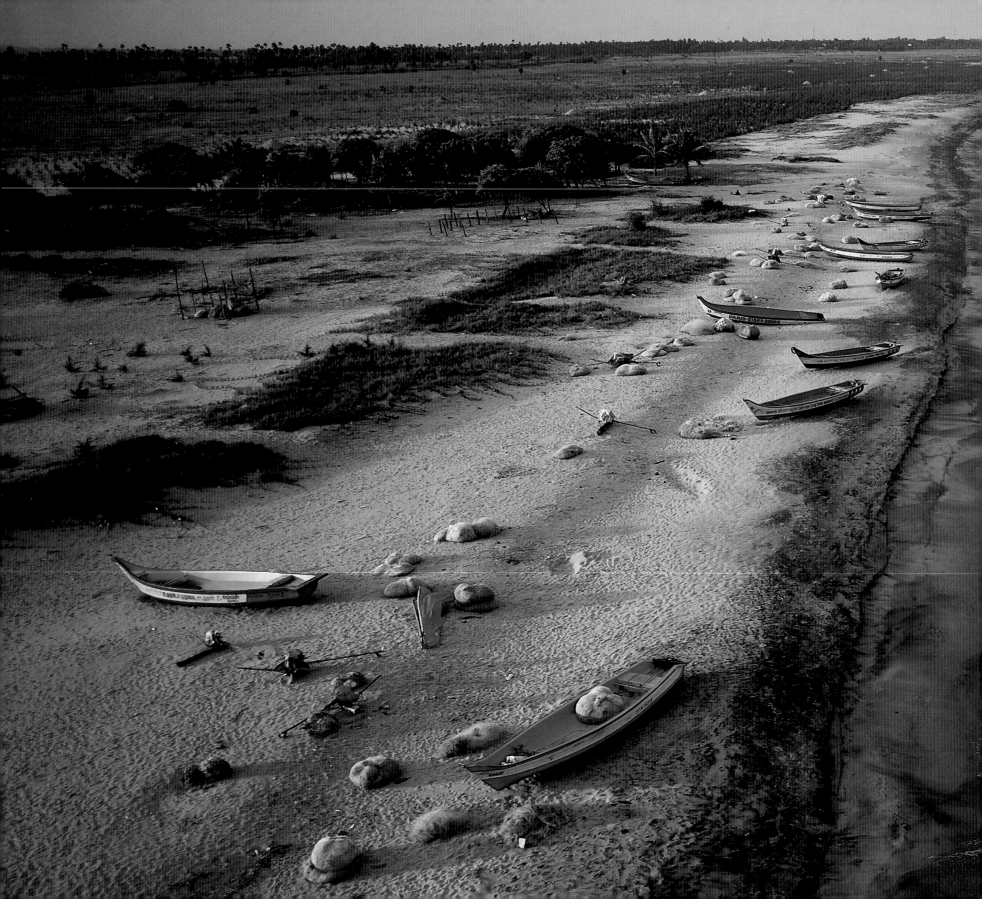

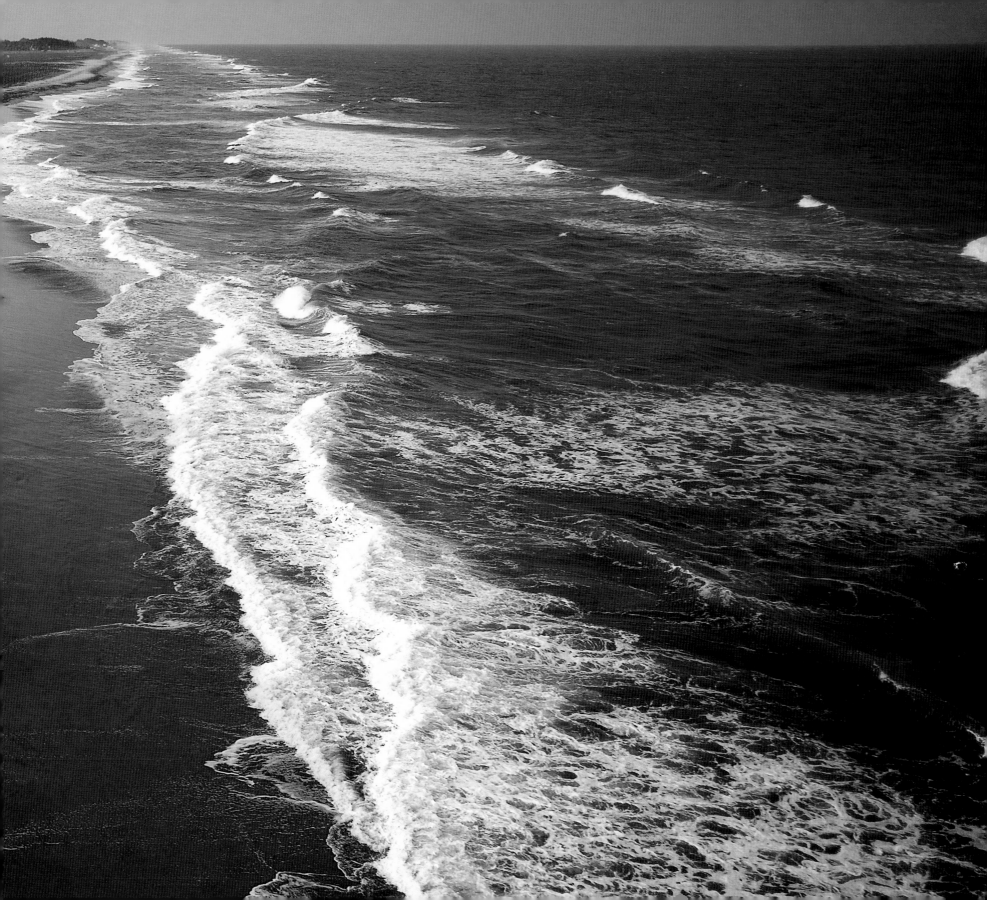

MAMALLAPURAM

Just a two-hour drive from Chennai, the capital of the southern state of Tamil Nadu, Mamallapuram is a World Heritage site famous for its magnificent rock carvings. Built in the seventh century by the Pallava king, Narasimha Varman I, also known as Mamalla (Great Wrestler), Mamallapuram even today has master craftsmen whose sculptures are in demand the world over.

The most famous site in this coastal village is the remarkably well-preserved seventh century Shore Temple, built by Mamalla for Lord Vishnu. Two Shiva shrines were later added to it by Mamalla's successor, Narasimha Varman II.

'Only a small mark, a painted stroke on the first floor facade, can be seen from the last tsunami...The real scar can be seen in the eyes of some fishermen whose villages were on the shore, first obstacles for the wave. But I'm glad to see their smiles, too, when they look up at my kite. I could fly day and night here. The ocean always brings enough wind, heavy, powerful. I like this place.' *Preceding pages, top and facing page:* The long white-sand beach of Mamallapuram adds to its tourist attraction.

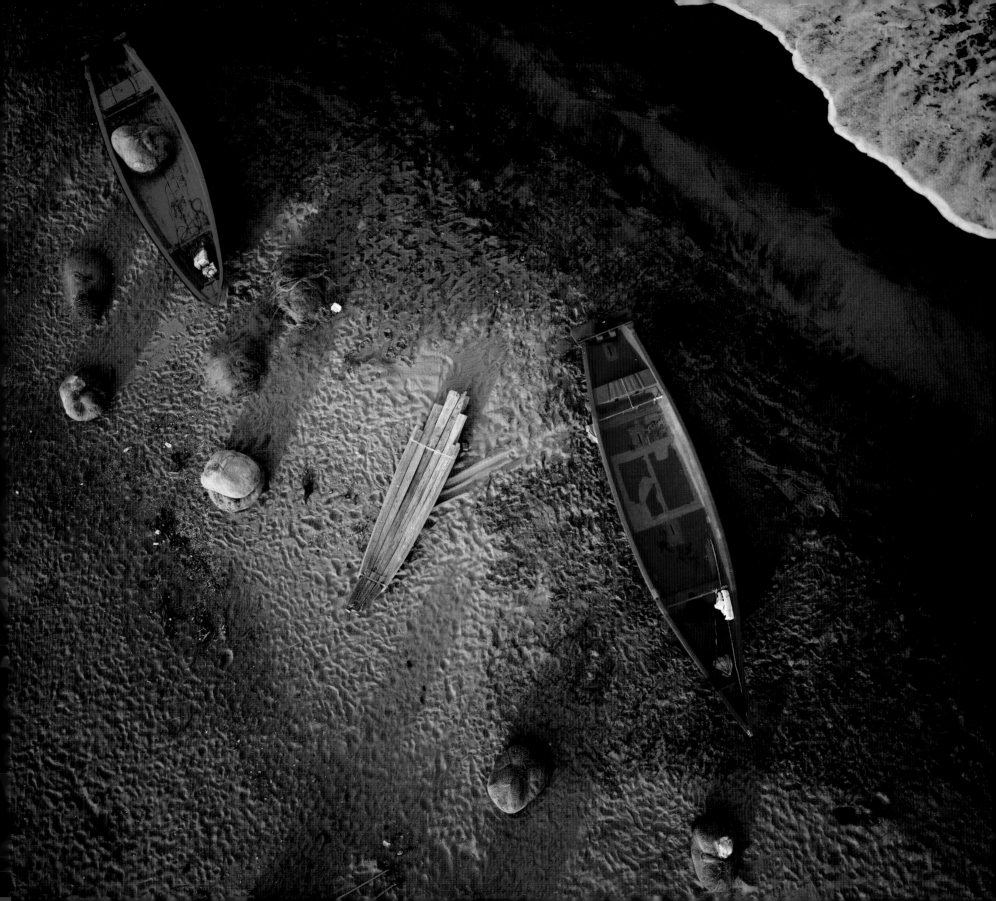

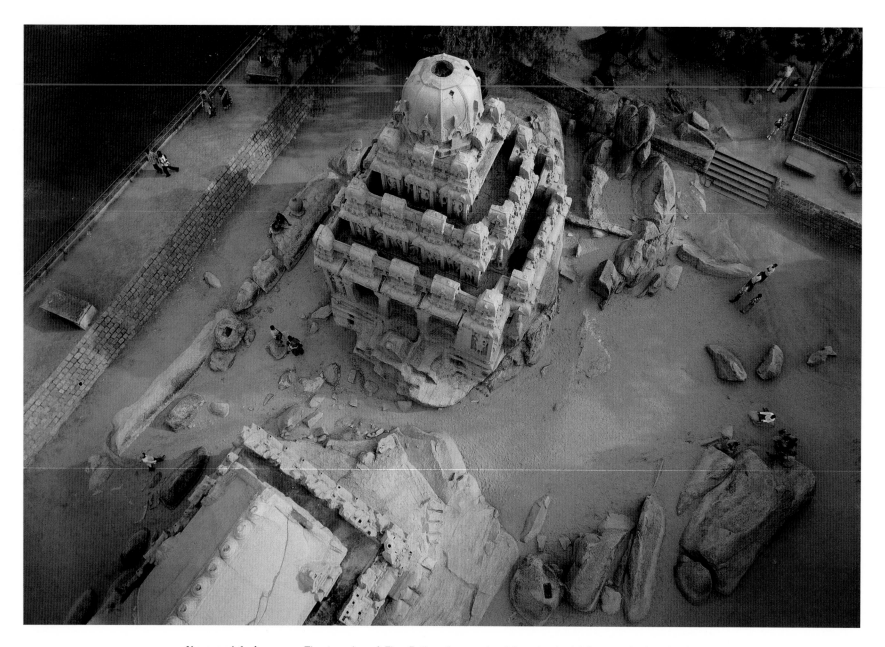

Above and facing page: *The temples of Five Rathas (processional temple chariots), named after the five Pandava brothers (protagonists of the epic* Mahabharata*), and their collective wife Draupadi, are fine examples of Pallava architecture. These temples were hidden in the sand until they were discovered by the British two hundred years ago. Carved in situ, the temples imitate the style and techniques of wooden architecture in stone.*

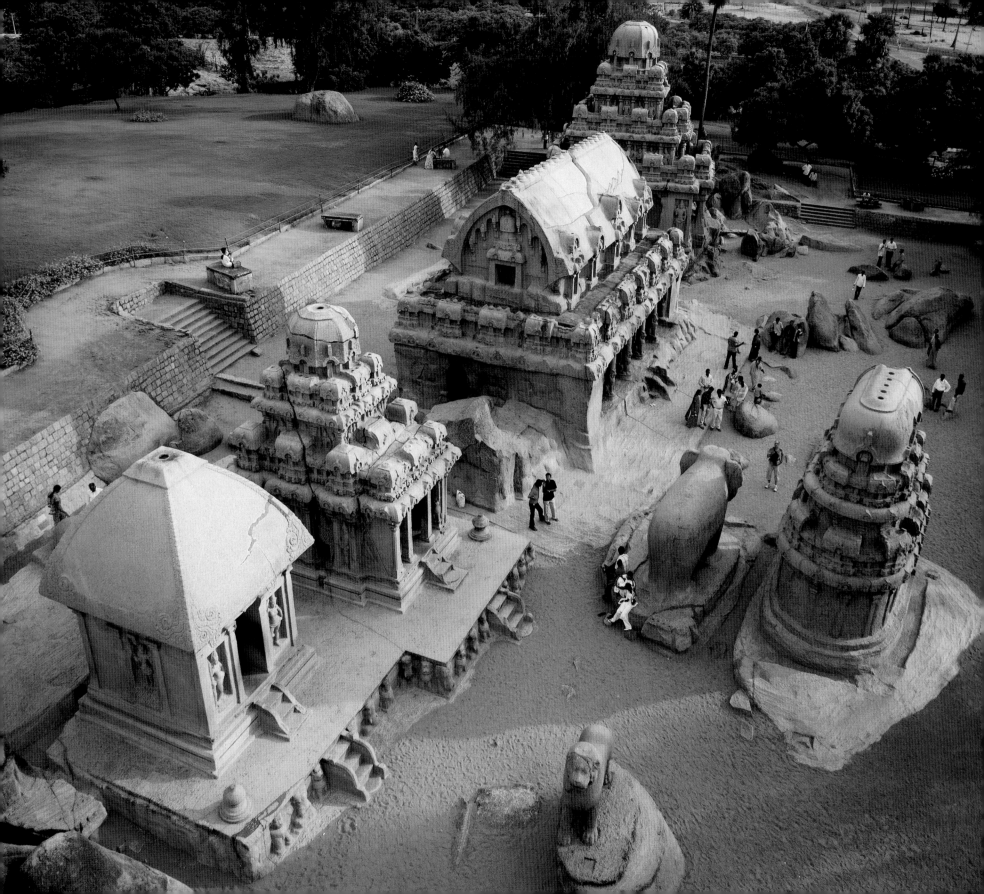

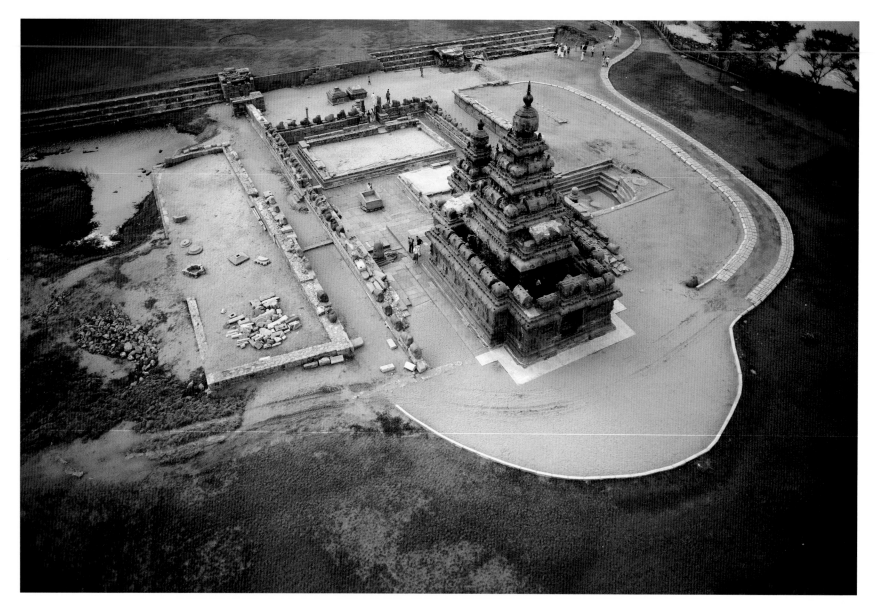

Above: *Dating from the eighth century, the Shore Temple is the earliest stone-built temple in South India. Its carved towers had a major influence on other temples in the region. The temple has a reclining Vishnu, two shrines for Shiva, and seated Nandis (bulls) around its low boundary wall.*
Facing page: *The lighthouse at Mamallapuram.*

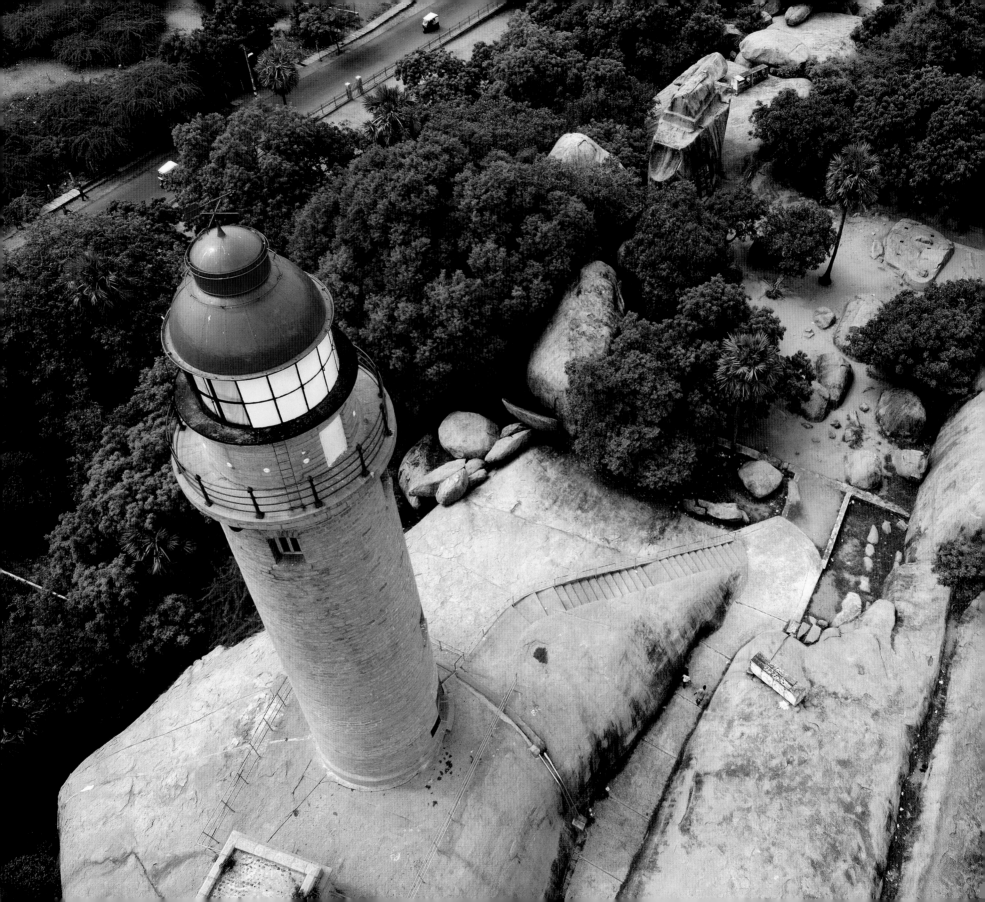

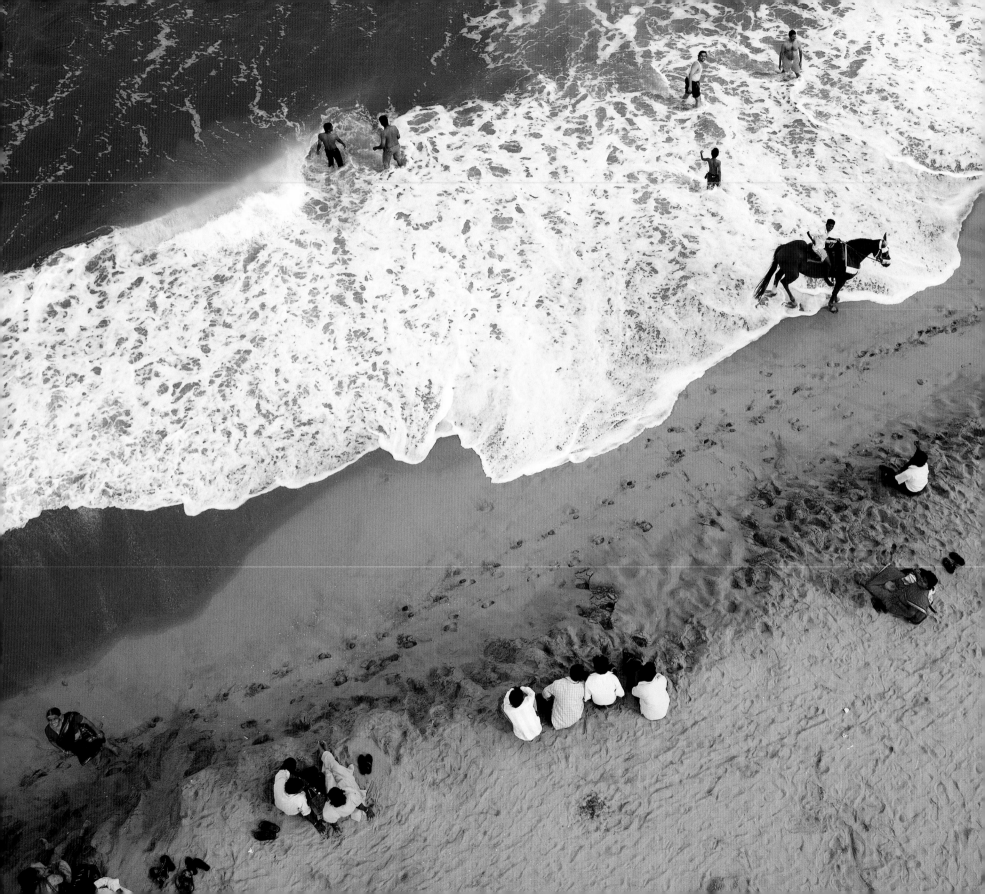

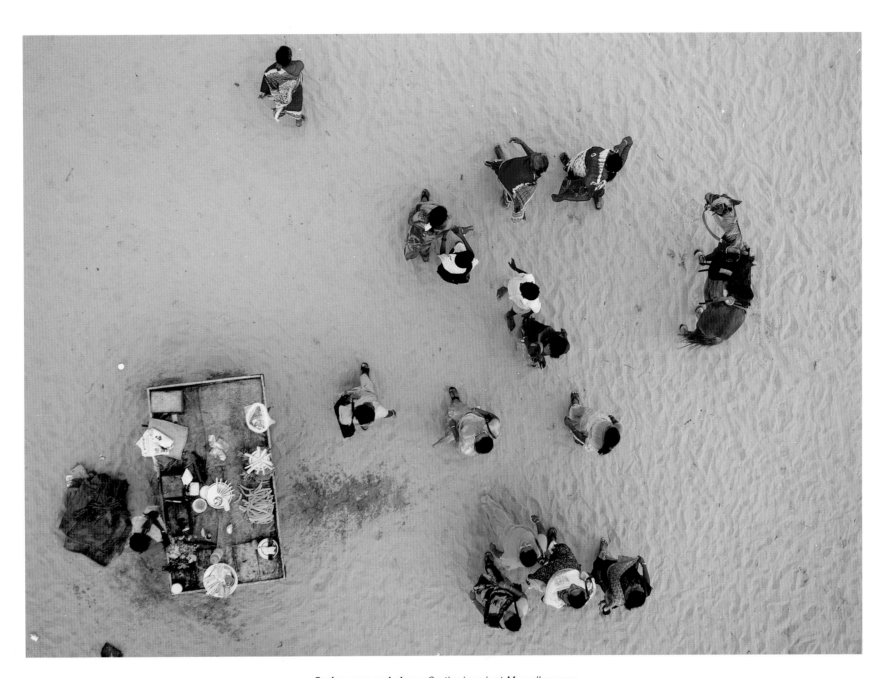

Facing page and above: *On the beach at Mamallapuram.*

HAMPI

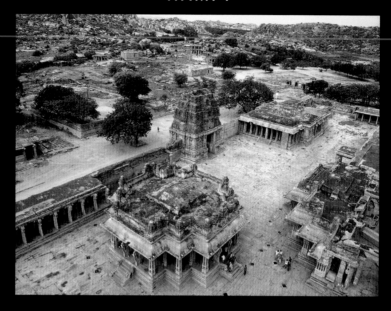

Located on the banks of the Tungabhadra river in the state of Karnataka, the ruined city of Vijaynagar, also known as Hampi, was the most powerful Hindu capital in the Deccan between the fourteenth and sixteenth centuries. A Portuguese traveller, Domingo Paez, who visited the city in 1520, found it to be fabulously prosperous.

The city was at its peak under the reign of Krishnadeva Raya (1510-29) and Achyuta Raya (1529-42). However, its fortunes came to an end when Muslims laid siege to it for six months and then ransacked it in the second half of sixteenth century.

'There is a special atmosphere – peaceful, relaxing – in the ancient city of Hampi. Perhaps it's because of the rocks, which are good for spiritual balance. Time stops here. And when I stroll around the ruins, I only have to close my eyes to imagine squads of elephants with a victorious army passing through the city, with the king riding his ceremony horse for one more victory parade.'

Above: *The Vitthala temple, with slender granite musical pillars which resonate when tapped, is the undisputed high point of Hampi. Dedicated to Vishnu, the temple has a stone chariot with an image of Garuda – its wheels were once capable of turning.*

Facing page: *The soaring Virupaksha temple, dedicated to goddess Pampa and her consort Shiva, is dominated by a 50-metre-high gopura.*

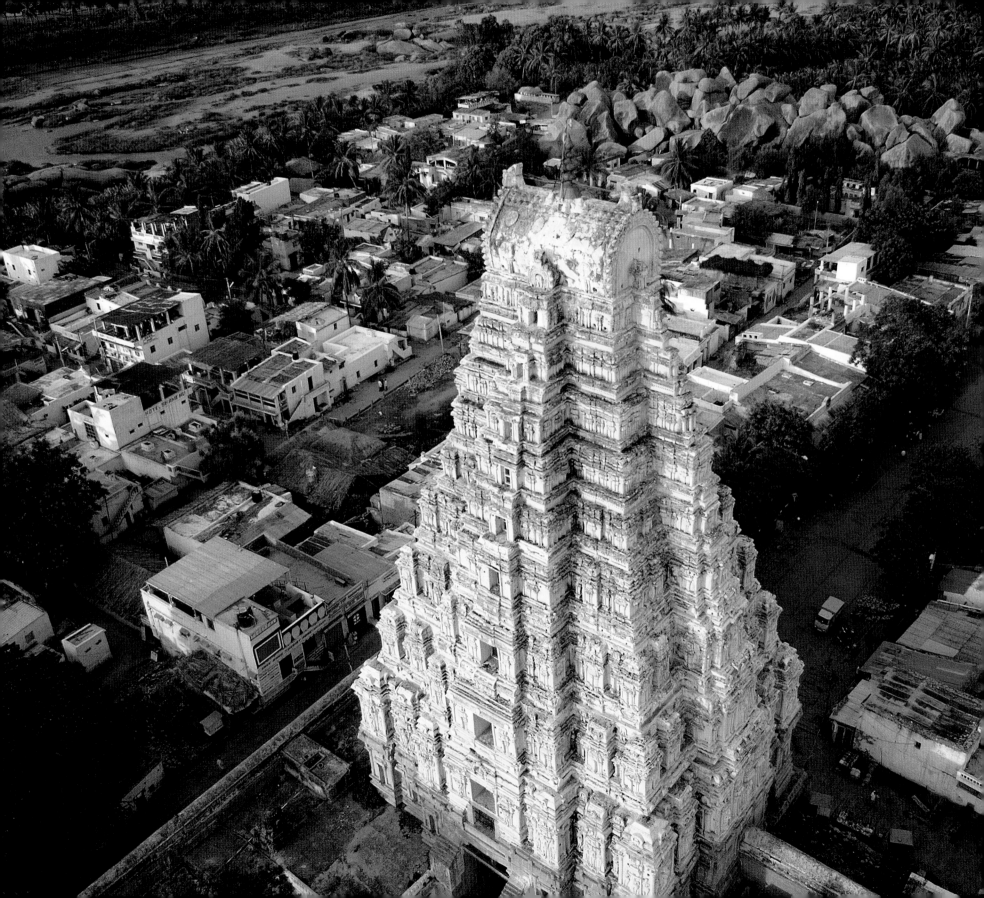

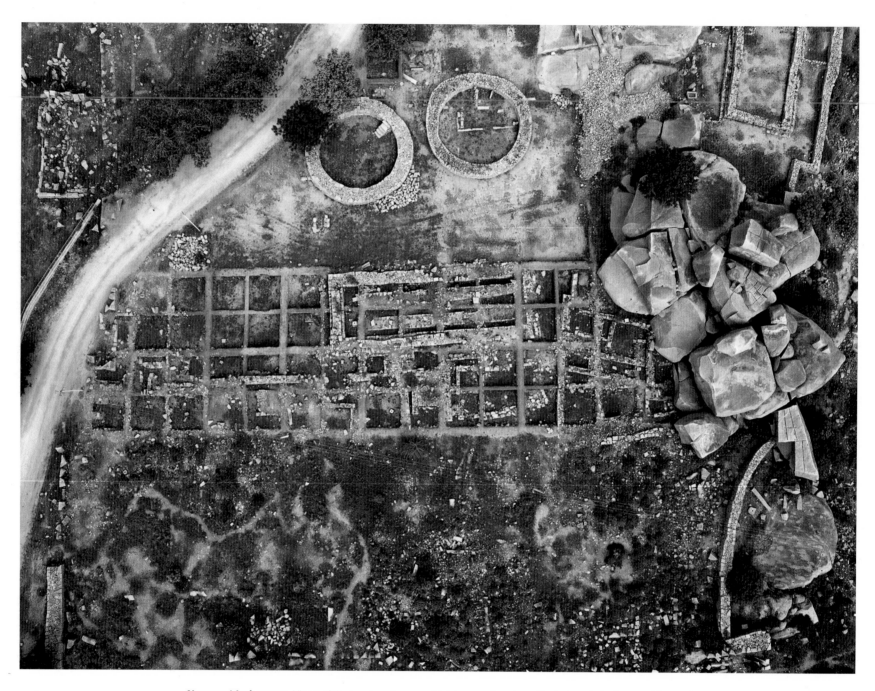

Above and facing page: *Views of the royal enclosure, which houses the elegantly designed elephant stables and the Lotus Mahal, a blend of Hindu and Islamic architecture styles, where the king used to hold his meetings.*

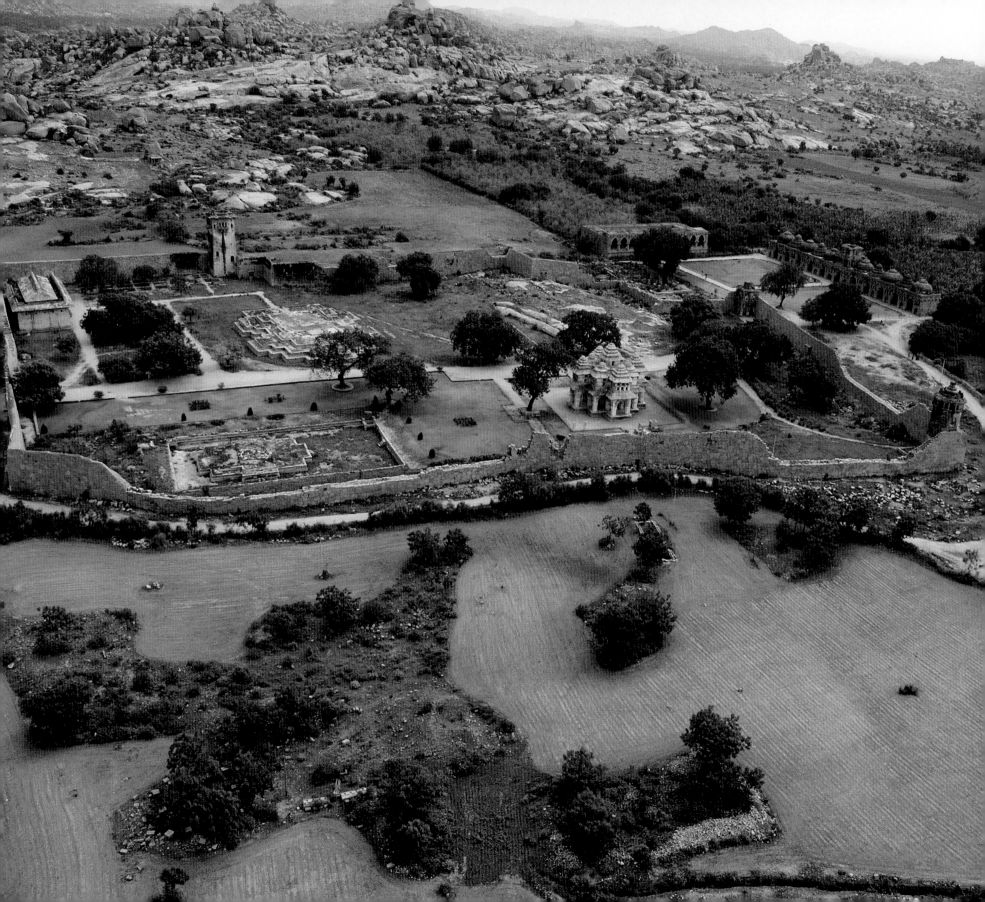

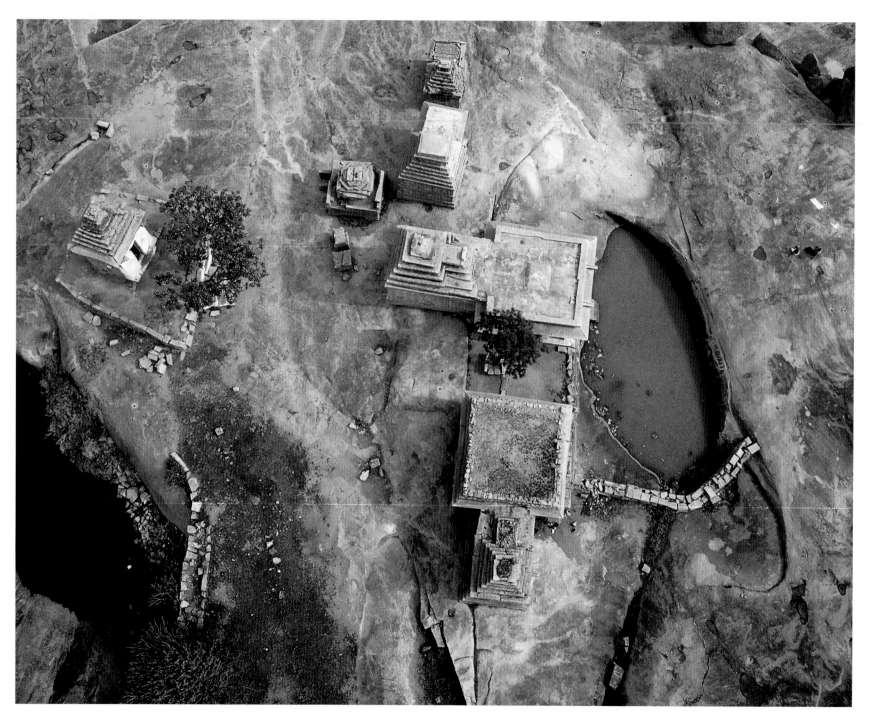

Above and facing page: *Ruins on Hemakuta Hill in Hampi. Dating from the earliest Vijaynagar period, the buildings include some Jain shrines.*

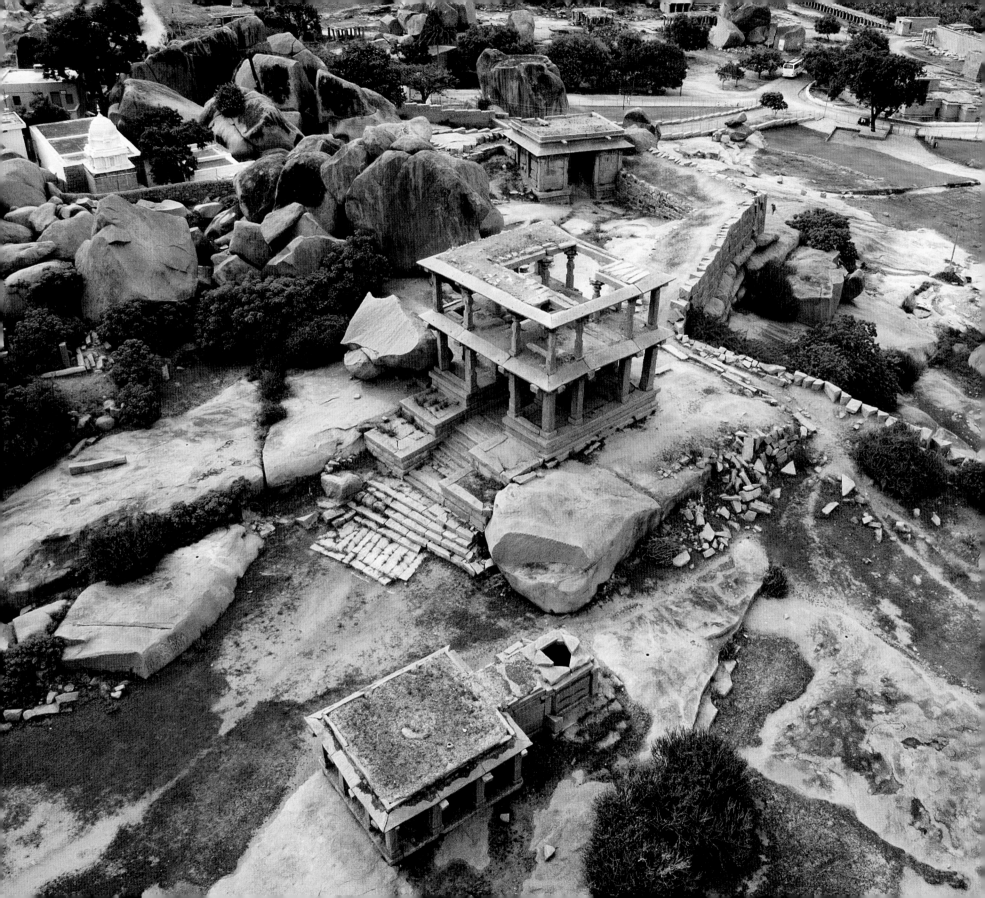

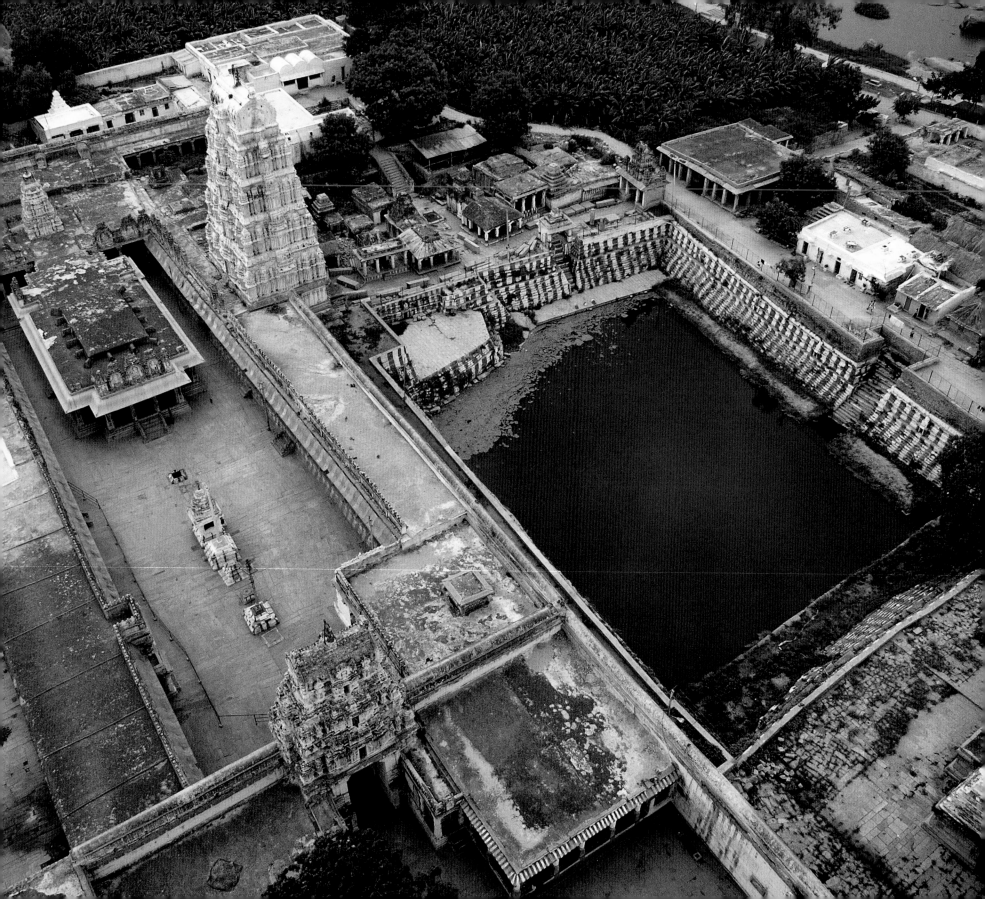

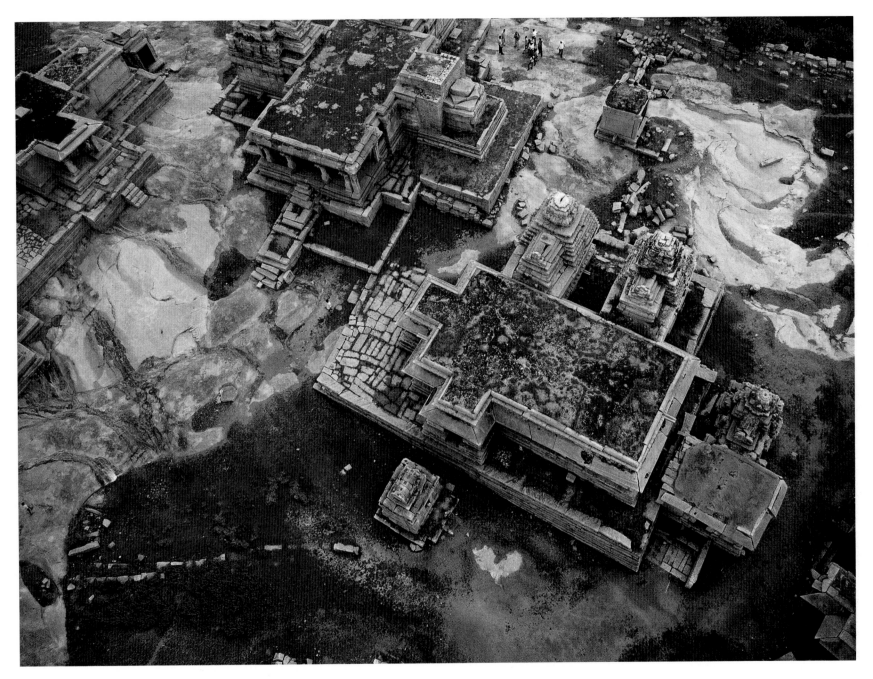

Facing page: *The Virupaksha temple and the area around it.*
Above: *The shrines on Hemakuta Hill.*

149

KERALA

Beaches and backwaters, paddy fields and coconut trees, hill stations and tea estates, boat races and martial arts, Ayurveda and wellness spas – Kerala has it all in good measure. Located between the Arabian Sea and the forests of the Western Ghats, the lush landscape of Kerala stretches for 550 km along India's southwest coast.

The richness of Kerala has attracted the outside world for centuries. With the arrival of a Portuguese fleet under Vasco Da Gama in 1498, direct trade between Kerala and Europe began. Rival powers Holland and France later entered the fray – and Kerala became the hub of trade in opium, sugar, coffee, silk, and weapons. This attracted the British East India Company, which captured the Malabar region. Tipu Sultan drove the British out in 1782 but was defeated ten years later, and the British continued to hold sway in Kerala right till India's independence in 1947.

Above and facing page: 'I feel like I am spending some days in a picture postcard. Nothing is missing. Exoticism, fishing activities, fantastic waves, perfect temperature, smiles and happiness, good music, yoga and comfort. It seems like Kovalam has found a true balance as regards tourism. There is no risk that something will ruin the scene. A few additions may come soon in the landscape, but the beauty of the place will always speak for itself.' Situated 16 km from Kerala's capital, Thiruvananthapuram, Kovalam was once popular with hippies and backpackers, but today attracts the rich western tourist as well.

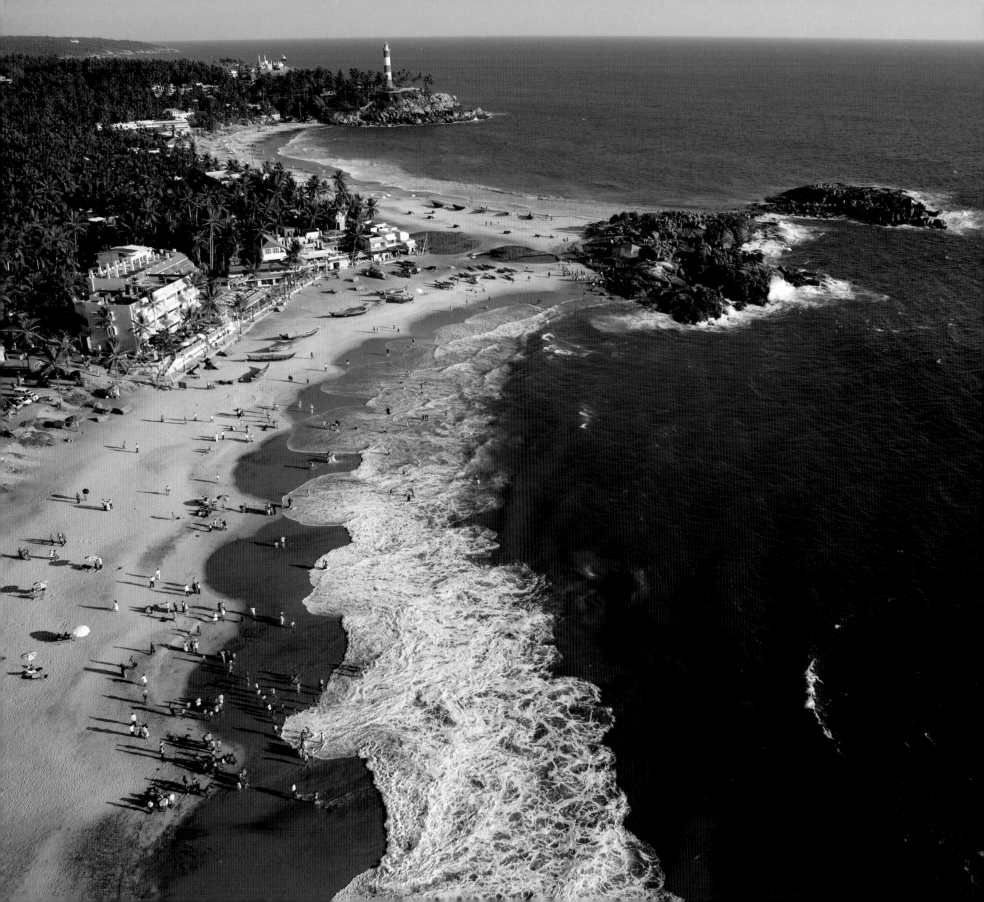

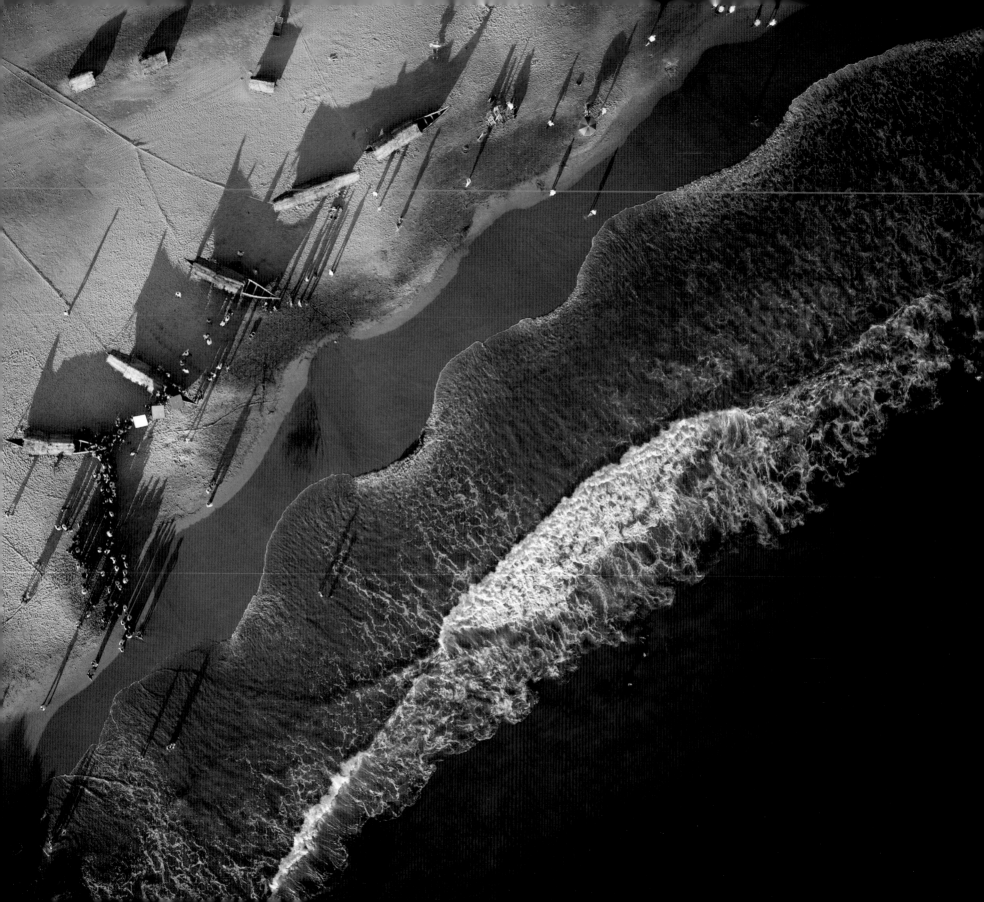

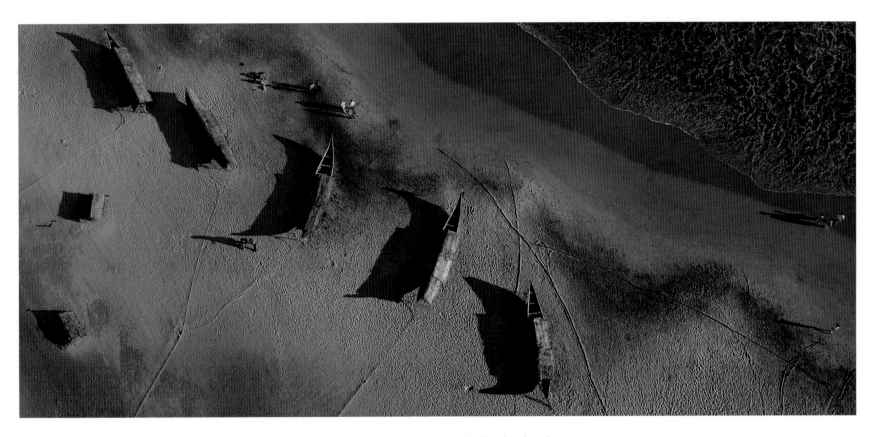

Above: *Fishermen's boats on the Kovalam beach.*
Facing page: *A Bollywood film being shot on the Kovalam beach.*

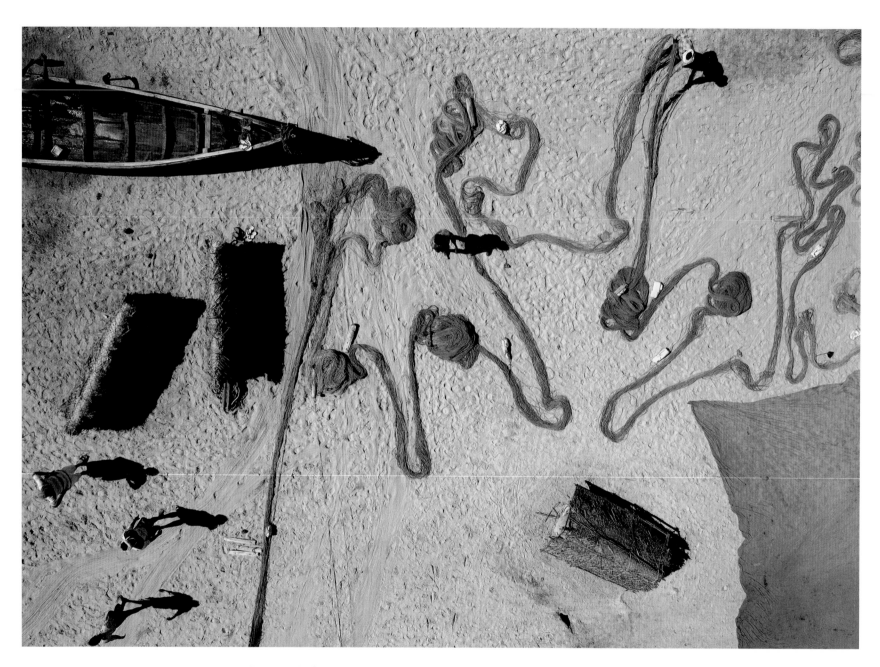

Above and facing page: *Fishermen preparing for their day's work in Kovalam.*

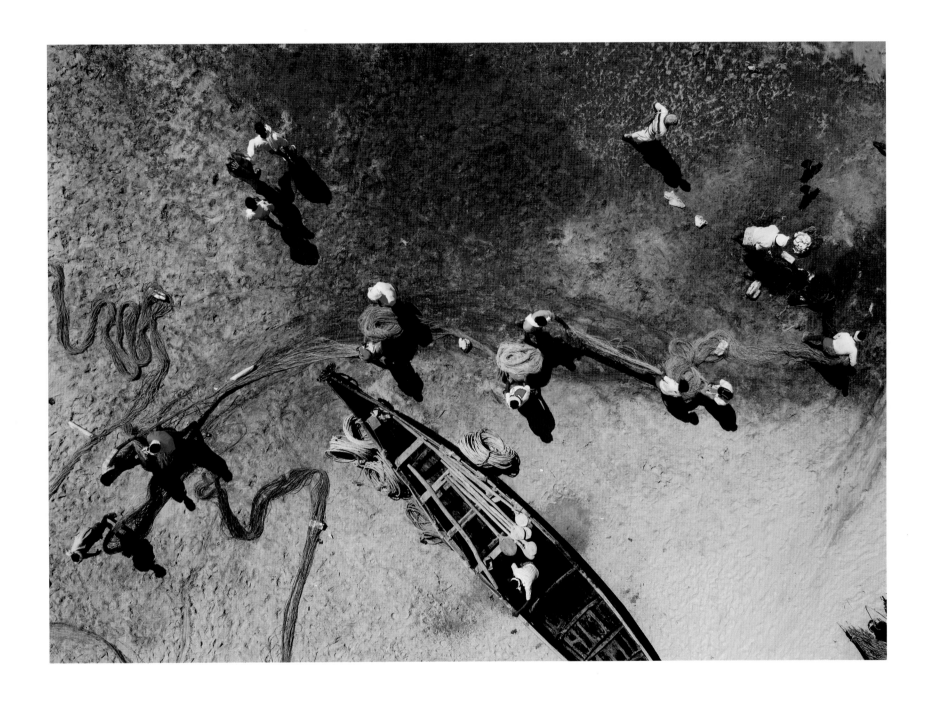

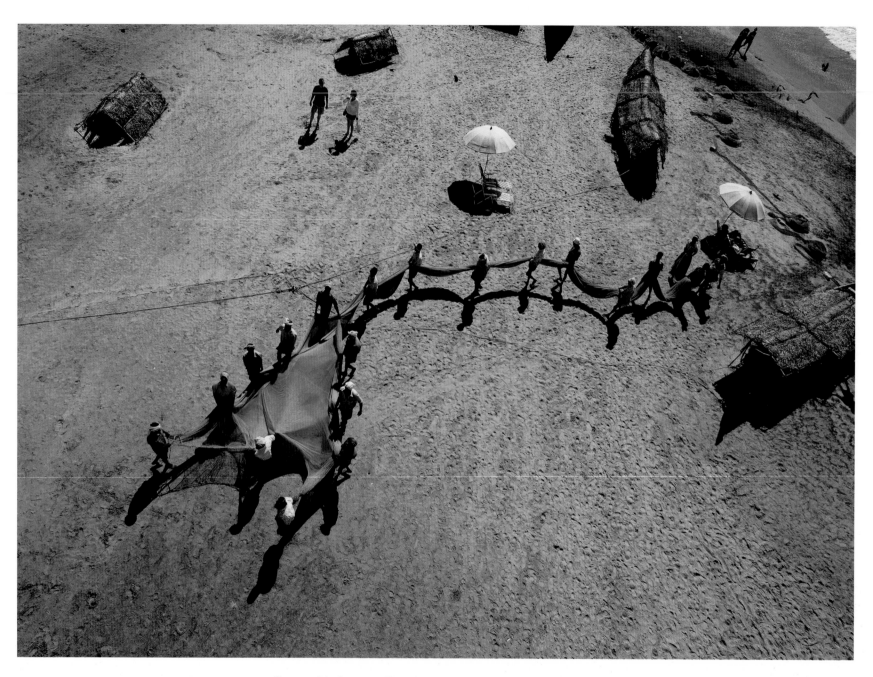

Above and facing page: *Fishermen drying their nets in Kovalam.*

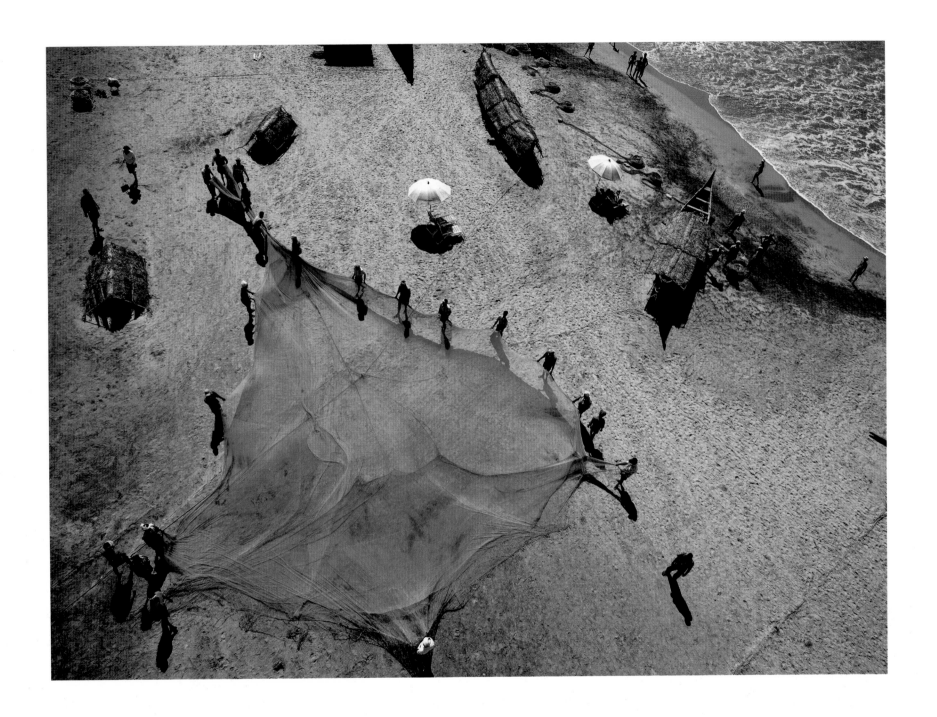

Above and right: *Local people enjoying the beach at Kovalam.*

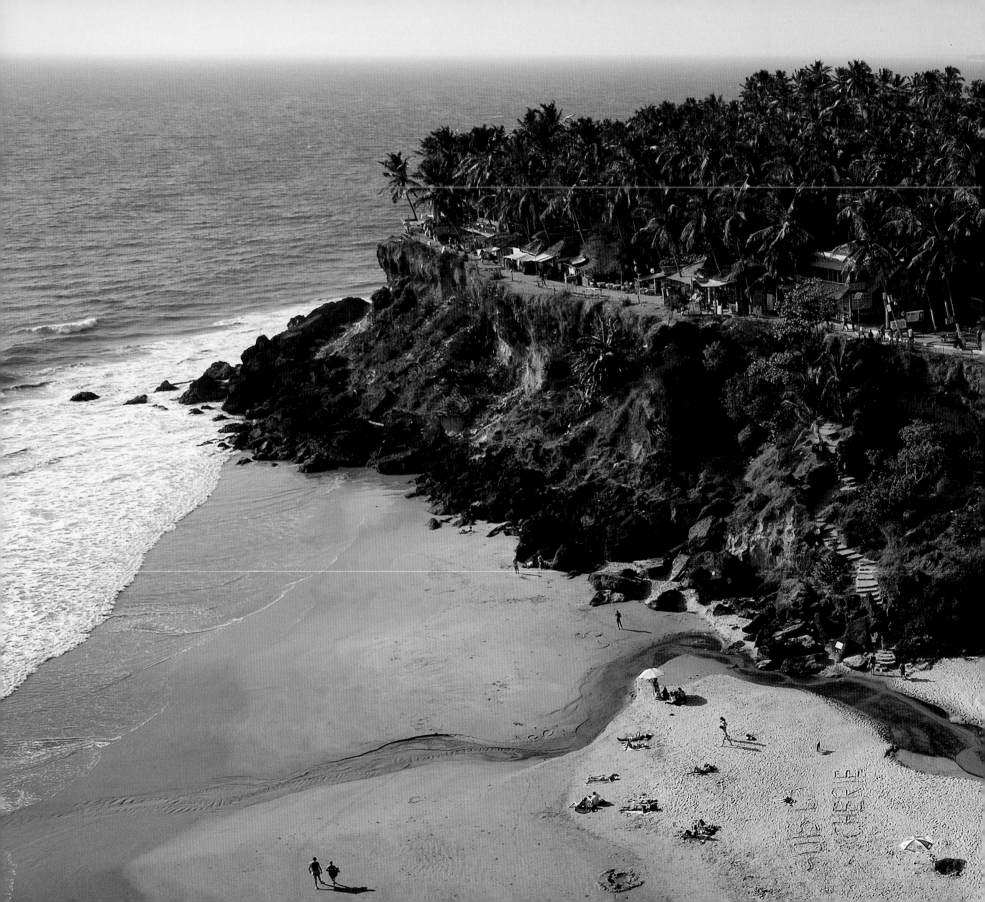

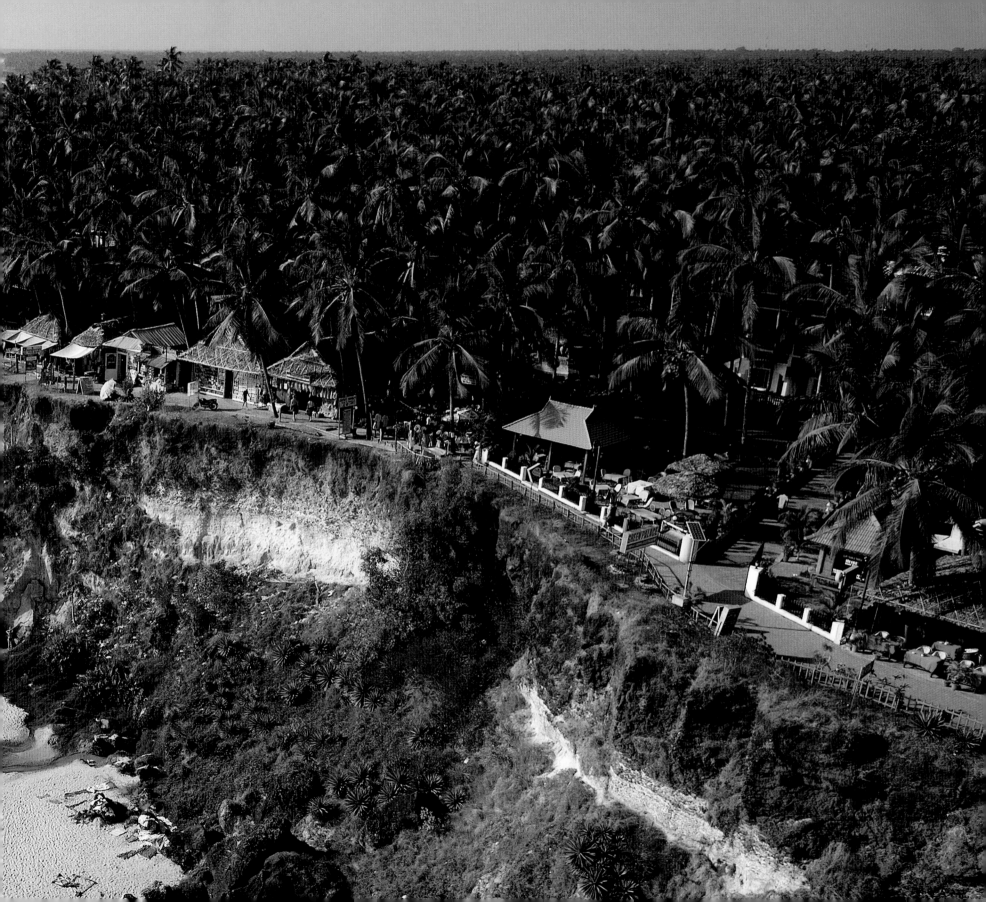

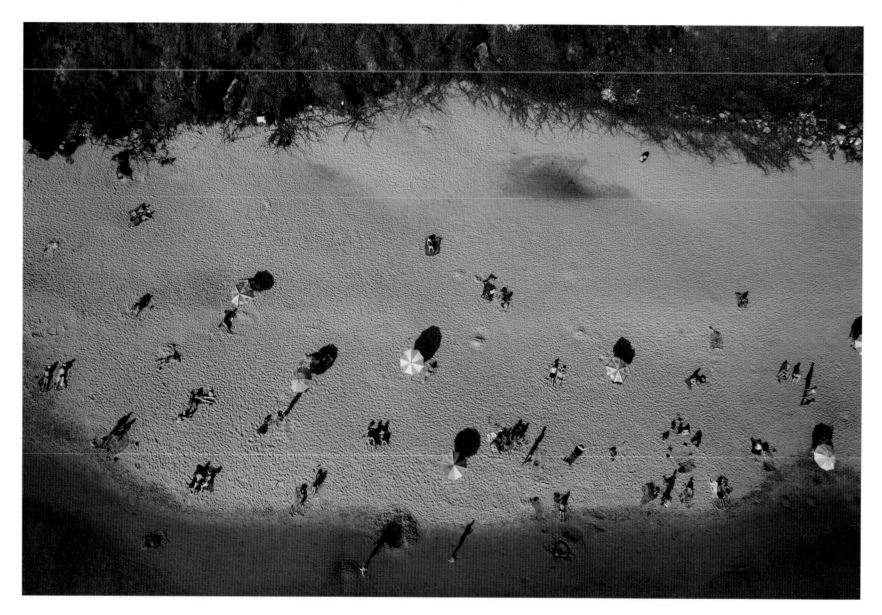

Preceding pages, above and facing page: 'I like the mix at Varkala beach, the way both worshipping Hindus and foreign tourists use and share the space. Both are curious about each other, like in a reciprocal show. While I walk along the shore with my flying kite, I feel like I am playing the third performer today...' Situated 40 km from Thiruvananthapuram, Varkala is a pilgrimage town associated with ancestor worship – Hindus come here to immerse the ashes of the dead. Peaceful and laidback, it's a safe, secluded place for the low-budget traveller.

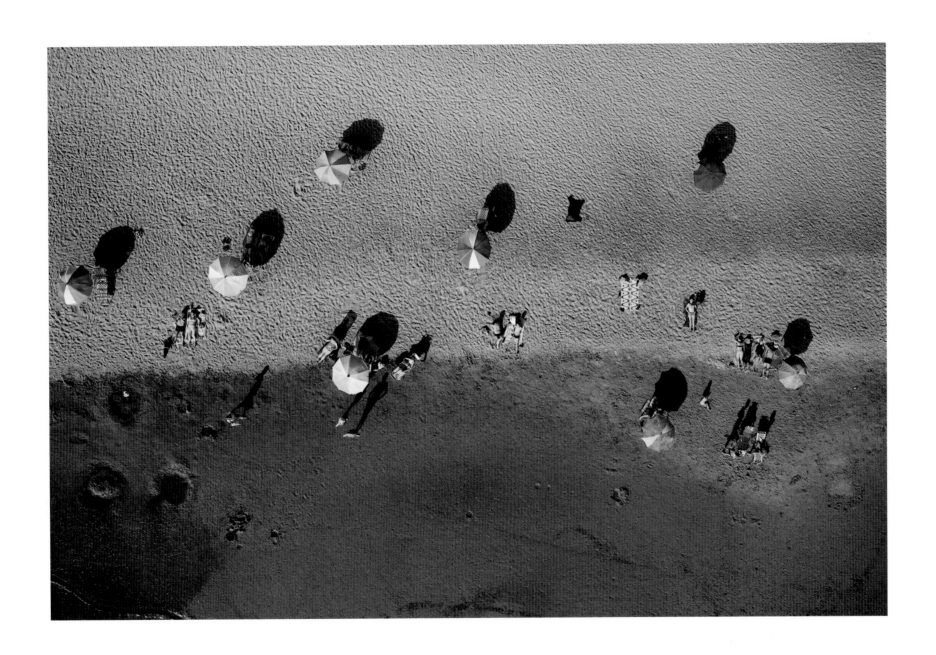

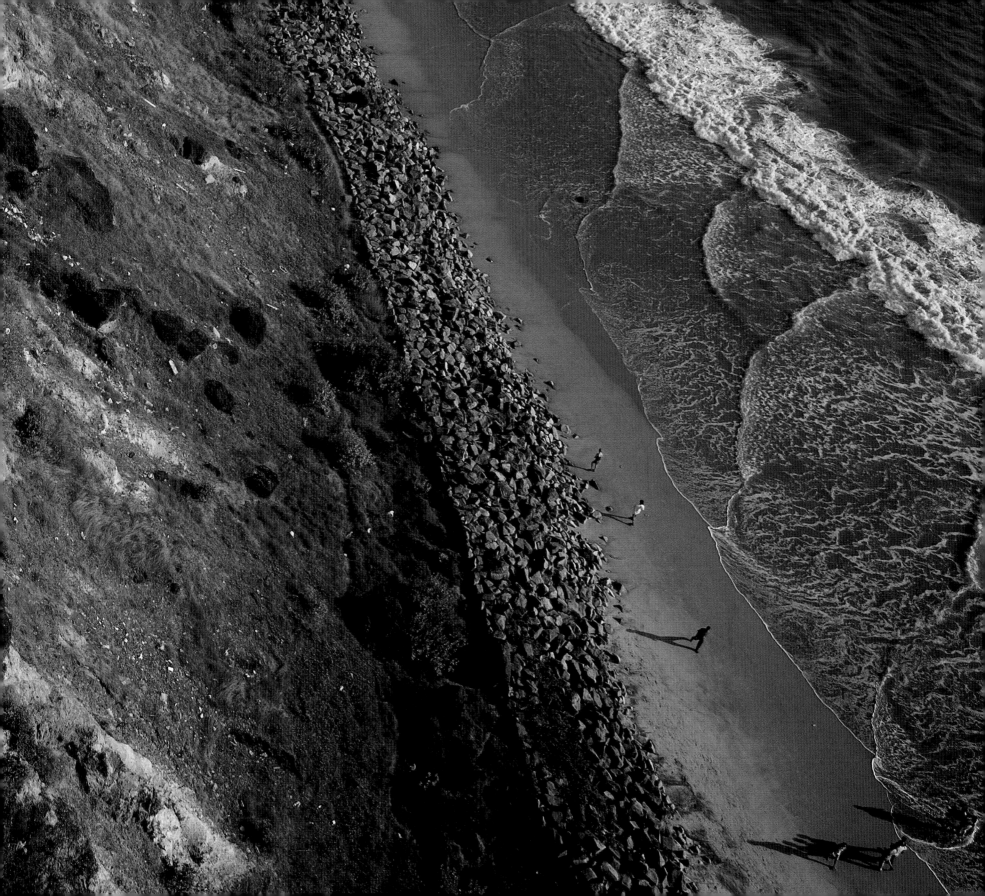

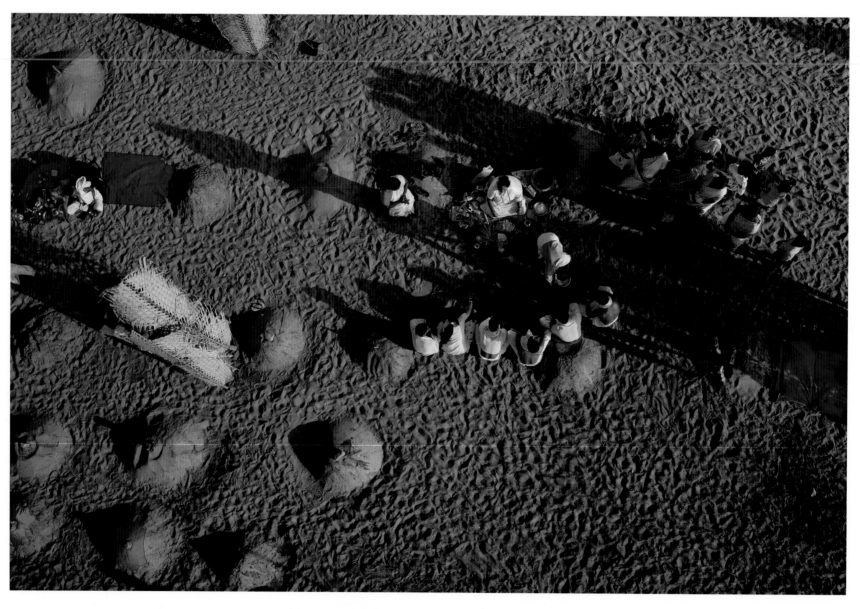

Preceding pages: *A new resort on a cliff in Varkala.*
Above and facing page: *Hindus performing a ritual before immersing the ashes of the departed one.*

166

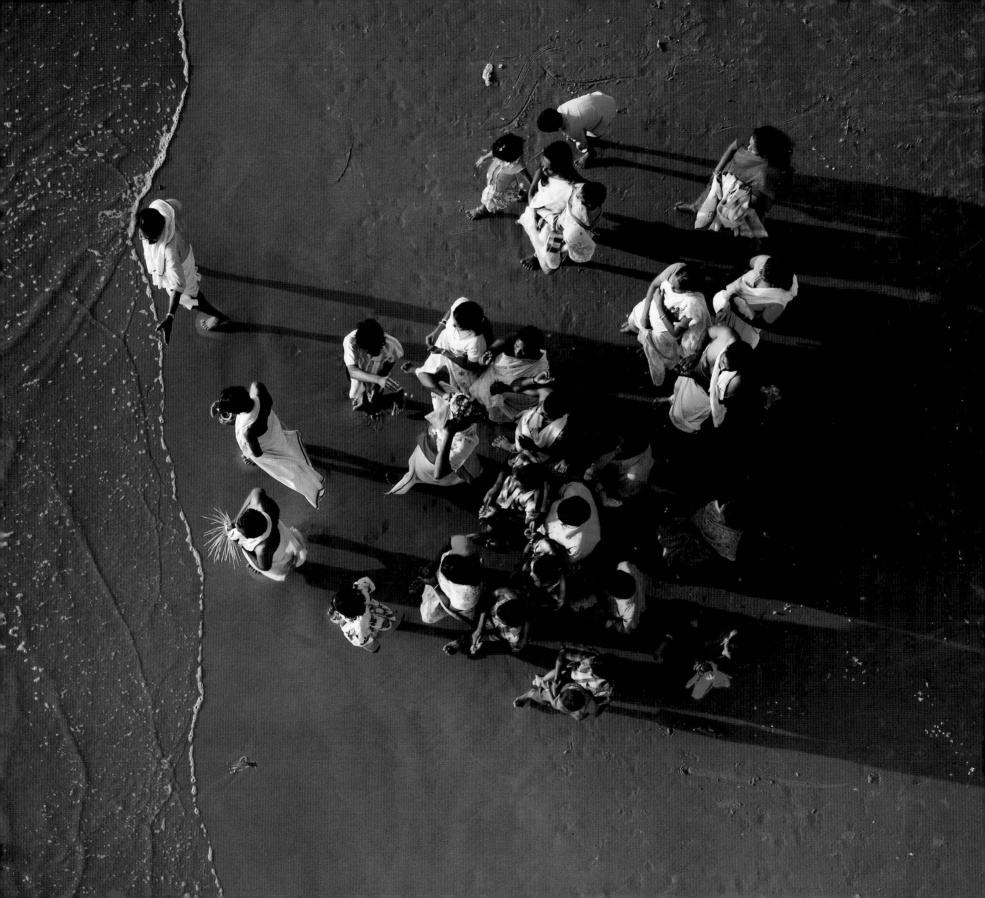

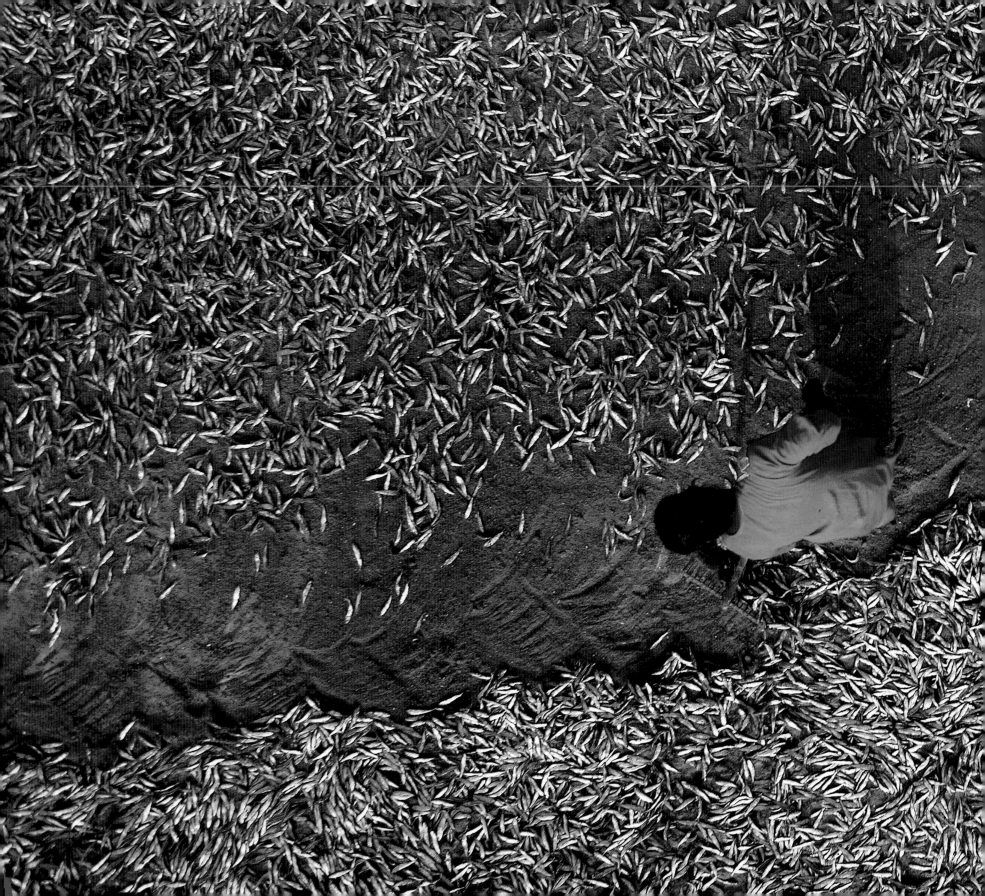

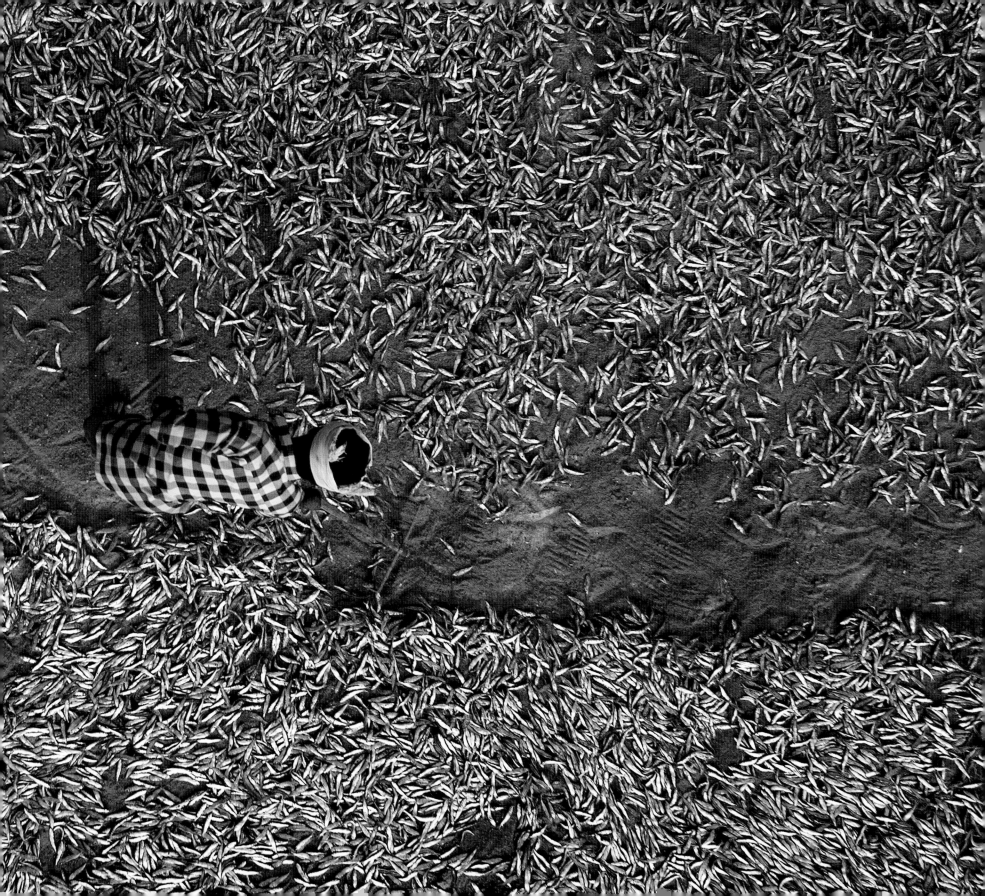

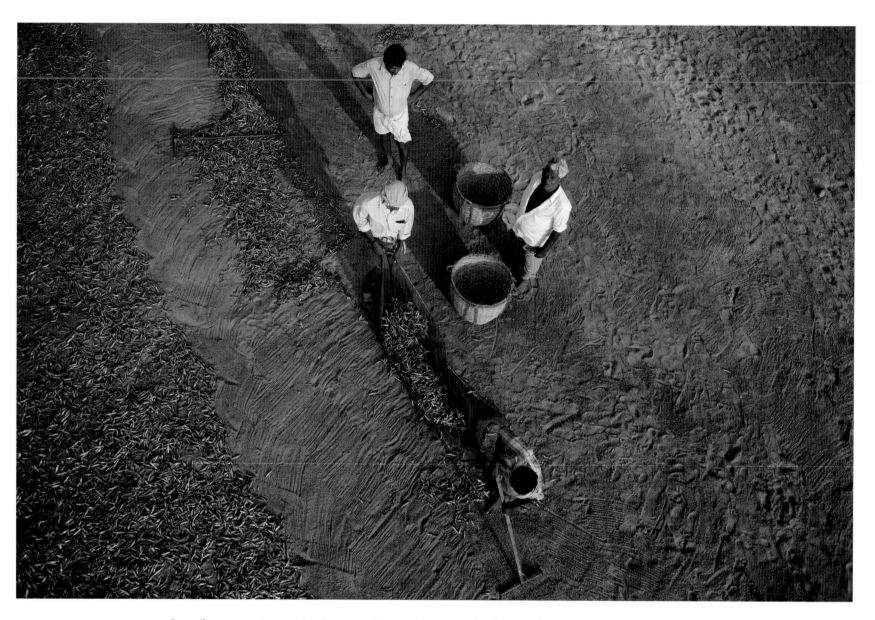

Preceding pages, above and facing page: 'The sea is generous for fishermen in Kozhikode (Calicut). And it is a paradise for seagulls – the sardines drying in the sun are a banquet for them. But my kite scares them and they all fly away... Maybe the fishermen will get inspired by this, and build a flying scarecrow!' *The communities of fishermen in the area come from all religions – there are Hindus, Muslims as well as Christians. At times they catch excess fish which remains unsold, and which they then dry on the beach to sell later during the rainy season.*

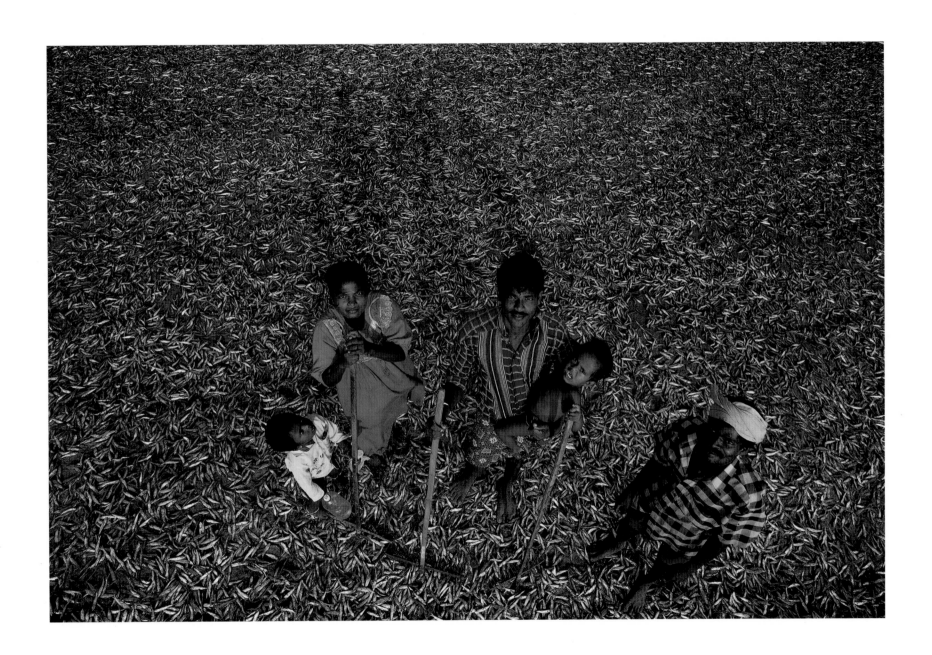

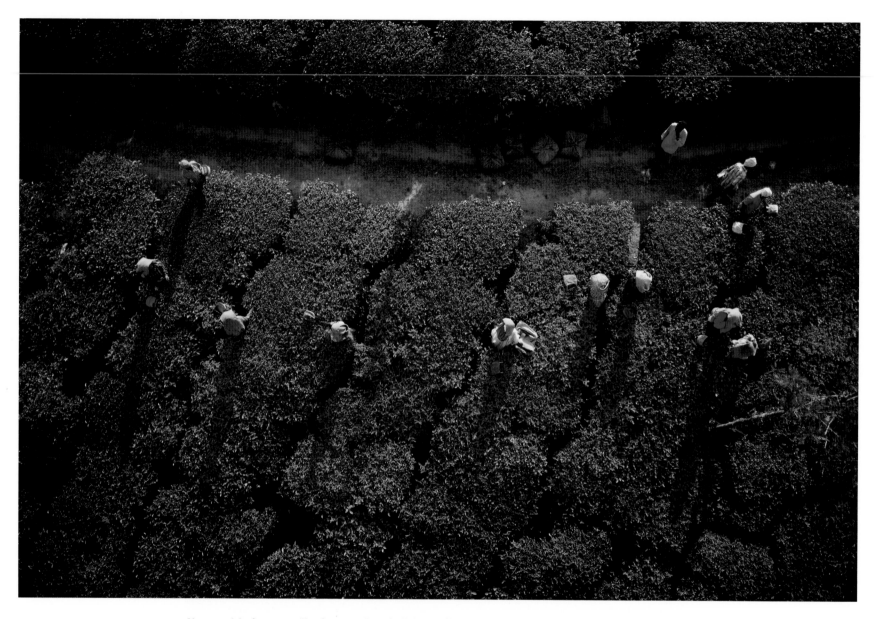

Above and facing page: 'Tea is everywhere in Kalpetta, like a beautiful green carpet coating the topography. When I ask if they use any pesticide, the estate manager laughs and says, "We can't afford it! But thank God, we haven't had any insect problem for years!"' *Kalpetta in Kerala's Wayanad district was once a major Jain centre. The tea produced here is usually taken to north India to be blended with Assam tea.*

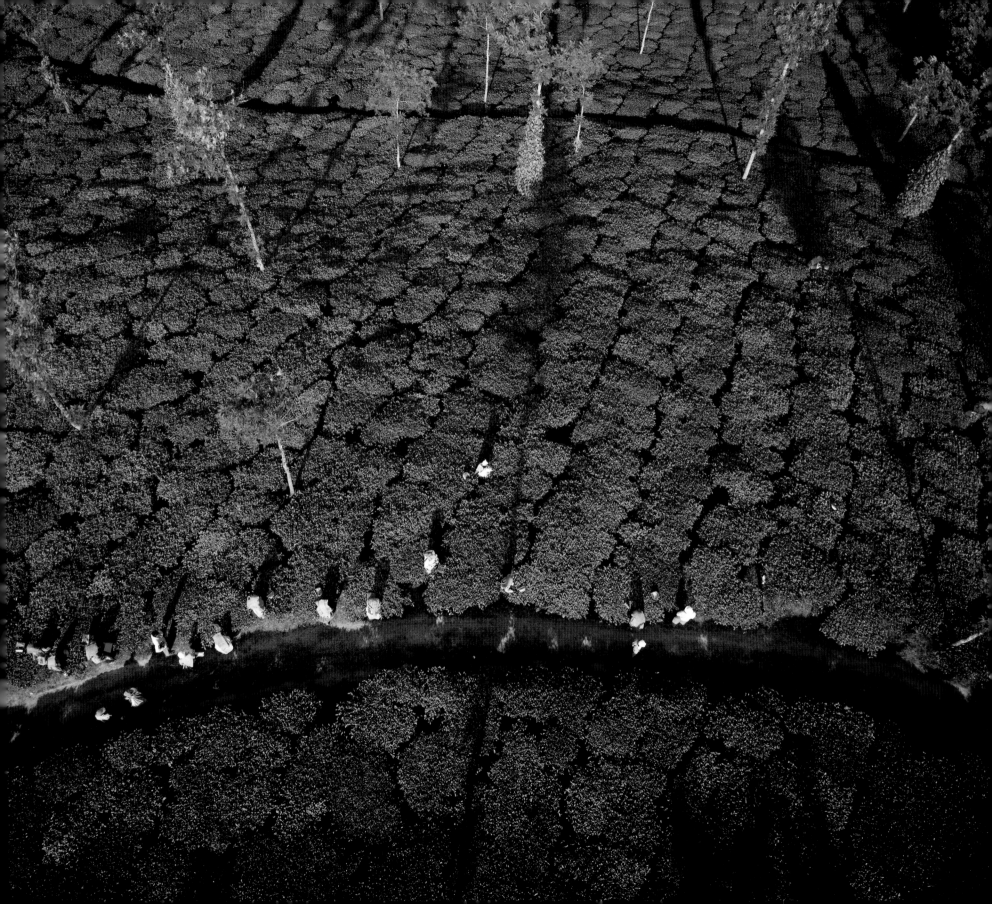

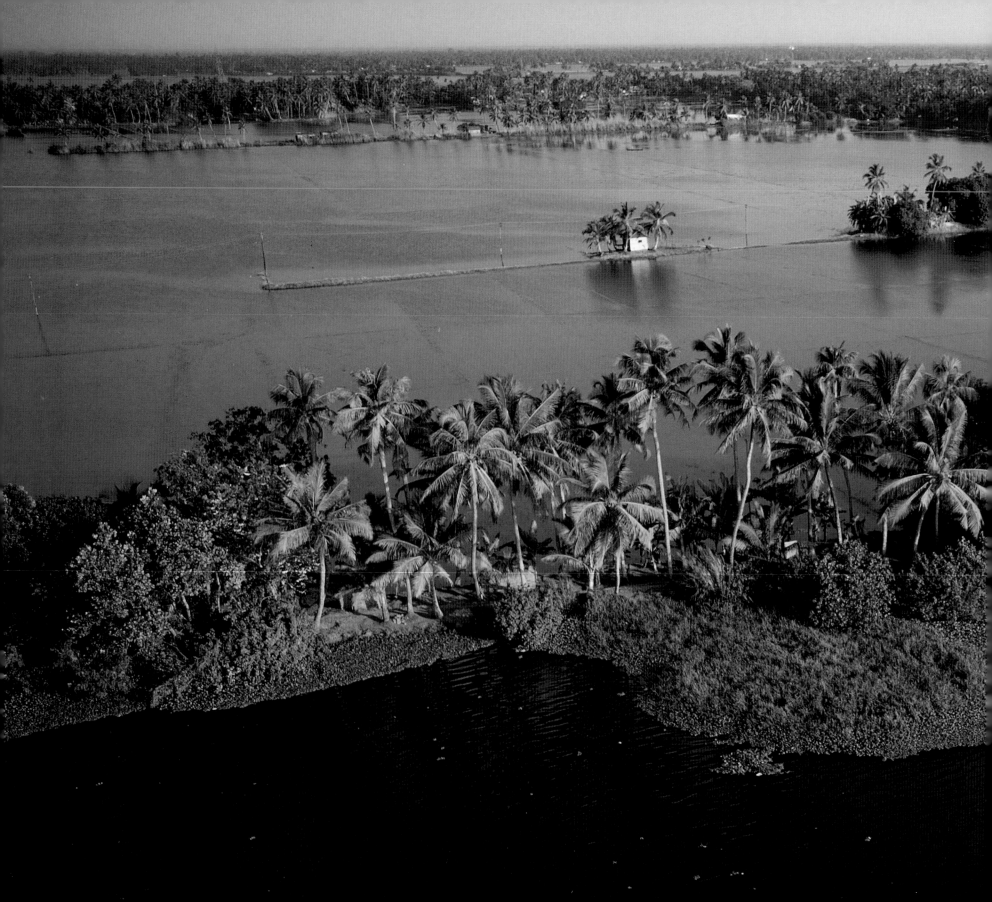

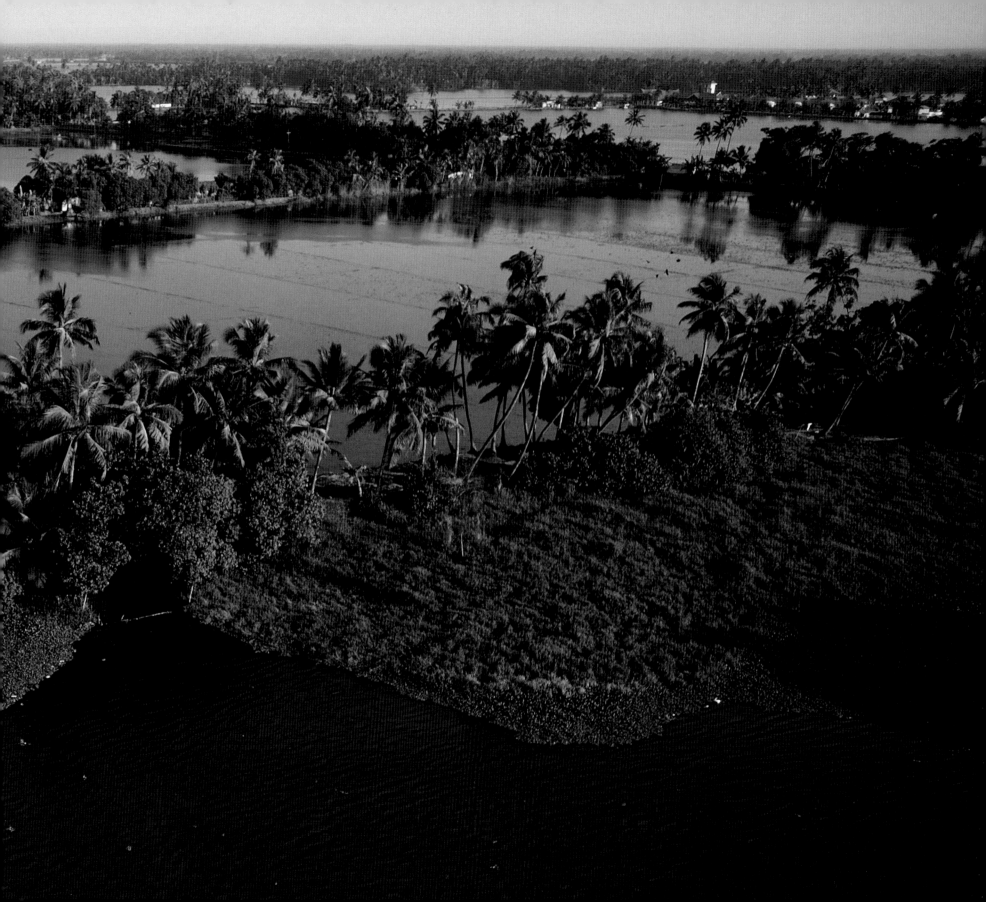

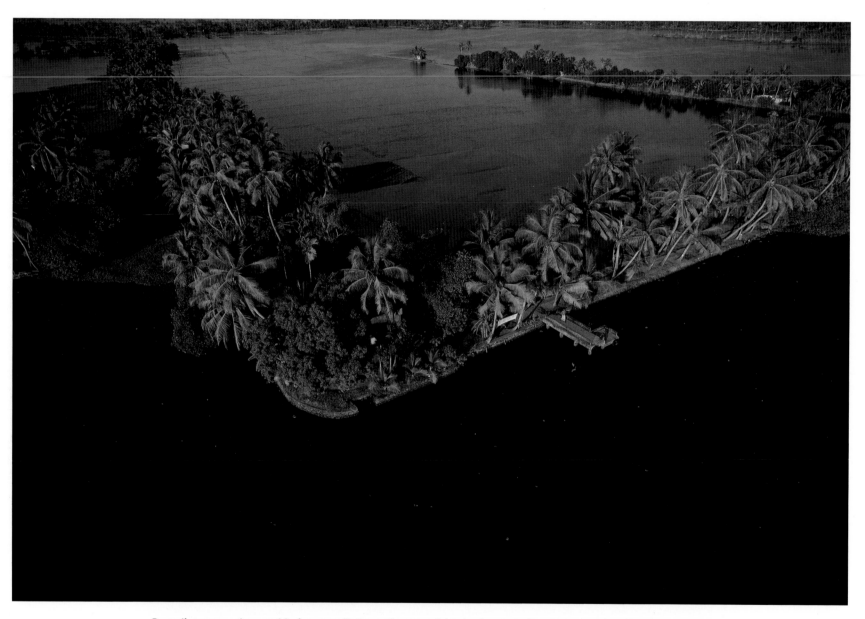

Preceding pages, above and facing page: 'Between the sea and the sky, for generations, three communities have interacted and shared the space in Alleppy. The fishermen, the coconut climbers and the farmers live off the resources of this amazing environment. After boating for a while, I wonder if the water is on the land, or the land is in the water. One can't go without the other. When I land on a bank, am I on an island surrounded by the sea? Or am I on a mainland with a lake? It's easy to get lost in the labyrinth of canals… and it's magic.' Once one of the best known ports along the Malabar coast, Alleppey (now called Alappuzha) is a town of interconnected canals, and a major centre from which to explore Kerala's backwaters.

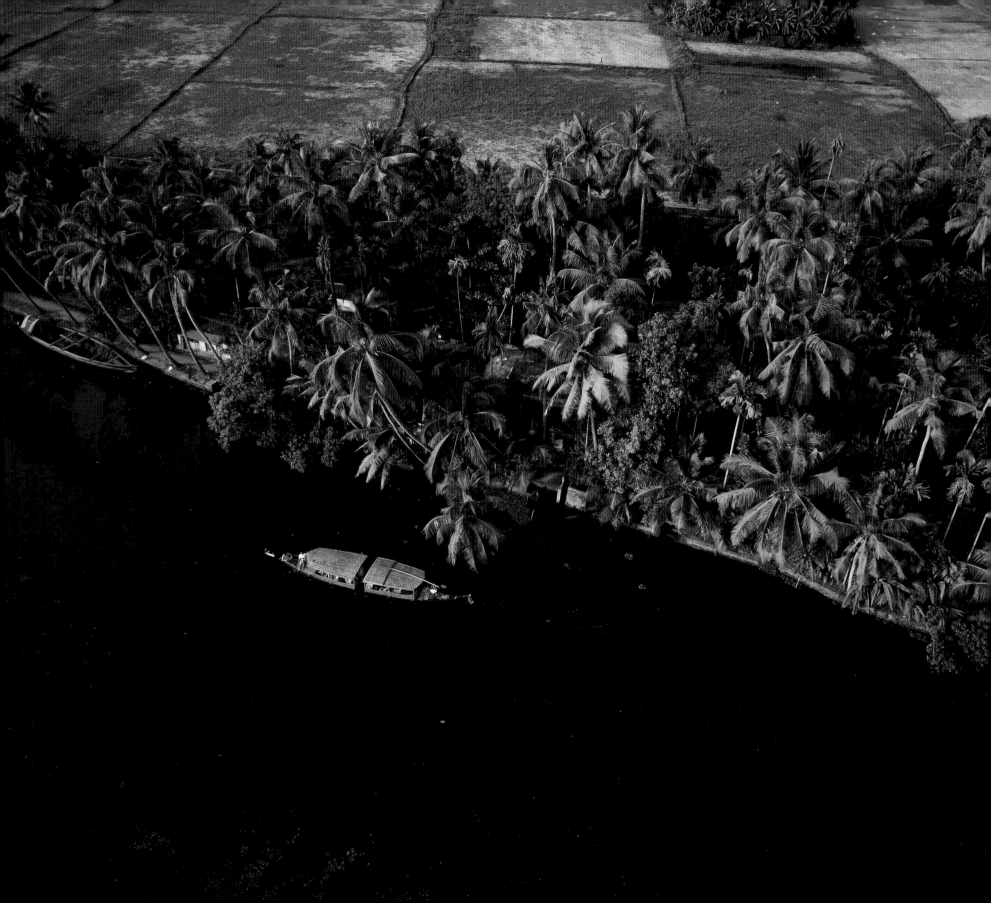

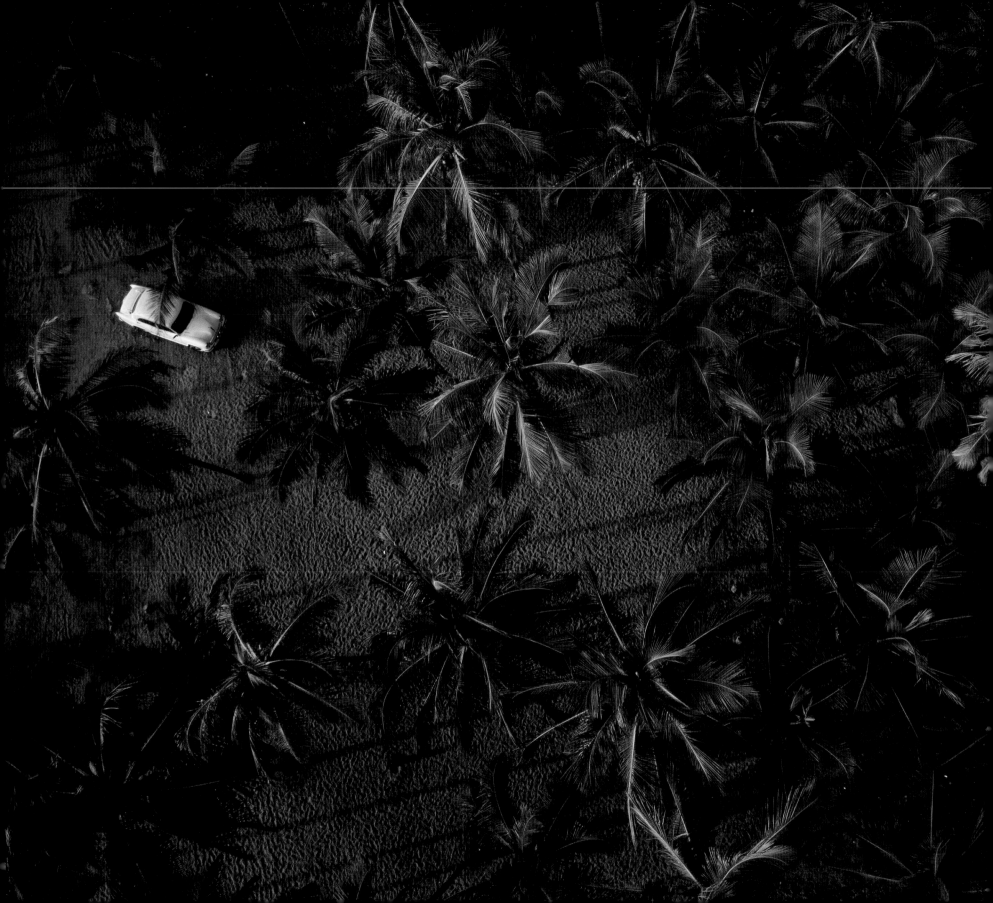

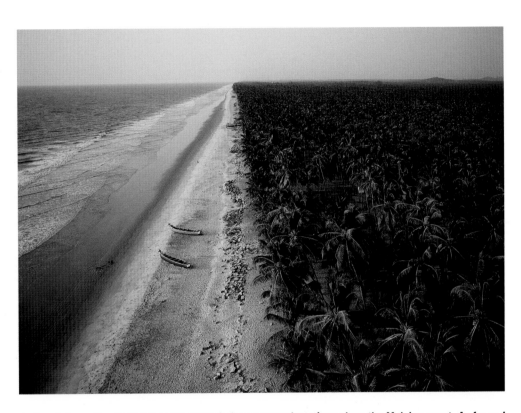

Left and above: 'I walk to the beach through the coconut plantations along the Malabar coast. As far as I can see, there are fishermen's houses, small villages under the trees. It's quiet, no mechanical noise, no engine spewing out black smoke. Only a carpenter's hammer sounding on a boat's hull, bird whistles, kids squabbling, big waves breaking 100 feet ahead. It smells of fish and iodine. Let's fly the kite and see what it looks like from above!' *The coconut came to the Kerala coast during the tenth and eleventh centuries, when a large number of people from Tamil Nadu left their land in search of better prospects and settled in Kerala, after spending some time in Ceylon. The trees grow very well along the sea coast and also along the river sides.*

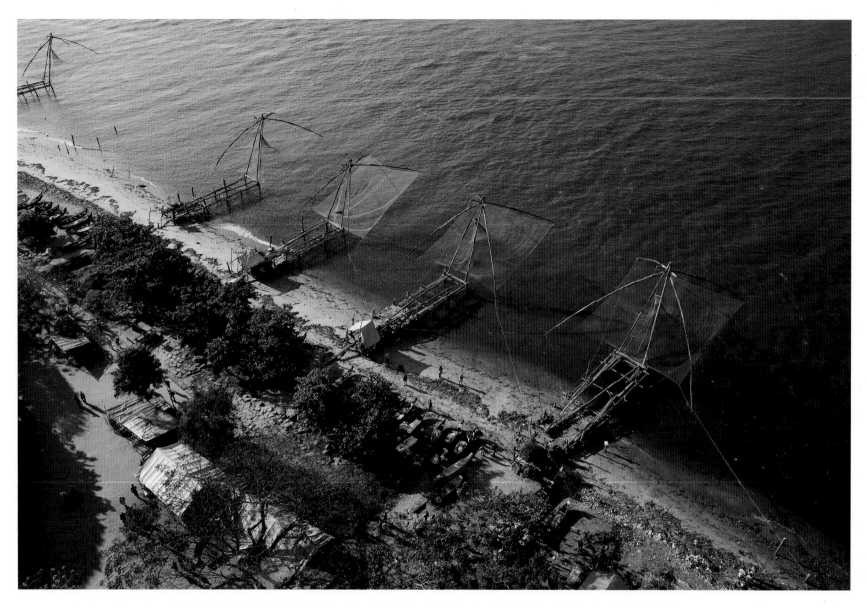

'On the beach in Kochi, I fly my kite at sunset, with a perfect breeze coming in from the west. Everything seems quiet – only some tourists hang around – and I can concentrate on my aerial shooting. But I am not carrying my permission letter with me... and end up spending six hours at the police station! I must prove I'm not interested in shooting any sensitive site in this strategic port of Kochi. I'm upset. I'm missing a fantastic evening for shooting, and will have to come back tomorrow, hoping for good conditions.'

Above and facing page: *Chinese fishing nets in Kochi. Brought in the thirteenth century by traders from China, the nets, generally fixed on the beach or riverbank, are lowered into the water at night with a lit lamp hanging from the centre to attract the fish.*

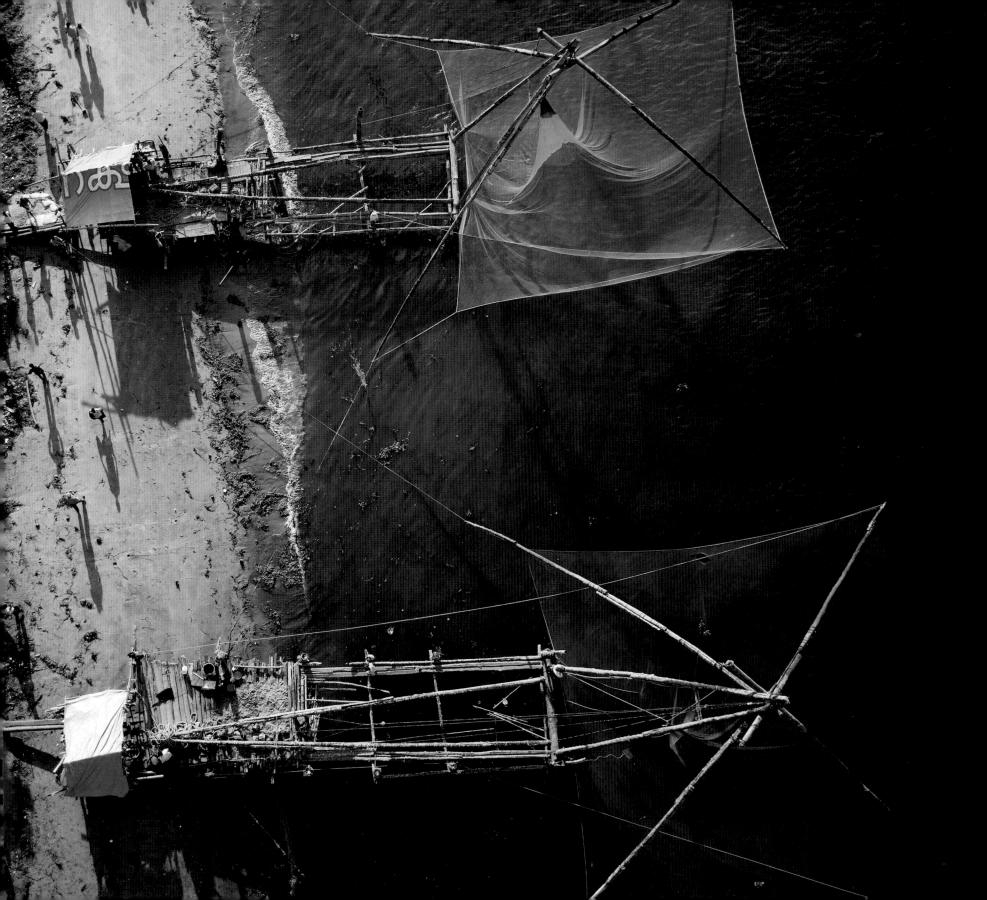

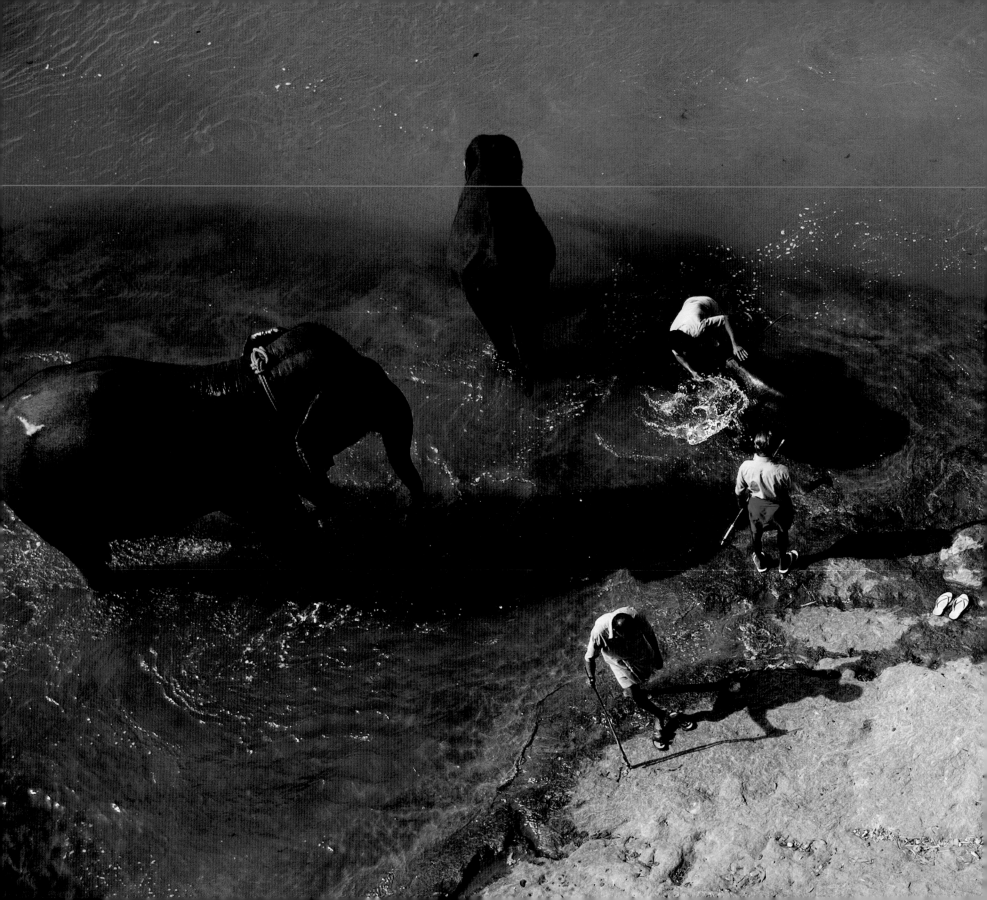

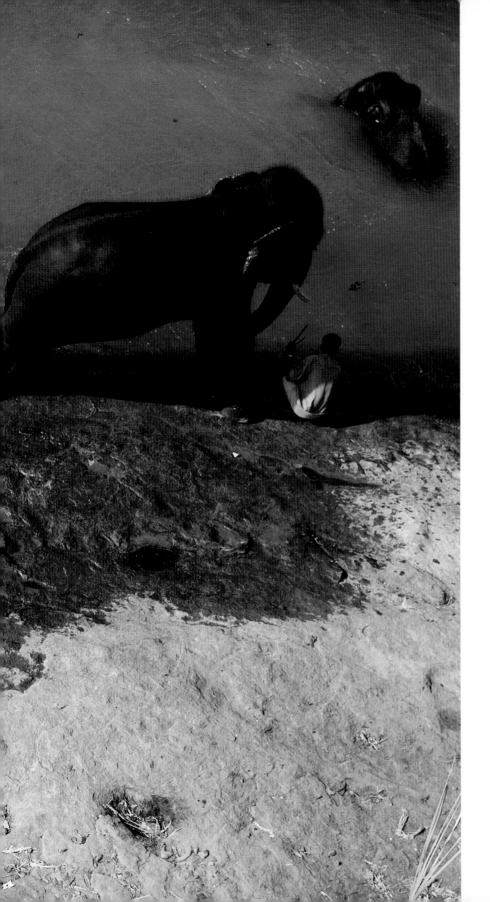

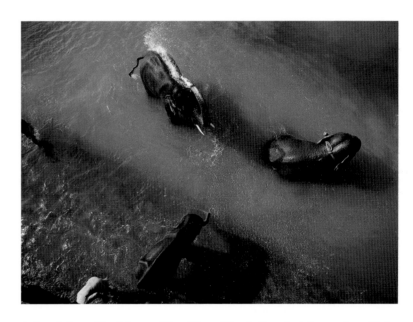

Left and above: 'I'm flying my kite while walking in three feet deep water, with the current throwing me off balance. I try to keep my radio safe and dry, sometimes wedged between my teeth. My camera sometimes gets so low it may get splashed by water, but the jumbos don't seem to care... They like to pose for it, though! Next time, I'll swim with them, I say to myself...' In this elephant training centre at Kodanad, near Ernakulam, baby elephants separated from their mothers, as well as injured ones are taken care of. Every calf has its own tamer, and there is an incredible relationship between them, respectful and tender.

KALARIPAYATTU

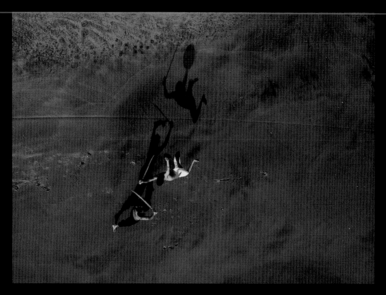

Believed to be the forerunner of all martial arts, Kerala's *kalaripayattu* dates from the twelfth century, when conflicts between feudal nobilities in the region were common. There were two branches of kalaripayattu – the *chaverpada,* or suicide squads, and the *chekavan,* or warriors who fought duels to death. Still taught widely in Kerala, kalaripayattu students learn to use weapons such as swords, spears, daggers and *urumi* (a flexible metal sword). The finely choreographed movements of kalaripayattu derive from Kerala's ancient dance forms such as *kathakali* (dramatised presentation of a play) and ritual arts such as *theyyam* (performed as an offering to deities).

Above and facing page: 'It's like the theatre of shadow puppets from Rajasthan. In my monitor, I don't even look at the kalaripayattu fighters, but only at their two-dimensional projection on the sand at the beach in Kozhikode. The shadows become the subject. And they have something that takes my thoughts to mythical acts of war depicted on Greek vases.'

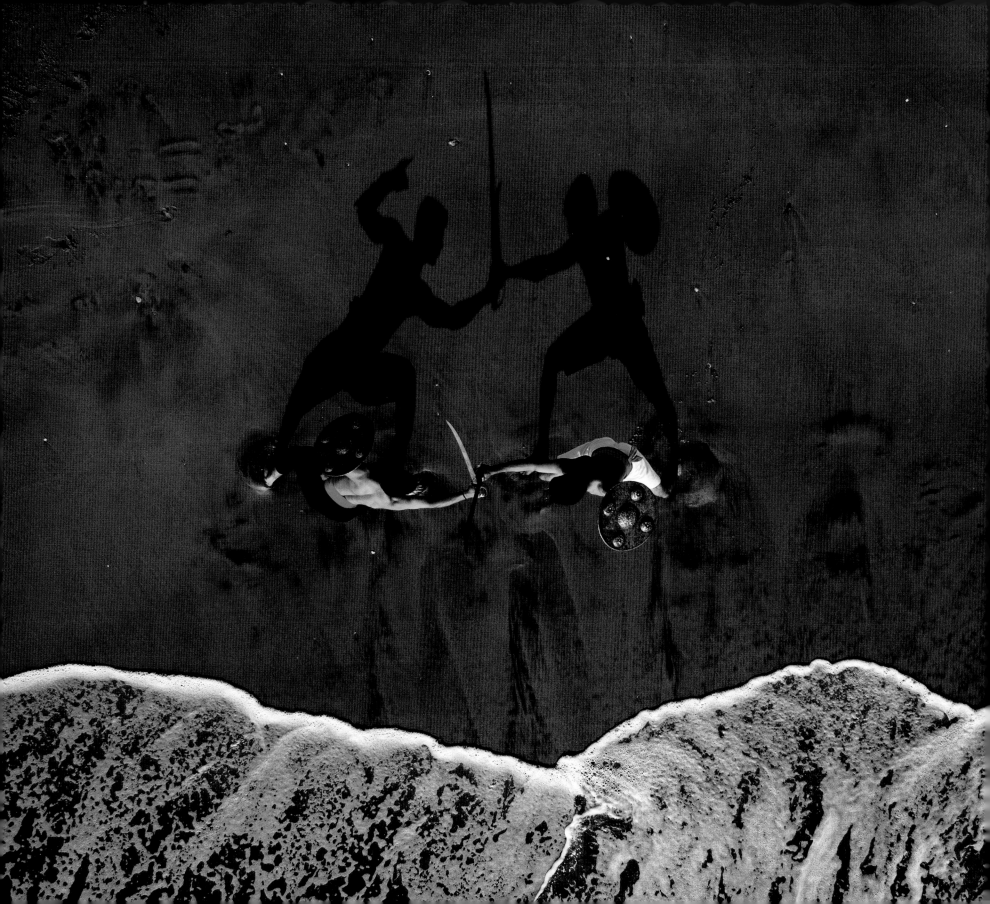

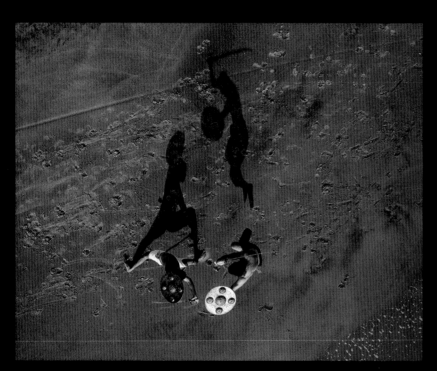
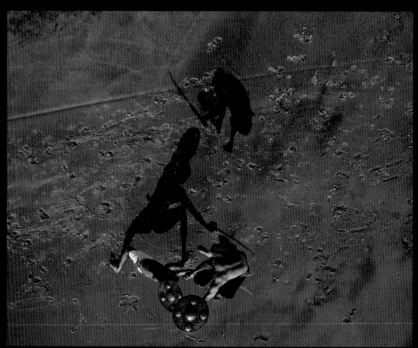

Above and facing page: *Students practicing the ancient art form of kalaripayattu at a beach in Kozhikode.*

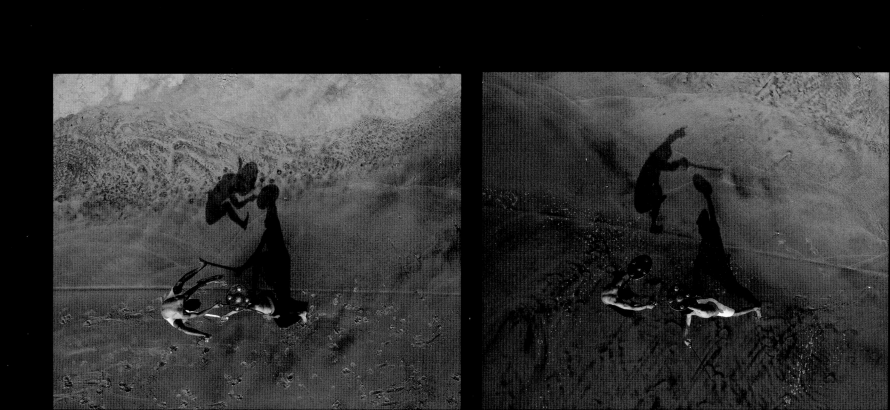

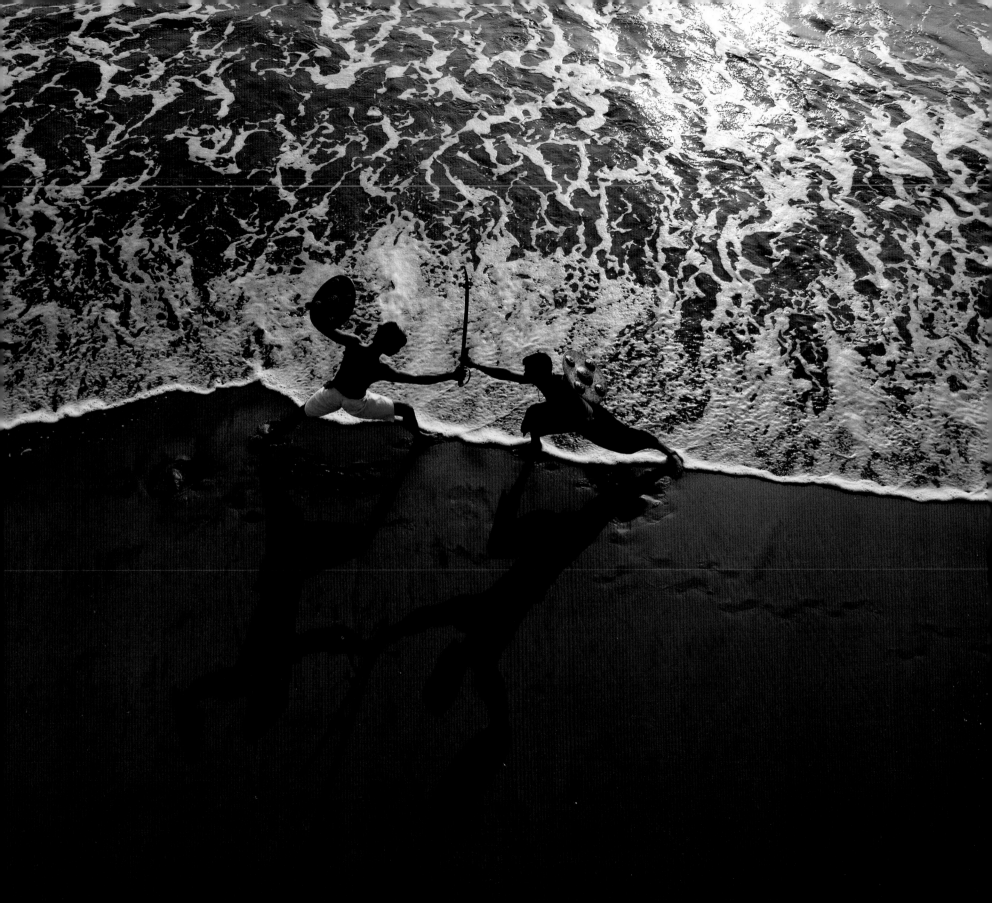

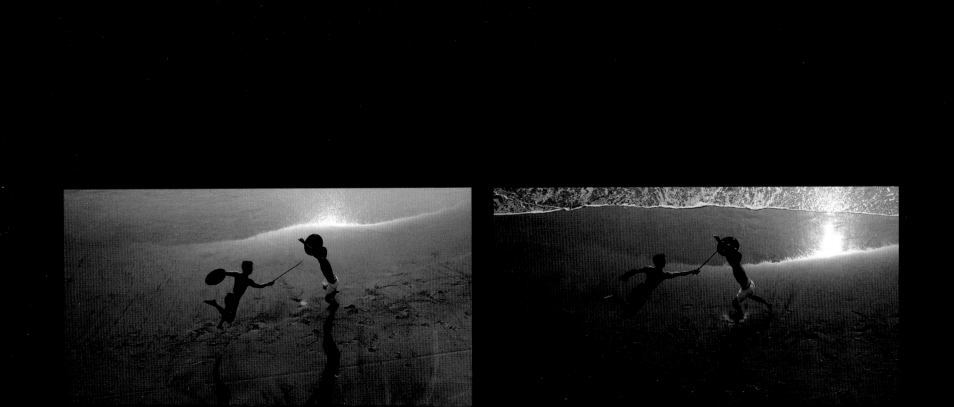

ACKNOWLEDGEMENTS

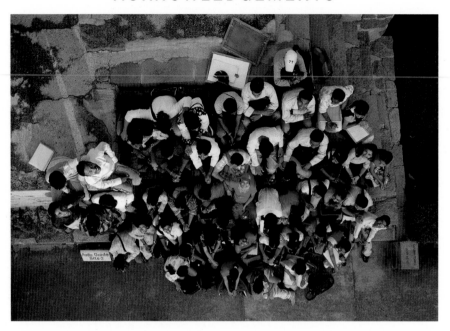

I want to thank India for everything it has given me.
Being there is a permanent gift for the senses, and this book is a tribute to its marvels.

I want to thank every acre of land above which I have flown my kites.
I want to thank all those faces smiling at me every single day I spent in India.
I want to thank everybody involved in the spectacle of traffic jams.
I want to thank the seats of the Ambassador car for being bumpy.
I want to thank the land of spices, whose smells waft into the car and colour my senses.

I want to thank India's heritage for keeping intact the scenes of my exotic fantasy,
built on stories of colourful kingdoms and enchanting nature.
I want to thank every living soul I met for their humanity.

And yes, I want to hug the policemen who arrested me at times, but who did their job with passion,
protecting the nation against such a strange flying and spying camera, holding back their smiles…
Thanks to all for the experience, and sorry for any inconvenience I may have caused.

But here are some of the individuals without whom nothing could have been possible: For their unfailing support, my entire family – including Alain Levy, for providing the missing link. Shri Amitabh Kant, Joint Secretary, Ministry of Tourism; my friends Minakshi and Kulbushan Jain, architects; Shri Parwanand Dalwadi, photographer; Alain Couturier, from Ahmedabad; HH Gaj Singh, 'Monty' Mahendra Singh and all the people at Museum Mehrangarh Trust, Jodhpur; HH Shriji Arvind Singh Mewar from Udaipur; Scott Skinner and Ali Fujino from The Drachen Foundation, Seattle; Tal Streeter, kite artist from New York; Didier Besombes and Tête en l'Air, Shop Photo, from Montpellier; Gilles Tarnier; Shri Babu Rajeev, Dr D.R. Gehlot, Dr R.S. Fonia, P.K. Mishra from Archaeological Survey of India; Nawab Jafar Mir Abdullah from Lucknow, for sharing his knowledge about his city and the history of patangbaazi; D.K. Burman from Agra; A.K. Tripati, Ajay Sharma, B.L. Gupta, Rajeev Lunkad from Jaipur; Shri Sanath Kaul, D.K. Sharma, from Delhi; Raj Kumar from Kerala; V. Elumalai; all Departments of Tourism of the concerned States; India Tourism Office in Paris; Shatrughun Jiwnani from the Baha'i House of Worship; Ajay Prakash, Roger Alexander and Runjiv Kapoor from Mumbai; Air India and Indian Airlines; Shri Mohan Kaliappa Nadar from Kozhikode, my soulmate in Kerala, with his extraordinary knowledge of his land; and Tondup, Wangdu, Selva, Attar, Sima, Rajesh, Kripal, Subha, who all shared my quest of the perfect wind.

I wish I could bring this book to you, Philippe.